P9-EFG-175

THE SEDUCTIONS OF DARWIN

THE

SEDUCTIONS

OF DARWIN

ART | EVOLUTION | NEUROSCIENCE

MATTHEW RAMPLEY

THE PENNSYLVANIA STATE UNIVERSITY PRESS | UNIVERSITY PARK, PENNSYLVANIA

Library of Congress Cataloging-in-Publication
Data

Names: Rampley, Matthew, author.
Title: The seductions of Darwin : art, evolution,
 neuroscience / Matthew Rampley.
Description: University Park, Pennsylvania : The
 Pennsylvania State University Press, [2017]
 | Includes bibliographical references and index.
Summary: "A critical study of the growing use
 of evolutionary theory and neuroscience to
 interpret art. Explores the question of what is
 gained from using ideas and methods from
 the biological sciences in the analysis of art"—
 Provided by publisher.
Identifiers: LCCN 2016033408 | ISBN
 9780271077420 (cloth : alk. paper) ISBN 978-
 0-271-07743-7 (pbk. : alk. paper)
Subjects: LCSH: Art and biology. | Evolution
 (Biology) in art. | Neurosciences and the arts. |
 Art—Philosophy.
Classification: LCC N72.B5 R36 2017 | DDC
 701—dc23
LC record available at https://lccn.loc.
 gov/2016033408

Copyright © 2017
The Pennsylvania State University
All rights reserved
Printed in the United States of America
Published by
The Pennsylvania State University Press,
University Park, PA 16802–1003

The Pennsylvania State University Press is
a member of the Association of American
University Presses.

It is the policy of The Pennsylvania State
University Press to use acid-free paper.
Publications on uncoated stock satisfy the
minimum requirements of American National
Standard for Information Sciences—Permanence
of Paper for Printed Library Material,
ANSI Z39.48–1992.

Typeset by
REGINA STARACE
Printed and bound by
SHERIDAN BOOKS
Composed in
MINION PRO
Printed on
NATURES NATURAL
Bound in
ARRESTOX LINEN

CONTENTS

PREFACE AND ACKNOWLEDGMENTS

This is a book about the nature of inquiry into art and culture. Its origins lie in a conversation with colleagues at the University of Birmingham prompted by the appearance on the library shelves of a curious volume: *Neuroarthistory: From Aristotle and Pliny to Baxandall and Zeki.* Written by an eminent scholar—John Onians—it posed provocative and important questions about the relation of art history to the natural sciences. Initially, I was inclined to be generous toward it for its ambitions. It came in the wake of a number of other works that had used ideas from the natural sciences, in particular, the biological sciences, to think through sociocultural problems. In prehistoric archaeology, for example, the mapping of patterns of gene distribution has led to some surprising and challenging ideas. A prominent example of this is Stephen Oppenheimer's work on British prehistory, which argues that there were significant population flows from Neolithic Spain to Wales in connection with the migration of labor in relation to flint mining.[1] For Oppenheimer, patterns of gene distribution also cast doubt on the standard view that the Celts emerged as a recognizable linguistic group in central Europe. Instead, he suggests, the data point toward an origin in the Iberian Peninsula, spreading east and north through France to Britain, northern Italy, and Switzerland. Likewise, Jared Diamond has explained a range of global historical phenomena in the light of large-scale evolutionary and environmental factors that impeded certain types of social and cultural organization in some locations and facilitated them in others.[2] Diamond has not met with universal assent, but his alternative framing of historical problems nevertheless illustrates how disciplines outside the humanities may have an important contribution to make to the understanding of human social and cultural development.

At first sight, *Neuroarthistory* fit into this pattern, but there was something eccentric about it that troubled me. It was not simply the contrived manner in which Onians tried to force a heterogeneous group of authors into

an intellectual lineage in order to buttress his own project. It was also the strangeness and crudeness of his basic claims, namely, that the study of brain behavior can explain complex questions of artistic intention and significance. This seemed misconceived at a fundamental level, yet rather than simply dismiss the book, as many have done, I decided to try to articulate what it was about the book that I found so concerning. Further investigation revealed that Onians's work is not an isolated instance but part of a growing body of literature devoted to the same topic. As such, it seemed that it would be a mistake merely to ignore it, not only because of the growing quantity of material being published but also because the project of neuroarthistory and neuroaesthetics has, with the promise of bringing scientific rigor, been gaining in legitimacy, securing significant amounts of funding from research councils across the world.

As I explored the claims of neuroarthistory in greater depth, I became increasingly drawn into a related endeavor: evolutionary aesthetics. This turned out to be the larger metanarrative framing neuroarthistory, since the latter links the study of the brain to notions of evolved cortical capacities and structures. It is for this reason that I decided to turn evolutionary theory and Charles Darwin into the leitmotif of this book. The focus on evolution permits me, too, to bring systems theory into the discussion, since evolution is a central preoccupation of systems theory, albeit in a way that many might not initially recognize. Few discussions of neuroscience or evolution have made their way into the pages of the main journals of art history or aesthetics. Equally, few art historians have engaged directly with this material. There are perfectly understandable reasons why; many of the claims advanced in the name of neuroarthistory and evolutionary aesthetics have been tendentious, unconvincing, bizarre, and even risible. The principal advocates are often to be found in other disciplines, such as archaeology, biology, psychology, anthropology, medicine, philosophy. Nevertheless, art historians ignore this field at their peril; apparently marginal ideas have a remarkable ability to redefine disciplines, and at present the exponents of evolutionary aesthetics, art history, and cultural studies in general have faced little serious and concerted questioning of their basic methodological premises. This book is driven by the belief that it is necessary to engage in just such a critical engagement.

Much of the discussion will come across as polemical in tone, and a recurrent theme is analysis of the numerous problems created by the race to incorporate ideas and methods from various branches of the biological sciences into the study of art and culture. Yet, as any philosopher will confirm, the term "critique" is derived from the ancient Greek verb *krīnō*, which means

to choose, and this book is about choices. It is about the choices available when we consider the natural sciences as a possible source of ideas and approaches to be deployed in the interpretation of artworks in particular and of cultural practices in general. How might theories of evolution and the brain enrich our understanding of art and aesthetic experience? Equally, what are their limitations? Does an understanding of their capacities enable us to cast light on the much-debated subject of the relation between art and science? The latter is still often discussed in crude dualistic terms that seem to have progressed little beyond the arguments about this same question that flourished in the later nineteenth century.

Through its engagement with a specific set of questions, therefore, this book attempts to help illuminate a much larger philosophical and methodological preoccupation. In so doing, it overlaps with the recurring calls for greater dialogue between art and science. In one sense, it is sympathetic to those calls, except that it tries to distance itself from much of the discourse of "openness" between different fields and paradigms of inquiry, which can often amount to little more than empty platitudes. It has been an intellectual commonplace, at least since Hegel, that negation and the working through of opposites underpin the most productive intellectual labor, not the well-intentioned search for commonality or the uncritical subsuming of differences in the name of unity. It is in that spirit that I have attempted to proceed.

This study owes its inception and development to discussions with many colleagues. It is not possible to list them all, but some individuals deserve particular thanks for the ways in which our conversations helped inform the ideas explored here. They include Francesca Berry, Horst Bredekamp, Leslie Brubaker, Richard Clay, Mark Collard, Raymond Corbey, Whitney Davis, Marta Filipová, Jennifer Gosetti-Ferencei, David Hemsoll, John Holmes, Jonathan Hurlow, Ladislav Kesner, Hubert Locher, Sylvester Okwunodu Ogbechie, John Onians, Ingeborg Reichle, Raphael Rosenberg, Kim Shapiro, Badrolhisham Mohammed Tahir, and Richard Woodfield. I would also like to thank the anonymous readers and my editor at Penn State University Press, Ellie Goodman, who has, as usual, been exemplary in her support and encouragement of this project. Finally, it would only be right to thank those who have managed to keep me grounded while undertaking the research for this project: Marta, Thomas, Ben, Peter, and Boris.

Bournville, March 2016

INTRODUCTION

In 1959, the novelist and chemist Charles Percy Snow delivered a now famous lecture titled "The Two Cultures." The cultures in question were those of the scientific community and the literary intelligentsia, and Snow's lecture analyzed the polarization of intellectual life due to the estrangement and gulf of incomprehension between the two. Indeed, he argued, more than just incomprehension, there existed mutual hostility and suspicion: "Thirty years ago the cultures had long ceased to speak to each other, but they at least managed a frozen smile across the gulf. Now the politeness has gone and they just make faces."[1]

Snow's lecture remains perhaps the best-known expression of what one commentator has referred to as his "technocratic liberalism," an optimistic embrace of the idea of a meritocratic and technologically advanced society that he set in opposition to the "Luddite" tendencies of the artistic and literary community of the 1950s.[2] It was the culmination of a larger debate in postwar Britain about the place of scientific inquiry, and, in the wake of the 1951 Festival of Britain, it drew on a wider process of introspection about the future of British society.[3] Snow's diagnosis focused on the specialization in education that occurred too early, and his consequent remedy was to broaden the educational curriculum. While he overstated the differences, his argument was to prove enormously influential, and it continues to be invoked as a point of reference in debates in this area. Indeed, the call for a dialogue between the arts and humanities and the sciences has become a recurring theme; national and international research councils and funding bodies frequently and actively encourage projects that cross the boundaries between the two.

A response to the immediate historical circumstances of postwar Britain, Snow's lecture was also rooted in a longer debate over the relation between the

social and natural sciences in Germany before the First World War. Occupying the attention of major thinkers of the time, including Max Weber, the debate concerned the status of historical and social knowledge. If empirical historical findings could not be generalized into normative statements comparable to the laws "discovered" by the natural sciences, how could the humanities defend their scholarly status? Famously, Weber's response to this question was to assert the distinctiveness of inquiry in the humanities. They did not need to mimic the natural sciences in order to attain legitimacy. "There is no absolutely objective scientific analysis of culture," he argued, for it consists of the "empirical science of concrete reality" and its aim is the "understanding of the characteristic uniqueness of the reality in which we move."[4] This purported difference was summarized by Weber's contemporary, the philosopher Wilhelm Windelband, as the distinction between the "nomothetic" concerns of the natural sciences and "idiographic" approach of the humanities.

Both thinkers acknowledged that this difference was not absolute. Windelband noted that "one and the same object can be the subject of nomothetic as well as ideographic inquiry." A language might be studied in terms of its grammatical, morphological, and syntactical structures and rules, but at the same time, "each language is a unique, temporary phenomenon in the life of human speech."[5] Likewise, Max Weber highlighted the use of the "ideal type" as a heuristic procedure in sociology. The ideal type, a "synthesis of a great many diffuse, discrete, more or less present and occasionally absent concrete individual phenomena . . . arranged . . . into a unified analytical construct," serves as the basis for the identification of historical and social patterns against which individual cases can be contrasted.[6] Despite such concessions, both men sought to mark out the distinctiveness and legitimacy of a domain of inquiry the objects of which could not be defined in terms of conformity to "objective" lawlike behavior. Linked to this, too, was the claim that the natural sciences are concerned with the objective, third-person explanation of observed phenomena, in contrast to the central role of understanding in the humanities, where actions and events are seen as the product of human agency and subjective intentions.[7]

Knowledge of the details of the dispute among German scholars of the early twentieth century is now of limited resonance except to specialists, but it laid down the outlines of a debate that has continued to the present. Definitions of science still revolve around notions of the role of "covering laws," as the philosopher Carl Hempel termed them. To quote Hempel, "Scientific explanations, predictions, and post-dictions all have the same logical character: they show that the fact under consideration can be inferred from certain other facts

by means of specified general laws."[8] It is often assumed, Hempel suggested, that the historical and natural sciences are distinguished on this very point, that the former deal with singularities that cannot be accommodated within a framework of generalized rules.

Hempel formulated this distinction in terms of the opposition between the nomological and the idiographic. Rather than thereby dismiss history as lacking the objectivity of the natural sciences, Hempel tried to argue that it, too, operates in a similar manner. "Historical explanation, too, aims at showing that the event in question was not 'a matter of chance' but was to be expected in view of certain antecedent or simultaneous conditions. The expectation referred to is not prophecy or divination, but rational scientific anticipation which rests on the assumption of general laws."[9] Hempel's formulation now belongs to the history of the philosophy of science, but the basic framework was taken up by scholars in the humanities.

Michael Baxandall, for example, used it in his analysis of art-historical interpretation. Recognizing that historians employ "soft" generalizations, Baxandall emphasized that art history is nevertheless a primarily idiographic enterprise. This is not only because "our interest as historians or critics is . . . towards locating and understanding the peculiarities of particulars," but also, he argued, because of the distinct focus of art historians. Historians study actions and events that may or may not be subsumable under covering laws, but art historians are concerned with artworks as the *deposits* of those actions. The historian may be concerned with works of art and other historical artifacts, but "his attention and explanatory duty are primarily to the actions they document, not to the documents themselves."[10] In contrast, the art historian is concerned with the document itself—a work of art—even though it is the result of an intentional behavior.

Given the debated status of unanalyzed notions of intentionality, agency, and authorship, one may wish to be more cautious than Baxandall, but he has nevertheless captured something important that distinguishes art history both from the model of scientific explanation advanced by Hempel and others and from what might be seen as the nomological dimension of historical inquiry. To take one of Baxandall's examples, we may be able to explain certain aspects of Piero della Francesca's *Flagellation of Christ* by reference to "antecedent or simultaneous conditions" such as patterns of church patronage, iconographical traditions, theological doctrine, and the like. But this only manages to identify the painting as an instance of a certain type, rather than capturing something about the specificity of *this* image in contrast to all the other versions of the flagellation.

This issue lies at the center of many of the attempts to overcome the division between the arts and the sciences, and it will be discussed again in this study. But before going further into methodological reflection, it is useful to consider more recent attempts to implement Snow's call for an integration of knowledge. Perhaps the most high-profile instance can be seen in the growing calls for "consilience." Its leading advocate has been the biologist Edward O. Wilson, who has attempted to summarize the ideal of consilience as a systematic and coherent approach to the production of knowledge. Envisioning himself as heir to such philosophes as Condorcet, Voltaire, and Diderot, Wilson sees consilience as picking up the tradition of Enlightenment thought that was interrupted by the French Revolution and the rise of romantic irrationalism.

Many of Wilson's arguments have a pertinence and force that are difficult to deny. He claims, for example, that one of the reasons for the failure of governments (and societies) to respond adequately to the challenges of environmental degradation is the fragmentation of knowledge. Biology, ethics, economics, environmental policy, and social science occupy different domains of knowledge, when there is an urgent need for them to be combined.[11] A leading entomologist, Wilson has been particularly preoccupied with how the biological sciences can be deployed to explain facets of human culture. His first major foray into this area, the book *Sociobiology*, sought to ground human social behavior in inherited biological traits. Although much disputed, not least because of its political and ideological implications, sociobiology became a substantial field in its own right, and it is currently enjoying renewed interest.

The idea of a dialogue between, or even a convergence of, different domains of inquiry may, at first sight, appear a largely positive goal; few dispute the value of interdisciplinary thinking. Yet it raises a host of questions that will be the focus of this book. Wilson's example of environmentalism is initially persuasive, except that the real object of criticism is the failure of government to take into account insights from numerous domains in the formation of *policy*, rather than the epistemological problem of the unity of knowledge. Wilson's argument, moreover, is based on an undeclared realist epistemology that assumes the world as a single object of knowledge, when there are many more constructivist positions that would cast into doubt the a priori possibility of a unified field of knowledge.

Aside from such theoretical issues, there are other reasons to be wary of the new "consilience," for in many cases the calls for such cross-disciplinary activity have been prompted less by a search for a dialogue of equals and rather more by a desire for intellectual imperialism, in which the proponents of the

natural sciences lay claim to superior explanatory powers. Wilson provides an illustration when he states, "Without the instruments and accumulated knowledge of the natural sciences—physics, chemistry, and biology—humans are trapped in a cognitive prison. They are like intelligent fish born in a deep, shadowed pool. Wondering and restless, longing to reach out, they think about the world outside. They invent ingenious speculations and myths about the origin of the confining waters, of the sun and the sky and the stars above, and the meaning of their own existence. But they are wrong, always wrong."[12] The arts and humanities, lacking the tools of the natural sciences, are lost in a world of delusional mythologies. A similar opinion is expressed in *Creating Consilience*, a recent collection of essays that examines how the humanities and the sciences might be "integrated." The nature of such integration is apparent, perhaps, in the first sentence of one of the essays in this collection, by the anthropologist Pascal Boyer: "Why is most cultural anthropology irrelevant?" For Boyer, it is because anthropology has written itself out of the concerns of most importance to contemporary society. His upbeat solution is that it should embrace the biological sciences, since, he asserts, "the traditional concerns of cultural anthropology are currently being given a new lease of life and often a much more lively public relevance by evolutionary biologists and economists, suggesting that there may be such a field as the 'science of culture.'"[13] Boyer is himself closely associated with a program of evolutionary anthropology that has claimed to identify the inherited biological roots of a wide range of cultural and social practices.[14] Yet of course the use of the term "irrelevant" invites the question: for whom? Boyer and his colleagues never provide an answer, but it is a recurring theme in this study, which starts from the premise that the construction of knowledge is a function of the interests of the inquirer, which, in turn, determine the questions to be asked.

One of the principal causes of the "two cultures divide" is, it is alleged, the emergence of conflicting ontologies. Scientists are ontological monists, whereas exponents of the humanities hold on tenaciously to a dualism of mind and body and to the mystifying concepts of *Verstehen* (understanding) and *Geist* (spirit) inherited from the German hermeneutic tradition.[15] Once such dualism is overcome, it is argued, the humanities and the sciences can be properly integrated, and more rational accounts produced of cultural practices and representations. Criticisms of such proposals are, it is claimed, little more than an unreflective response to their counterintuitive implications. "Because of our innate folk dualism, human level realities—beauty, honor, love, freedom—strike us as pertaining to an ontological realm entirely distinct from the blind deterministic workings of the physical world, and we are always

ready to trot out the emotionally fraught charge of 'reductionism.'"[16] This trivializes, of course, the philosophical stakes involved. While some defenders of the specificities of the humanities may fall back onto unanalyzed notions of mind, subjectivity, and intention, such breezy dismissal makes no serious attempt to understand and engage with the philosophical underpinnings of the humanities.

One of the shrillest voices of all in this debate has been that of Richard Dawkins. Having written a number of groundbreaking works in evolutionary biology in the 1970s, Dawkins has since become the advocate of an increasingly fetishized and reified notion of science.[17] Taking particular aim at religious belief, Dawkins has tended to dismiss anything other than "scientific method." It is not the goal of this book to defend religions against his polemics, but it is legitimate to express concern at Dawkins's wish to monopolize the field of inquiry in the name of a simplistic, philosophically and historically uninformed image of "science." The voices calling for consilience or for a dialogue between the sciences and the humanities therefore often seem to be aiming at anything but an open conversation. They envisage not a meeting of equals but, instead, an encounter in which the purported illusions motivating the humanities are shown for what they are and replaced with a properly rational program of research.

This book is concerned with the attempts to apply such an outlook to the study of art. It examines questions to do with theories of aesthetic response as well as issues relating to the historical understanding of art. There are some obvious examples of the interaction between scientific research and art-historical inquiry. Technical art history, for instance, is a by-product of modern chemistry, and its relation to the natural sciences is not in question.[18] However, this study focuses less on that well-defined subfield of art history and more on the particularly prominent role that the biological sciences have played in the project of rethinking art and aesthetics. The theory of evolution has been of central importance in this context, and one might even argue that the call for consilience amounts to little more than an attempt to create a neo-Darwinian framework for the analysis of art. Indeed, evolutionary aesthetics has become a recognized field, and much of this book is devoted to the critical appraisal of the claims of neo-Darwinian accounts of art and aesthetics. Other, related approaches have also gained prominence, however. These include neuroarthistory and the attempt to analyze artistic creativity, as well as the response to art and architecture, using techniques devised in brain science. This book also examines systems theory. More usually seen as a product of the interest in management and computerized systems in the 1960s,

systems theory has a much wider set of conceptual roots, and in the writings of its most important representative, the social theorist Niklas Luhmann, the theory of evolution is a central organizing theme. It has gained particular traction with theorists of contemporary art.[19]

Almost as soon as art history emerged as a modern discipline, art historians expressed anxiety about its status. This anxiety related not only to its assumed role as a mere auxiliary discipline to history but also to its status as a "scientific" enterprise. At the first-ever international congress of art historians, held in Vienna in 1873, the convener, Rudolf Eitelberger, declared that "art history was created through scientific work—and it is only through scientific work that it has a future."[20] This claim, as much a defensive plea as a confident assertion, reveals the fear that art history might be vulnerable to the charge that it was little more than an exercise in dilettantism, its exponents pursuing personal aesthetic preferences when writing about art. It was to counter such suspicions that Eitelberger proclaimed its scientific status, a view that was repeated by his successor as professor of art history in Vienna, Moriz Thausing, who in his inaugural professorial address of the same year declared that taste and aesthetic value had no place in art-historical scholarship.[21]

The term *Kunstwissenschaft*, used by Eitelberger and Thausing to denote art history, suggested not only "science" but also "scholarship."[22] It had a less restrictive set of meanings than the English term *science* would suggest, and German *Kunstwissenschaft* embraces a broad spectrum of practices, from positivistic and archaeological documentation of factual information to iconological interpretation and formal and technical analysis. Nevertheless, almost from the inception of their discipline, art historians showed a lively interest in the natural sciences. Darwin's *On the Origin of Species*, first published in 1859, played an important part in influencing the thought of art historians across Europe and North America in the late nineteenth century. For many, the overall shape of art's history could be conceived of as an evolutionary process; Gottfried Semper, Alois Riegl, Franz Wickhoff, and Max Dvořák all espoused this concept. This not only informed the understanding of forms; Riegl and Heinrich Wölfflin also saw art as an index of the evolution of vision. The meaning of this concept remains much debated, but it reveals the clear influence of Darwinism.[23] Wölfflin's and Riegl's contemporary Aby Warburg mapped the history of art onto the evolution of human emotional and aesthetic response, with the constant possibility of the reemergence of atavistic impulses from a primitive past.[24] Warburg's interest in the representation of bodily gesture, for example, was indebted to his repeated reading of Darwin's study *The Expression of Emotions in Animals and Man* (1872). In Britain, too,

Darwinian thinking was marshaled to provide an explanatory framework for the development of artistic forms; the anthropologists Alfred Haddon and Henry Balfour, for example, both described the history of artistic decoration in evolutionary terms, mapping out the genealogy of a wide range of artifacts.[25]

Alongside their interest in the theory of evolution, Wölfflin, Riegl, and others responsible for the development of modern art history sought to explain style and aesthetic response in terms of physiology and the psychology of perception. Younger scholars, such as Yrjö Hirn (1870–1952), Wilhelm Worringer (1881–1965) and, later, Ernst Gombrich (1909–2001), continued this interest.[26] But the subsequent identification of art history as one of the humanities entailed the marginalization of attempts at such integration.[27] Edgar Wind may have attempted, in *Experiment and Metaphysics*, to draw parallels between scientific experimentation and art-historical inquiry, but this work fell stillborn from the press.[28] Gombrich attempted to explore the psychology of perception, but his work was effectively ignored by the art-historical establishment. The occasional eccentric publication, such as Patrick Trevor-Roper's attempt to explain the work of a range of artists by reference to the defects in their vision, has done little to alter the larger general pattern.[29]

It is therefore all the more striking that in recent years there has been a renewed effort to bring scientific (read: biological) methods and concepts to bear on the understanding of art. This book proceeds on the premise that despite the often unhelpful tone of their aggressive and triumphalist rhetoric, the exponents of consilience cannot be simply ignored or dismissed; their claims require critical scrutiny. This is especially so given that neo-Darwinian approaches aim to explain some of the most fundamental questions to do with art, such as the nature of artistic creativity, the character and purpose of aesthetic experience, the process of artistic transmission, art's social purpose, and, ultimately, art's origins.

Speculation as to the origin of art is coterminous with the history of writing about art; Pliny the Elder's account of painting in the *Natural History* opens with a comment not merely on who the first artists were but also on how painting first emerged.[30] Every subsequent major writer on art, from Vasari to Winckelmann, Hegel, Riegl, and Gombrich, includes an account of art's origins, and the discovery of Paleolithic artifacts and rock art in the nineteenth century gave added impetus to such conjecture. Moreover, the question of origins has been taken up again with renewed vigor in recent years, encouraged by neo-Darwinian theorizing about art and culture. Authors with otherwise disparate theoretical and ideological commitments, such as Ellen Dissanayake, Denis Dutton, Steven Mithen, and Winfried Menninghaus, have

all advanced evolutionary theories of art, with an emphasis on its adaptive function. In the absence of other satisfactory metanarratives, evolutionary theory has also been used as the underpinning of "world art studies."[31]

The first chapter of this book examines and critiques the argument that art emerged as an evolutionarily adaptive behavior, not only by questioning the strength of its claims, or indeed of its politically problematic assumptions (heteronormative models of sexual and social behavior are frequently inserted into descriptions of the Paleolithic primal scene), but also by interrogating its *value* as a statement about art and art behavior. It may be persuasive to assert that art was the product of some adaptive mutation, but there is no way of knowing, and it is difficult to identify evidence for such a claim, or even to agree on what *might* count as evidence. In other words, I argue that such theories are underdetermined—one might even add "unscientific"—and an indicator of this might be that the meaning of the term *adaptive* remains markedly uncertain. Some authors have pointed toward parallels in the mating rituals of other species to suggest that art was primarily directed toward reproduction. In contrast, others have suggested that art emerged out of a reservoir of behaviors that were reinforced by, and crucial to, human cognitive development. Still other commentators have suggested that art's representational function, its ability to evoke virtual and fictional realities, built on and enhanced the ability to weigh up possible worlds, a capacity that underpins deliberation on different courses of action and their possible consequences. Finally, some have argued that art was adaptive inasmuch as it enhanced the sense of communal identity and thereby ensured the reproduction of the group. Each of these arguments is equally plausible, but the difficulty is that there is very little evidence for which might be *more* plausible. This touches on a wider debate over the concept of underdetermination.

The philosopher of science Larry Laudan has argued that the critique of underdetermination is not necessarily decisive, inasmuch as a weaker criterion of rational defensibility may be all that is required to sustain an argument.[32] This may be the case, but the difficulty with evolutionary aesthetics is that the models of adaptation advanced are all *equally* defensible, and the decision to select one over another is ultimately dictated by extrinsic criteria.[33] One might thus begin to dispute the claim that the biological sciences provide a superior interpretative approach. Instead, it turns out that a central aspect of evolutionary theories of art lacks any "logical" or "scientific" basis.

One can, of course, make similar criticisms of the humanities in general and art history in particular. Even the most descriptive account of a work of art is a selective interpretation of what the commentator is observing; "close"

reading, a much-repeated trope in recent years, is anything but close, since it is a selective attention directed by the wider interests of the interpreter. Moreover, as James Elkins has argued, although art historians have frequently drawn on "nomothetic" frameworks, from iconography to semiology and cultural materialism, there is nothing objective or nomological about their application to specific instances.[34] The difference, however, is that art historians are all too aware of the contingent, interest-driven, and ideological nature of their work. In other words, they make few of the claims on behalf of their practice that the exponents of consilience make in relation to their own.

The difficulties mount up when one interrogates the issue further. Even if it *is* accepted that art emerged as an adaptive behavior, this is of little help when tracing art's subsequent historical course. For example, certain types of landscape painting *may* perhaps evoke primal ancestral memories of a Pleistocene natural environment to which humans were adapted, as various authors suggest, but this helps little when trying to analyze the history of landscape as a subject of artistic representations.[35] How does this help when trying to determine the historical relationship between a classical landscape by Claude and a transcendentalist vision of northern Germany by Caspar David Friedrich, for example? How does it help when trying to determine the relationship between individual paintings of the same subject, Friedrich's *The Oak Tree in the Snow* (1829) and Gustav Klimt's *Tree of Life* (1909), if they are both expressions of the same atavistic impulse?

This type of criticism can be applied equally to the subject of the second chapter of this book, namely, the use of evolutionary theory to describe artistic diffusion and the development of artistic traditions. Aby Warburg was the first to attempt such a project, using the biologist Richard Semon's theory of memory to describe artistic reproduction and variation.[36] Comparing artistic images to mnemic traces imprinted on biological organisms, Warburg envisioned the Renaissance as a process of mnemic recall, in which the retrieval of classical symbols was a reactivation of latent memories imprinted on the collective memory. Semon saw mnemic replication not only as a repetition of the same but also as a process where mutation could introduce variation, leading to the production of new lines of descent. This opened up the possibility that artistic tradition was not merely doomed to an eternal recurrence of the same, but rather could subvert the meanings of ancient memories buried in the inherited stock of visual imagery. Artistic tradition could thus be as much about the sublimation of primitive inherited impulses as about their repetition.

This model clearly bears similarities to Darwinian notions of evolution and descent, in which genetic lineages are either passed on and reproduced

unchanged to subsequent generations, or are passed on in mutated form and even confer reproductive advantages on their bearers. Warburg focused his study of artistic transmission on dynamograms—those visual symbols that were charged with cultural memory. More recently, in his book *The Selfish Gene*, Richard Dawkins took up the idea with the concept of the meme, the unit of cultural transmission that could be compared to the gene in biological evolution. For Dawkins, memes are handed down, repeated, and transmitted because of one of a range of qualities that bestows success on their ability to reproduce. A melody may be highly memorable; an image may be particularly moving or striking in the specific context in which it is produced. In other words, it will be better "adapted" than others in that it has features that render it more likely to be passed on. Other authors have attempted to construct similar theories of cultural and social adaptation. Of these, the most ambitious is Walter Runciman, whose wide-ranging historical sociology is founded on notions of social evolution and adaptation.[37] This is so not only in the case of larger-scale theories of social adaptation but also in more specific claims about the adaptational function of art. It is possible to see almost *any* social (and cultural) phenomenon as either adapted or maladapted, depending on the perspective chosen. Given that historical phenomena come into existence for a certain time, it is possible to assert their superior adaptivity over what preceded them, but, equally, since nothing lasts forever, it is also possible to argue that everything is maladapted, since all eventually comes to an end. As the biologist John Maynard Smith has admitted, the claims often advanced "become irrefutable and metaphysical, and the whole program merely a test of ingenuity in conceiving possible functions."[38]

The issue of arbitrariness comes to the fore when more detailed studies of individual cultural and artistic practices are examined. Numerous authors, from Alfred Barr and George Kubler to more recent writers such as Mark Collard and Franco Moretti, have attempted to construct evolutionary trees, or "cladograms," that map out the lines of ancestry, continuation, variation, and extinction of specified artistic and literary objects. A common difficulty in such accounts is that the features they use as the basis of such mapping—clues in the case of detective fiction for Moretti, geometrical figures in textile designs for Collard—are chosen arbitrarily. It would be possible to use other features, equally arbitrarily, to reach quite different conclusions.

Such evolutionary accounts ultimately run the danger, too, of offering a positivistic tautology: certain cultural and artistic practices persist or gain greater influence than others—in other words, are "selected"—because they are more successfully adapted. This weakness is evident in the work of Niklas

Luhmann, the focus of the final chapter. Luhmann's systems theory has had a growing impact on aesthetics and art history, initially in Germany, but now, gradually, in the Anglophone world as well.[39] Evolution is central to Luhmann's theory of social systems, according to which systems persist through time by means of the processes of self-reproduction, variation, and selection. But systems theory suffers from the same weakness as other evolutionary theories: namely, while it observes such processes at work, it lacks a midlevel theoretical framework for identifying how or why certain variations are selected and others are not. This deficiency is especially significant given that in systems theory the environment is not seen as a constraining factor (against which certain variations are better adapted than others), but rather as something that is itself defined by the system. In other words, the process of variation and selection is determined entirely within the system, but systems theory has no theory of the *grounds* for such determinations. It is limited to making two observations: there is variation, and there is selection.

The third chapter addresses what has become one of the most contentious and disputed areas in which biological insights have been applied to the study of art: neuroarthistory. Although associated with John Onians in particular, it has been promulgated by a number of authors, who have used neuroscience to explore familiar issues in aesthetics and the history of art.[40] Subjects have ranged from the meaning and origins of Paleolithic art—it was the visual expression of a profound evolutionary leap in human cognition and neurological structure—to more detailed art-historical case studies, such as responses to modernist abstraction, classical Greek architecture, and the Renaissance invention of perspective. For such theories, the power of art is due to its ability to stimulate certain evolved neurological processes. Conversely, neuroarthistory claims that artists and architects derive their creative disposition from specific patterns of neural development; certain areas of the brain are overdeveloped, and these are the centers of creative activity.

Neuroarthistory has been the object of trenchant criticism, not least from researchers in the neurosciences, who have criticized its superficial understanding of neurological processes.[41] Although some of these criticisms are outlined here as well, my main concern is, again, with neuroarthistory's explanatory value. Arguably, even if reactions to artworks *can* be correlated with observed patterns of neural activity, it is open to question whose interests this insight serves. Does neuroarthistory generate findings that address the disciplinary concerns of art historians, or does it merely use artistic raw material to provide "data" that are primarily of interest to those researching the operations of the brain? What would it mean for the results of functional

magnetic resonance imaging (fMRI) scans of the brain to be of significance for art-historical investigation? How might it shape the course of the discipline? What answer might there be to the suspicion that neuroarthistory merely uses the vocabulary of neuroscience to describe commonplaces about the formative role of social and natural environments? What does neuroscience add to conceptions of aesthetic experience? The limitations of this approach are all the more apparent when it is used to account for individual episodes in the history of art; it turns out to be unable to provide any method for distinguishing between responses to individual artworks, much less for considering their aesthetic, cultural, or other value and significance.

Critics of the new Darwinism in the humanities are often accused of a blinkered attitude, of an ideological and willful blindness that interferes with the possibility of genuine and meaningful dialogue with the natural sciences. In some cases, this accusation may be justified, but it should not be allowed to distract attention from the serious issues that attend the attempts to apply neo-Darwinian and neuroscientific ideas to the analysis of art. C. P. Snow's original complaint was about the lack of meaningful engagement between the two cultures, which had become both socially and intellectually estranged. Overcoming this division may undoubtedly be an important objective, but, as stated earlier, many proponents of consilience aim at something more ambitious: the wholesale subordination of the humanities to a scientific paradigm. Yet even advocates of a "naturalization" of the humanities have recognized that this is impossible. Neurology can, at best, describe individual brain states, but this is far from explaining the cultural and artistic objects that are of interest to the humanities. As Jan Faye puts it, "Cultures, norms and meanings supervene on numerous brains and their interactions, as mediated by language and other cultural symbols, which are themselves not neurophysiological states. . . . Individuals who share a common culture or communicate via some communal symbolic medium do not share some common brain state."[42]

At the center of the debate over the value of the natural sciences for the understanding of art is the question of the unity of knowledge. The premise of this book is that the desire for such unity is at the heart of the problem, for it is a misconceived project. It is no small irony that one of the most forceful advocates of epistemological pluralism has been Niklas Luhmann, whose vision of a system-oriented modernity stresses its "polycontextural" nature.[43] For Luhmann, there is no overarching form of knowledge that would encompass all insights generated by individual social, biological, and psychic systems. The perspectives of individual systems may interact (Luhmann speaks of "structural coupling" or "interpenetration"), and indeed they may

sometimes depend on such interactions, but, in contrast to the proponents of consilience, this is far from constituting a single field of knowledge.

Cashed out in concrete terms, this means that insights from the natural sciences and the humanities may well converge on topics of shared interest, and that the possibilities of such convergence have to be examined. The argument, for example, that the emergence of representational art across the world at an approximately similar time is linked to crucial evolutionary developments in human cognition is compelling, unless one is committed to a nonnaturalistic theory of human mind. Equally, for all their contentious and problematic character, Darwin's speculations as to the sexual origins of aesthetic experience merit serious attention. Likewise, through quantitative analysis it is possible to detect patterns of development that enable the reconstruction of evolutionary "trees" of artistic and cultural reproduction, variation, and selection. Nevertheless, in each of these cases the most striking feature is the limits of such explanations.

Even though an important cognitive evolutionary step may have been taken some forty thousand years ago that enabled the emergence of complex representational imagery, this can tell us little about the *subsequent* history of such imagery. A similar restriction besets the Darwinian reading of aesthetic sensibility. It may be that the sense of beauty is descended from earlier responses to visual display in mating rituals and is thus rooted in sexual selection, but such distant origins have long since been overwritten by layers of cultural meanings, which are precisely what concern art and cultural historians. In other words, evolutionary theory may provide an additional explanatory layer, but it does not easily replace more established discourses in the humanities. It is possible to map out patterns of cultural evolution, but the data generated require interpretation about the *significance* of such processes, which requires the application of a wide range of other methods and concepts from the humanities.

Such reservations do not entitle one to dismiss such initiatives out of hand, for they may offer important insights and, on occasion, lead to a reframing of established questions. As the individual analyses suggest, the use of the evolutionary framework poses questions about how one might formulate models of art-historical change and time, about the cross-cultural validity of the categories of art and aesthetic experience, about the relation between art and sexuality, about the use of quantitative information in art-historical analysis, about norms of evidence and argumentation. At the same time, they suggest that the proponents of consilience of the arts and sciences are less entitled to the confidence that has often been a hallmark of their interventions.

It may be objected that in concentrating on questions of *value*, i.e., whether such approaches offer a "difference which makes a difference," as Gregory Bateson put it in another context, I have adopted an instrumental attitude toward inquiry.[44] In response, I argue that in an important sense it is entirely pointless to debate whether Constable's *Hay Wain* is as it is owing to the way in which his brain was formed in childhood, or whether we enjoy the landscape paintings of Albert Bierstadt because they evoke buried primordial memories of our Pleistocene past, or whether we find Myron's *Discus Thrower* beautiful because his proportions signify his genetic and hence reproductive fitness. I am not in a position to adjudicate the truth-value of research into mirror neurons, or the evolution of the human mind, nor are any other art historians. My concerns lie elsewhere, with issues such as whether the claims to greater rigor advanced by the proselytizers of consilience are borne out by the examples of "scientific" approaches to art and culture, whether they offer decidable and compelling propositions, and whether the explanations offered provide answers to the kinds of questions that preoccupy art historians and critics, as well as theorists of art and culture in general. My aim is therefore to interrogate what is gained when the world is represented in this way rather than in others. The remainder of the book will explore what such an interrogation might consist of and whether it, too, has positive value.

ART, BIOLOGY,

AND THE AESTHETICS

OF SELECTION

In 1993, the Russian émigré painters Vitaly Komar and Alexander Melamid conducted a now famous poll of the American public in an effort to gauge popular taste, asking their subjects to indicate their preferred artistic subject matter.[1] The resulting composite image that Komar and Melamid produced, a painting they titled *America's Most Wanted*, bore a close resemblance to typical mid-nineteenth-century landscape paintings of Hudson River school artists such as Albert Bierstadt and Thomas Cole, and consisted of a pleasant pastoral scene set by a lake, with a foreground populated by typical North American flora and fauna and agreeably rolling hills in the background. To add a touch of mischief, Komar and Melamid added George Washington in the foreground, along with a hippopotamus wallowing in the shallows. The two artists undertook a similar exercise with a range of other countries, including Kenya, Russia, France, China, Iceland, and Portugal.[2] There was a striking commonality across cultures in terms of the ideal landscape image.

If we take this parodic exercise seriously for a moment, the similarity of the preferred image across disparate cultures can be interpreted in two ways. One possibility, put forward by Arthur Danto, is that it demonstrates the extent to which the global saturation of images has produced a common kitsch aesthetic.[3] Danto points out that the painting recalls the landscape imagery

of popular calendars, and concludes that it is therefore no surprise that the idealized landscape should be remarkably consistent from one culture to another, since the global traffic in images has eroded cultural specificities. In this regard, Komar and Melamid unintentionally revealed their own cultural biases, for while their questionnaire focused on preferred subject matter, and on such questions as whether the interviewees preferred an image of a famous person or of an "ordinary" person, there was nothing in the questionnaire to suggest that the resulting painting should be executed in the style they ultimately chose to employ.

The philosopher Denis Dutton offers an alternative interpretation. Dutton argues that the cross-cultural similarities in preference betray a shared ancestral psychological heritage. As Dutton notes, "Human responses to landscapes also show atavisms, and the Komar and Melamid experiments are a fascinating, if inadvertent, demonstration of this. . . . This fundamental attraction to certain types of landscapes is not socially constructed but is present in human nature as an inheritance from the Pleistocene, the 1.6 million years during which modern humans evolved."[4] For Dutton, the preferred landscape corresponds to the east African savannah where humans evolved and includes a number of features, such as varied wildlife (hence a bountiful source of food) and places of refuge from potential predators, that stimulate atavistic desires for security that are engraved deeply in the human evolutionary inheritance from the distant past.[5] In other words, *America's Most Wanted* is a representation of the ideal habitat of our prehistoric ancestors. The fact that a wide array of alternative landscape ideals have subsequently been depicted in art—from the fascination with alpine scenery to absorption in the sublimity of the desert or the polar regions—does not contradict this claim, Dutton argues, for the survey reveals that despite such layers of historical acculturation, a deeper instinctual preference will resurface in the right circumstances.

Dutton's account is informed by the work of the geographer Jay Appleton, who argued in *The Experience of Landscape* that the desire for prospect and refuge was an innate, biologically inherited response to landscape. Appleton's theory has been taken up by a number of figures. The architectural historian Grant Hildebrand, for example, has tried to examine responses to the built environment in a similar vein. The aesthetic response to architecture, he argues, is shaped by evolved innate preferences formed during the period when humans were hunters and foragers; architectural forms that are attuned to such preferences are thus seen as "beautiful." As Hildebrand states, some architectural scenes evoke "an archetypal image whose physical manifestations

would have conferred a survival advantage. . . . In this way an innate liking for such scenes would have persisted, even intensified, with the procession of generations over time."[6] Examples include the desire for "refuge and prospect," i.e., protection from the elements (and predators), combined with the maintenance of a vantage point over prospective prey; the desire for "enticement," which answers to natural human curiosity and the pleasure gained from new experiences; and the preference for "order and complexity," in other words, the pleasure gained from ordering a complex visual environment into "survival-useful" categories.

I do not wish to intervene in the debate between Dutton and Danto at this point, or to explore Hildebrand's and Appleton's conception of the aesthetics of landscape. Rather, I cite them as instances of a growing body of thought that attempts to account for aesthetic preferences in terms of human evolution and the evolved disposition of humans to prefer certain configurations over others. As the arguments of Dutton and others demonstrate, evolutionary aesthetics rests its case on the presumption of primal inherited preferences that are, crucially, linked to humans' adaptive responses to the demands and opportunities of the environment. The source of this presumption is Charles Darwin's theory of evolution, and Darwin is frequently referred to by the advocates of evolutionary aesthetics. Although this chapter is concerned primarily with the latter, it is useful to consider some of the basic tenets of Darwin that underpin the neo-Darwinian speculations of Hildebrand, Appleton, and Dutton.

DARWINIAN THEORY

Darwin's two most important ideas are those of natural and sexual selection. In *On the Origin of Species* (1859), Darwin introduced the idea of natural selection by adaptation.[7] This idea is now perhaps so well known that it might be deemed unnecessary to provide more than an outline of its basic premises. These amount to the proposition that evolution comprises the dual processes of variation and selection. On the one hand, biological reproduction involves random variations (contemporary biologists describe them as the mutations or "errors" that can occur in the transcription of DNA during reproduction) that differentiate offspring from their parents. Such genetic variations may have no impact on the organism but, equally, they may bestow an advantage on its capacity to survive to maturity and reproduce (thereby passing on those variations to the next generation) or, conversely, inhibit that ability and thereby be "maladaptive."

Darwin describes variation in terms of the divergent behavioral traits or morphological features of the individual organisms in question, and although this view has been superseded by genetic science, it remains pertinent in that while *variation* occurs at the genetic level, *selection* takes place at the level of the organism (as the "phenotype"). Organisms and their behavior are the phenotypic expressions of genetic variations, and accumulated variations over successive generations lead to incremental changes that, over time, propel the emergence of new species. Selection also underlies the diversity of species; some may evolve into new forms, but new species may also coexist alongside the descendants of organisms that have preserved older traits unchanged. At the same time, the new species may displace the older one, out of which it has evolved, through its greater success at exploiting the resources available and hence reproducing itself. It has therefore been "selected" through its superior ability to adapt to the external environment (including, for example, competition with other organisms for the same resources, contending with predators, and adjusting to climatic conditions). The environment itself is subject to change, other species evolve, and natural selection ruthlessly separates out those species that are able to weather changed circumstances and those that are not.

Darwin's idea has since been associated with the crude formulation of the "survival of the fittest," an expression originally coined by the social theorist Herbert Spencer, but already in the *Origin of Species* Darwin recognized that natural selection alone could not completely account for the observed diversity of life.[8] Many animals had behavioral and morphological traits that seemed to bestow no reproductive advantages, and thus could not be seen as making the organism better "adapted." Consequently, he advanced the possibility of sexual selection as a second mechanism of evolutionary development, by analogy with the effects of breeding: "if a man can in a short time give elegant carriage and beauty to his bantams, according to his standard of beauty, I can see no good reason to doubt that female birds, by selecting, during thousands of generations, the most melodious or beautiful males, according to their standard of beauty, might produce a marked effect."[9] Later, in *The Descent of Man,* he made this a central theme of human and animal evolution. At its heart lies the claim that many acquired traits have no adaptational value at all but have been selected because they increase the success of the organism in the struggle between individuals (usually male) either to drive away or kill rivals or "to excite or charm those of the opposite sex, generally the females, which no longer remain passive, but select the more agreeable partners."[10] The hypertrophic antlers of the red deer, the splendor of the peacock's tail,

and the elaborate structure of the male bowerbird's bower, for example, have no evident adaptational value; rather, they have been selected by successive generations of females such that they are now permanent traits of the males. In humans, too, Darwin suggests that racial differences are due to sexual selection, where, in different regions of the world, the preference for different skin types or facial physiognomy, for example, has led to their eventually becoming inherited traits.[11]

Even in Darwin's lifetime, there were criticisms of the inbuilt gender biases of this model, for it was based on an ideal typical construction of the male of the species seeking to attract a female mate, and Darwin focused on the importance of display in males.[12] Yet, as Elizabeth Grosz has argued, not only did Darwin also attend to cases where female display was the decisive factor, but his account also challenged existing social mores in suggesting that female choice drove sexual selection.[13] Male contemporaries were disturbed by the implications of Darwin's vision; his counterpart and one-time collaborator Alfred Russel Wallace (1823–1913), for example, dismissed sexual selection and attempted instead to make natural selection the fundamental driver of evolution.

For the present discussion, the most significant issue is that Darwin introduced aesthetic considerations into the theory of evolution; the appeal of an individual to a prospective mate was, he suggested, a question of *taste*, for visual display clearly played an important role in the process of selection and reproduction.[14] This is evident not only in the signaling of sexual difference through spectacular visual display but also in the way that ornamental forms and patterned markings have evolved particularly striking forms that have nothing to do with mere brute survival or protection against potential predators. This explanation can be marshaled to explain aspects of human biology, too; the lack of human bodily hair and other differences between men and women are, he argued, a consequence of sexual selection, and not some naturally selected adaptation.

Wallace's objections were influential, however, inasmuch as subsequent commentators have argued that such judgments are still, ultimately, about survival. The beauty of the peacock's tail or the bowerbird's bower are often referred to as "costly signals." Thus the fact that the male bowerbird spends a disproportionate amount of time on its bower, or that the stag's antlers can often reach completely impractical dimensions, indicates an energy surplus that goes beyond the ability to secure the resources merely to survive; these features offer a visible indication of the organism's overall health and the "fitness" of its genes. This view has persisted up to the present. Wolfgang Welsch,

for instance, has argued forcefully that "beauty is a signal for fitness. The female is (for the benefit of her offspring) interested in the reproductive fitness ('good genes') of the male; she takes male beauty as a signal for this; that is why male beauty stimulates interest and pleasure on the female side and why the females select the beautiful males. They are guided by beauty's property as a fitness indicator."[15]

The significance of this conflation of natural and sexual selection will be examined later. Most immediately, it is useful to consider Darwin's interest in the implications of sexual selection for the understanding of aesthetic sensibility, for he consequently suggested that the sense of beauty was not limited to humans but could be seen as an evolutionary inheritance from earlier animal origins. "When we behold a male bird elaborately displaying his graceful plumes or splendid colours before the female . . . it is impossible to doubt that she admires the beauty of her male partner." Indeed, he went further still, suggesting that "man and many of the lower animals are alike pleased by the same colours, graceful shading and forms, and the same sounds."[16]

Darwin was especially interested in birdsong. This is often so intricate, he argued, that it cannot possibly be seen solely as a matter of adaptation. Others have since concurred; many birds seem so to elaborate their singing as to suggest pleasure in the activity for its own sake.[17] Subsequent research has also suggested that even though birdsong is primarily a tool of sexual selection, female birds do not impulsively respond to the songs of males but actively sample the songs of a significant number of birds before choosing a mate.[18] Birds thus exhibit a form of aesthetic comparative judgment.

Yet while Darwin opened up a space for speculation on the evolutionary origins of aesthetic sensibility, he also inserted important caveats. With the great majority of animals, "the taste for the beautiful is confined, as far as we can judge, to the attractions of the opposite sex. . . . No animal would be capable of admiring such scenes as the heavens at night, a beautiful landscape or refined music. . . . Such tastes are acquired through culture."[19] At a certain point, therefore, the human sense of beauty had become attached to objects unrelated to natural or sexual selection. In other words, culturally shaped preferences appeared to have overridden the relation between sexual selection and aesthetic taste. As Anthony O'Hear has argued, "We hear no stories of animals reflectively, disinterestedly, admiring some aesthetic feature of their environment."[20] Moreover, most research on birdsong has reaffirmed its functional basis in sexual selection; numerous studies have indicated that the more complex and extended the song, the more likely it is to attract a mate. In a reiteration of Wallace's approach, it is thus suggested that since

birdsong demands a significant amount of energy, the ability of a male bird to perform complex songs signifies fitness and access to an extensive territory with plentiful resources. Even the most intricate birdsong turns out to have a functional basis.

EVOLUTIONARY THEORIES OF ART

Darwin was not the first to suggest that music had origins in the deep past of human existence. An early foray into this possibility was advanced by Herbert Spencer, whose essay "The Origin and Function of Music" (1857) suggested that music might have arisen out of primal emotional expression and had subsequently assisted human emotional and intellectual development.[21] By the late 1800s, the theory of evolution had become a central guiding concept in the humanities. At times, this could be the direct importation of Darwin's ideas; at others, it could be a more vaguely formulated notion of artistic development as an evolutionary process. In *Physiological Aesthetics* (1877), the science writer and novelist Grant Allen (1848–1899), for example, attributed the capacity for aesthetic sensibility to evolutionary development.[22] Two years later, James Sully (1842–1923), a philosopher and psychologist who had studied with Helmholtz, discussed, like Spencer, the origins of music, arguing that humans and animals had shared preferences for certain sounds due to their role in attracting mates.[23] The theory of evolution was also adopted by art historians, particularly in Austria and Germany. Of these the best known is Aby Warburg, whose concern with expression, gesture, and representations of the body in Renaissance art was heavily informed by his reading of Darwin's *Expression of Emotions in Animals and Man*. Warburg's idea of art as a vehicle of memory, in which primitive inherited emotions could remain latent in the images of the past, also drew on commonplace ideas about human cultural and intellectual evolution.[24] Above all, his concept of *Nachleben* (survival) was indebted to the work of Edward Tylor, who came up with the notion to account for the persistence, among many peoples, of cultural and social traits that were deemed to have been long superseded in the process of human evolution.[25]

Such engagement with evolutionary theory waned during the course of the twentieth century, as the pressure on the humanities to seek out areas of congruence with the natural sciences lessened. Owing to its association with social Darwinism and, at its most extreme, the cultural politics of Nazi Germany, evolutionary theory became further devalued in the humanities. Dutton's

revisiting of the concept thus came as a surprise, but it followed a gradual renewal of interest that was initiated by the publication, in 1975, of Edward O. Wilson's deeply influential book *Sociobiology*. A biologist by training, Wilson sought to draw parallels between animal behavior and human society; the similarities between them are more than accidental, he argued, for they indicate the biological roots of human social behavior and confirm the concept of humans as social *animals*. Wilson made only passing reference to art, but his comments demonstrated clearly how a sociobiological approach to art might proceed. Like Darwin, he paid particular attention to birdsong. "Human beings consider the elaborate courtship and territorial songs of birds to be beautiful," he noted, "and probably ultimately for the same reason they are of use to the birds. With clarity and precision they identify the species, the physiological condition and the mental set of the singer. Richness of information and precise transmission of mood are no less the standards of excellence in human music."[26] Wilson also drew parallels between the carnival activities of chimpanzees, such as whooping and drumming, and human singing and dancing. Both serve, he argued, to reinforce group identity, an affinity that he used to suggest that the one originated in the other. Sociobiology has since become an established although much-contested field, and has opened up the possibilities of Darwinian analysis for a wide range of social and cultural practices.[27]

The appearance of Richard Dawkins's *Extended Phenotype* (1982) gave an additional impetus to the development of evolutionary theories of art. Dawkins came to prominence in the 1970s with *The Selfish Gene*, which put forward the now standard argument that natural selection operates at the level of genes and that individual organisms are the phenotypic expressions of genes. In *The Extended Phenotype,* Dawkins argued that phenotypes are not limited to organisms but can also be seen in their wider impact on the environment, ranging from interaction with other organisms (such as parasites) to much-cited examples of environmental change caused by animals, such as the beaver's dam or ant's nest. This account prepared the way for viewing *human* cultural practices as phenotypic expressions of genes. Dawkins also speculated on the processes of cultural reproduction with his now notorious concept of the "meme," a term used to designate units of cultural transmission comparable in their functions to the gene in biological evolution.

Dawkins and Wilson were followed in the 1990s by the emergence of evolutionary psychology, led by Leda Cosmides and John Tooby.[28] Its basic thesis is that the human mind is as much an evolved outcome of natural selection as the human body is.[29] In other words, all the features of human psychology are successful adaptations to the sequence of environmental challenges faced by

human and protohuman ancestors, during which time other, variant forms of behavior, psychological dispositions, and cognitive abilities were not ultimately retained, since they were nonadaptive and may even have been maladapted, destructive tendencies. Furthermore, the mind is conceived as a multifunctional modular structure—the metaphor of the Swiss army knife has been advanced—in which a variety of different cognitive skills, such as the ability to use language, to recognize faces, and to detect cheats, arose independently in response to discrete evolutionary pressures.[30] The idea of mental modules as "special purpose computational mechanisms" had already been advanced by the philosopher of mind Jerry Fodor in the 1980s, but a decade later the idea was reinterpreted in Darwinian terms as a result of evolutionary selection.[31] According to this theory, modular intelligence replaced the "general intelligence" of our animal ancestors. This idea is informed by the discovery in neuroscience that certain mental functions are localized in particular areas of the brain, and also by the fact that the analogy with biological evolutionary theory *requires* the identification of basic units of replication comparable in function to genes. Indeed, this idea has been developed further in the analysis of cultural phenomena: one of its best-known advocates, Steven Pinker, has tried to identify the particular evolved subroutines and submodules of the brain involved in speaking generally and in specific linguistic acts.[32]

EVOLUTIONARY AESTHETICS

Evolutionary psychology has provided a powerful impetus for Darwinian ideas about art; numerous authors have argued that certain features of art and literature are the expression of evolved features of human psychology and cognition, and can be understood only in this context. As Mark Pagel, a prominent exponent of this view, has argued, humans are "wired for culture." In other words, cultural practices (including art) are the phenotypic expressions of cognitive abilities that are the product of evolution and thus are "hard-wired" instinctual mental traits. The archaeologist Steven Mithen, for example, has argued that the explosion of human creativity over the past hundred thousand years, associated with the birth of art, is the result of a crucial evolutionary step: the ability to *transcend* the modular division of the mind and to combine the abilities of different cognitive domains. Inasmuch as an important dimension of creativity is the ability to draw analogies between otherwise disparate elements, it was the ability of early humans to combine different cognitive capacities that made art possible.[33]

Implicit in the reliance on evolutionary psychology is the assumption that while human cognition evolved as a result of adaptations to environmental pressures during the long prehistory of the human species, it has ceased to evolve in any significant way during recorded history. In other words, modern humans have a mind that evolved in response to an entirely different set of circumstances: the Pleistocene environment in which humans became biologically distinct from other primate species.[34] Modern cultures and societies are just a veneer laid over much older mental instincts, an idea that is also central to Dutton's interpretation of the case of Komar and Melamid. As one recent essay has suggested, reading nineteenth-century British novels is an exercise in engaging with Paleolithic politics, since the intersubjective relations depicted in Victorian fiction are rooted in deeper evolved patterns of social interaction.[35] Attempts to analyze a wide range of social and cultural phenomena, from delinquency, to sexual difference, to parental love, to homicide, as the causal effects of the mind's evolution—its "architecture," as evolutionary psychologists often term it—have proliferated.[36]

For evolutionary aesthetics, therefore, the origins of taste lie in adapted preferential responses to environments that are conducive to survival. However, just as Darwin speculated that the origins of aesthetic sensibility lay in animal sexuality, many neo-Darwinian authors have advanced similar notions, although it should be noted that in most cases this has involved a conflation of sexual and natural selection. One example is the claim that the sense of beauty originated in a desire for forms and ratios that functioned as "fitness indicators."[37] According to this argument, males have a cross-cultural preference for a specific hip-to-waist ratio (from 0.7 to 0.8) in women, which Dutton ascribes to the fact that it is an indicator of childbearing capacity (in contrast to a ratio of 0.9, which is symptomatic of prepubescent girls and postmenopausal women). This preference overrides any culturally relative preference for larger or thinner women; in all cases, the *ratio* is constant. Likewise, the preference for facial and bodily symmetry is linked to the fact that it is an indicator of overall health. Judgments about bodily appearance as a sign of a person's fitness as a potential mate act as a template for all judgments of beauty, and this underlies all aesthetic sensibility.

In similar fashion, the evolutionary psychologist Geoffrey Miller has grounded aesthetics unambiguously in *sexual* selection. In *The Mating Mind*, Miller states unequivocally that art and beauty serve as "fitness indicators." This relates not merely to the way that certain aesthetic values, such as symmetry, may be outward expressions of genetic health, but also to the function of art as a costly activity. As Miller notes, "We find attractive those things that

could have been produced only by people with attractive, high-fitness qualities such as health, energy, endurance, hand-eye co-ordination, fine motor control, intelligence, creativity, access to rare materials, the ability to learn difficult skills and lots of free time. Also, like bowerbirds, Pleistocene artists must have been physically strong enough to defend their rival creations against theft and vandalism by sexual rivals."[38]

For the anthropologist Camilla Power, the focus of interest has been the role of art as a product of, and also an agent of, sexual selection. Analyzing female puberty rites among the Nuba, the Fang of west Africa, and the Bemba of Zambia, Power argues that the use of pigment in bodily decoration is a way of attracting prospective mates. This practice has ancient origins, she claims, and it followed the disappearance of other visual signals that a women was ovulating. Adorning the body in red pigment was thus a kind of "sham menstrual advertising."[39] According to this argument, the development of increasingly complex designs was a kind of evolutionary arms race, in which women competed with one another to attract the fittest mate. Men subsequently co-opted this strategy, adorning their bodies in order to enhance their own attractiveness.

The idea of art and beauty as tools in the service of sexual competitiveness has been extended beyond broad, general, theoretical questions to the interpretation of specific artifacts. One much-debated example is the analysis of Paleolithic hand axes by Steven Mithen and Marek Kohn, who have speculated that they were instruments of sexual selection. Struck in particular by the prevalence of large hand axes that seemed too unwieldy to use, they suggest that such artifacts were forms of conspicuous display comparable to the peacock's tail. "The manufacture of a fine symmetrical hand axe," they write, "[might] have been a reliable indicator of the hominid's ability to secure food, find shelter, escape from predation and compete successfully within the social group. Such hominids would have been attractive mates, their abilities indicating 'good genes.'"[40]

Not all evolutionary accounts have derived the aesthetic sense so directly from sexual impulses, however. Pagel refers to art as a "cultural enhancer," in other words, "something that exists solely to promote the interests of a replicator."[41] As such, it is much more deeply inscribed in the process of natural selection. Describing culture as a "survival vehicle" that, as a supplement to the human body, enables genes to reproduce, Pagel asserts that art does so through its capacity to elicit or motivate emotions, strengthen beliefs or resolve, transmit information, or increase the cohesion of a particular group. All of these functions aid the survival of the individual or group and thus enable genetic transmission from one generation to the next.

Pagel is less interested in how certain forms of visual display serve as analogues of reproductive "fitness" and more in how art functions as a vehicle of natural selection by enhancing individual and group survival. Not only have humans evolved to respond to art, he suggests, but "art" has learned to manipulate that evolved response mechanism in order to ensure its reproduction. In this sense, "art" acts like Dawkins's selfish gene, using humans and their art-making behaviors as phenotypic vehicles. This provocative account not only relies on a highly questionable ascription of agency to art but promotes an unanalyzed and essentializing concept of art. It is also vulnerable to the obvious criticism that for every example of art that increases group cohesion, it is possible to cite counterexamples—the riots prompted by the first futurist performances, the revulsion at Manet's *Olympia,* the criticisms of Carl Andre's "bricks" (*Equivalent VIII*)—that achieve precisely the opposite result. Such examples bring out what is implicit in Pagel's view, namely, that it might be hostile to modernism as "maladaptive"; but if this is the case, it is hardly compatible with what he declares to be a *general* theory of art. The larger difficulties of this position will be examined in depth later.

Darwin drew parallels between human music and birdsong. The mere existence of the latter attested, he argued, to the primitive and distant origins of music, and recent authors have made similar claims.[42] A prominent instance is Steven Mithen, who posits the biological origins of music and has proposed the existence of a protolanguage "Hmmmmm" in which music and language were not yet distinguished. Mithen also argues that the sense of rhythm, which was essential to the emergence of music, is rooted in the development of bipedalism, which required a very specific set of motor skills, including rhythmic coordination of the body in order to maintain balance. Consequently, "as our ancestors evolved into bipedal humans so, too, would their inherent musical abilities evolve—they got rhythm. One can easily imagine an evolutionary snowball occurring as the selection of cognitive mechanisms for time-keeping improved bipedalism, which led to the ability to engage in further physical activities that in turn required time-keeping for their efficient execution."[43]

Another proponent of evolutionary aesthetics who links the sense of beauty to something other than sexual preference is Ellen Dissanayake, whose *Art and Intimacy: How the Arts Began* argues that the aesthetic sense is rooted in the primal intimacy between mother and child, which provides a template for subsequent social forms of intimacy and bonding. Art serves to underline this process; physical and emotional behaviors central to the mother-child relationship are formalized through the "ceremonial reinforcement" that is the foundation of art. Art is grounded in an evolved universal capacity, yet,

as she notes, "Advocates of the sexual selection hypothesis focus on art as being a costly display of the artist's beauty, virtuosity, skill, and creativity. Yet these features too are not in themselves art, but broader entities that some but not all instances of art may have or use. Conversely, they are also to be found outside the arts. . . . Granted, art is frequently beautiful, skilful, or costly. . . . But so are other things—a colorful bird or a field of wildflowers, a perfectly-executed gymnastic feat, an ingot of gold."[44] In contrast to such explanations, the sense of beauty, she argues, originates in the phenomenon of "making special," in other words, that construction of a shared focus of attention between infant and mother that enables the infant to pick out some aspect of the world as the object of special interest.[45] This is, of course, a rather vague formulation, and its implications will be explored shortly, but it demonstrates that not all evolutionary accounts are tied to the Darwinian theme of sexual selection.

Alongside its use in broad theoretical accounts, the theory of evolution has also served as the basis for the analysis of artworks. Under the banner of "cognitive cultural criticism," a number of authors have attempted to view individual works through the lens of evolutionary psychology. One of the leading representatives of this approach, Lisa Zunshine, has argued strongly for the need to ground interpretation in the analysis of how texts and images mobilize or challenge universal human psychological traits acquired as part of the human evolutionary heritage.[46] This approach has become particularly prominent in literary studies, where there have been attempts to identity "universals" anchored in evolved predispositions of the human mind.[47] These relate to literary narrative, but Ellen Spolsky has made a parallel attempt in relation to visual representations, coining the term "iconotropism" to denote a universal innate and evolved cognitive "hunger" for visual imagery that answers psychological needs that other types of representation cannot.[48] Raphael's *Transfiguration* instantiates this phenomenon, she argues, in the way it answers the problem of cognitive dissonance. Spolsky is referring here to what she calls "gappiness," the inability of the brain's mental modules to coordinate their separate activities to produce a unified perception of certain impressions and ideas. The story of Christ's transfiguration prompts just such "gappiness" through the notion of the simultaneous presence of the divine and the human, and while Raphael's painting does not entirely resolve this paradox, it nevertheless manages to "re-present a situation that was counter-intuitive—that a man could simultaneously appear as a god—in a way that made it possible for the specific community in which he worked to understand and accept."[49]

The basic tenet of evolutionary aesthetics is that the capacity for making art and aesthetic sensibility are transcultural phenomena grounded in evolved human biological and psychological dispositions. These innate features arose because they were "adapted" behaviors; in other words, they bestowed some form of competitive advantage on those human ancestors who developed them. Frederick Turner, another prominent exponent of this view, has stated unequivocally that the sense of beauty is a natural intuition or "capacity of the nervous system," and as such, "beauty is in some way a biological adaptation and a physiological reality: the experience of beauty can be connected to the activity of actual neurotransmitters in the brain, endorphins and enkephalins."[50] The capacity for aesthetic experience is due to the human genetic inheritance.

As such, evolutionary aesthetics is also the latest incarnation of a debate concerning the universality of art, and it constitutes an increasingly prominent candidate as a foundational concept for the study of art on a global basis. Dutton does not use the terminology of "world art," but he makes a number of sharp criticisms of those who stress the incommensurability of different cultural and artistic practices or even contest the pertinence of the term "art." First, he suggests that the often-rehearsed criticism that the idea of aesthetic experience is an Enlightenment construct amounts to little more than the claim that the Kantian tradition of aesthetic thought was an ideological program that failed to do justice even to the varieties of artistic enjoyment in eighteenth-century Europe. In other words, it offers no decisive disproof of the universality of art, only an argument against the universality of a particular concept of art. Conversely, he points out, there are many art discourses and practices that are not so distant from those formulated in Europe. They range from ancient Egypt, where art developed as a semiautonomous practice with distinct codes and traditions, to premodern China, where there was an advanced discourse of connoisseurship, with a flourishing market in copies and forgeries of master paintings.[51] Moreover, Dutton suggests, defenders of the thesis of cross-cultural incommensurability may be guilty of an intellectual sleight of hand, comparing ritual and craft artifacts of small-scale non-Western cultures with high art products of the European tradition. A more meaningful comparison, he argues, would be of European and American folk art, where aesthetic form is intimately bound up with use and other values.

Such observations give cause for reflection, but even if one agrees with the argument about the cross-cultural nature of art and aesthetic sensibility,

neo-Darwinian ideas still exhibit important weaknesses. Before examining them in detail, it is worth considering how "Darwinian" the accounts discussed so far really are. It can be argued that by conflating natural and sexual selection, they have more in common with Wallace than with Darwin himself. Darwin's original proposition was that sexual selection introduced an element of unpredictability and random chance into evolution. Evolution was no longer driven just by the mechanism of adaptability and survival, but also by arbitrary preferences in taste. This explains the renewed interest in Darwin among a range of authors, from feminist and gender theorists such as Elizabeth Grosz and Joan Roughgarden to the Adorno and Benjamin scholar Winfried Menninghaus, scholars who are ideologically completely opposed to the adaptationist assumptions of many of the authors discussed so far.[52]

Disturbed by the implications of the theory of sexual selection, Wallace, in his book *Darwinism*, reasserted the primacy of natural selection. This would cancel out aesthetically driven mating choices. Darwin, however, had suggested just the reverse; though he acknowledged that the suggestion that females had powers of discrimination and taste was "extremely improbable," he nevertheless argued that the facts supported the thesis that "the females actually have these powers."[53] As Grosz has argued, "sexual selection unhinges the rationality of fitness," and this may be, she speculates, why Wallace's account subsequently gained favor, since it renders sexual selection more amenable to "scientific attempts to measure and render predictable its operations."[54] Formulated in this way, a Darwinian theory of art might have more in common with the materialist and physiological aesthetics of Nietzsche than with the evolutionary theories examined so far.[55] It is an open question, therefore, what Darwinism and the theory of evolution *mean* for the analysis of art, and it is notable that many contemporary authors, among them Dutton, Miller, Hildebrand, and Brian Boyd, have opted for the rationalistic version promulgated by Wallace rather than the potentially more radical vision offered by Darwin himself.

Aside from the issue of how Darwin's legacy has been interpreted, basic problems of neo-Darwinian aesthetics require scrutiny. The first of these is the question as to whether a basic category error has been committed, for it is assumed that the pleasure associated with sexual selection can be equated with aesthetic experience. Darwin indicated that the *roots* of taste might lie in female admiration of the plumage of a prospective male mate, or of the magnificence of its bower, but he was vague about the precise relation between such sensory judgments and human aesthetic taste, asserting only that while "animals have a sense of beauty, it must not be supposed that such sense is

comparable with that of a cultivated man, with his multiform and complex associated ideas."[56]

The concept of animal aesthetics and its relation to human aesthetic judgment is thus not critically examined, resting on a simplified conception of the aesthetic as mere sensory pleasure. In this sense, it is an aesthetic theory without a theory of the aesthetic. The evolutionary position ignores, for example, the distinction between beauty and the merely agreeable; the equation of animal visual (and other) sensory response with human aesthetic sense is merely assumed rather than demonstrated or argued for.[57] Stephen Davies has suggested that the preferences expressed by animals may better be regarded as protoaesthetic in character, but even this suggestion is problematic, since the nature of such "protoaesthetic" preferences would have to be analyzed, and it would be necessary to provide an account of how, when, and why they developed into identifiably "aesthetic" ones and what the difference between the two might be.[58] Indeed, arguments for the presence of an aesthetic sense in animals have often rested on striking examples such as the peacock or the bowerbird, but visual signals that attract a mate are important among a wide range of animals, from crustaceans to insects, and few have been inclined to see *these* as endowed with a comparable sensibility. Indeed, while *humans* may find the bowerbird's bower aesthetically appealing, there is no evidence that the female bowerbird regards it in those terms; it may just be a programmed response to a visual stimulus, and it is important to consider whether other nonvisual factors may play a role, too, including olfactory stimulation.

These questions lead to the more general discussion of how judgments about fitness as a mate or, in the case of landscape, conduciveness to survival may relate to aesthetic preference. The ambiguity about the relationships between these different kinds of preferences becomes apparent when considering Dissanayake's thesis about the origins of "making special." Its roots lie, she argues, in the primal infant-mother relationship, in which the newly born child learns to attend to specific signals—facial expressions, vocalizations, bodily movements—and mark them as having particular significance over others. The evolved ability to respond to these signals provides the infant with a protoaesthetic "behavioural reservoir" that will later develop into the ability to make special.[59] But if this explanation is accepted, it still needs to account for how and why such a protoaesthetic reservoir evolved into artlike behavior rather than into other kinds of non-art behavior. Arguably, waging war, hunting, planting crops, and making tools rely on a similar repertory of evolved skills, but in each case the particular object of special attention differs. More generally, regardless of whether evolutionary theories focus on

sexual selection or on the infant-mother relationship as the putative origin of art and aesthetic experience, they offer a quasi-positivistic claim *that* there was a process of selection (sexual or otherwise) and *that* there were certain pre-aesthetic conditions and skills that may have been selected, but fail to further amplify the issue. What remains to be determined is why artlike behavior takes the specific forms that it does in particular places and times. In other words, an argument formulated to defend the notion of the evolved inherence of aesthetic sensibility in human nature can do so only at the cost of being able to analyze the diversity of cultural forms it adopts; it has no theoretical capacity to account for specific aesthetic preferences. This argument extends to the question of aesthetic *value*. As Davies has noted, "even if we are evolved to prefer savannah and similar landscapes, this tells us nothing about why anyone would prefer a painting by Constable to an unimaginative calendar photograph of parkland."[60]

One of the most powerful arguments to reveal the limitations of evolutionary aesthetics and, in particular, the idea of adaptation is provided, ironically, by Richard Dawkins. In *The Extended Phenotype,* Dawkins argues that while evolution takes place at the level of genetic mutation and not at the level of the individual or the group, one must avoid seeing certain physiological traits or adaptive behaviors as directly causally related to certain genetic origins. This caution is needed, he claims, because of the complexity of the relationship between the gene, its phenotypic expression, and the external environment. There is often a built-in time lag, which means that a behavior or trait may be an adaptation evolved in response to an environment that no longer exists. The easiest illustration of this can be found in certain animal responses (Dawkins cites the examples of moths flying into candles and hedgehogs rolling up into a ball when facing a car) in which adaptive behaviors are shown to be mismatched to their environment. A comparable, although slightly more complex, example, he argues, is that of human homosexuality. Even *if* homosexuality is the result of a genetic mutation, and Dawkins recognizes that this is a contentious issue, to claim that it is linked to a specific gene misses the complexity of the issue. For, he notes, "It is a fundamental truism, of logic more than of genetics, that the phenotypic 'effect' of a gene is a concept that has meaning only if the context of environmental influences is specified, environment being understood to include all the other genes in the genome. A gene 'for' A in environment X may well turn out to be a gene for B in environment Y. It is simply meaningless to speak of an absolute, context-free phenotypic effect of a given gene." This has major consequences for the idea of the gene "for" homosexuality, Dawkins argues, because "a gene for homosexuality in our modern environment might

have been a gene for something utterly different in the Pleistocene. . . . It may be that the phenotype which we are trying to explain did not even exist in some earlier environment, even though the gene did then exist."[61] The reference to a single gene "for" a phenotypic effect is now dated, and it is now held that interacting groups of genes (genomes) rather than individual genes may be related to physiological or behavioral effects. Nevertheless, Dawkins's argument is important and of direct relevance to the evolutionary theory of art, for it questions the tendency of exponents of evolutionary aesthetics to trace phenotypic effects—art making and the exercise of aesthetic judgment, for example—back to genotypic transformations that allegedly took place in the Pleistocene. This argument would imply that the evolved mental capacity now putatively seen as responsible for certain aesthetic preferences may have equally been a capacity for something entirely different, its phenotypic expression something that no longer exists.

In his reading of Komar and Melamid, Dutton, by contrast, assumes that aesthetic predispositions evolved in the Pleistocene era have undergone no subsequent evolution in response to the multiple environments humans have since come to inhabit. Dawkins's observations, however, suggest the need for caution. There is no certainty that the adaptive preference for a certain kind of landscape among our Pleistocene ancestors would now be expressed phenotypically in a preference for an artistic representation of the same kind of landscape. This is doubly the case given that Dutton makes no distinction between a Pleistocene response to a landscape and the response of a twentieth-century viewer to a *painting* of a similar landscape or, in the case of Hildebrand, to the aesthetic configuration of a spatial environment of a work of architecture.

ADAPTATIONS TO WHAT?

One argument underpinning the claim that aesthetic judgment has origins in evolved species-wide biological preferences is that certain constants transcend cultural difference. A number of authors have asserted the ubiquity of a male preference for a certain hip-to-waist ratio in women, and this ratio serves as a general fitness indicator. For sociobiologist John Alcock, "The physical features that man finds attractive are properties of young adult women in current good health who are primed for successful reproduction. Thus the preferred body mass index of women is twenty to twenty-four kilogrammes per meter of height," and this preference is rooted, he argues, in the fact that this ratio serves as a fitness indicator.[62]

There is plenty of evidence to suggest that this ratio is of rather more recent vintage, however, and that it perhaps dates back only as far as classical Greece and is specific to Mediterranean and European cultures. Preclassical art, such as the korai of archaic Greece or the devotional statuettes of Bronze Age Cyprus, demonstrate rather different norms. As George Hersey has suggested, one can surmise that as late as the Bronze Age there was considerably greater proportional diversity than that associated with the classical Greek canon.[63] In the absence of other types of evidence, this is a speculative suggestion, but no more so than the claims of evolutionary aesthetics. Indeed, it can be argued, for example, that in a Pleistocene environment where predators were common, an equally important indicator of "fitness" and suitability as a mate might have been the ability of a potential mother to flee with her child and escape danger. Here, the hip-to-waist ratio would matter less than her overall athleticism; body mass might then have been more important than hip-to-waist ratio. Alternatively, with the availability of food always contingent upon unpredictable external factors, an athletic body might not be such an advantage, since it would have little stored body fat to tide one over during a lean period and ensure that infants were provided for.[64] In other words, the hip-to-waist ratio is arbitrarily chosen; many other factors could lay equal claim to priority as determinants of fitness, depending on what one decides it is fitness *for*. The identification of evolutionary factors is a matter of projection based on the cultural lens of the commentator.

This points to a larger problem, namely, that potentially *any* biological factor can be adduced as evidence of the origins of the aesthetic impulse. Indeed, there are any number of plausible evolutionary and biological explanations about the origins of art and the aesthetic sense. This echoes a criticism leveled at sociobiology when it was first formulated in the 1970s. As Richard Lewontin argued, such explanations are often "an exercise in plausible storytelling rather than a science of testable hypotheses."[65] It is this that underlies the often-leveled charge, first formulated by Lewontin and Stephen Jay Gould, that evolutionary theories frequently offer little more than "just-so stories."[66]

This is evident in the numerous *different* theories of the adaptational function of art and the aesthetic sense. In addition to art's alleged function as a fitness indicator, it has been claimed that art enables humans to represent nonexistent states of affairs as a mode of self-extension, or that it enables humans to rehearse strategies for survival, or to shape the attention of others, or to construct an intelligible model of reality, or to organize motivational systems above and beyond immediate instinctual reactions. In each case, the putative adaptational function is asserted, but there is no means by which

such explanations can be critically scrutinized or a judgment made about their relative merits. To cite one critic, there is "no way to adjudicate between [Joseph] Carroll's belief that literature provides an emotional skein to brute existence and Dutton's that literature was useful for counterfactual role playing or [Blakey] Vermeule and Dutton's that literary language was a kind of courtship ornament or [Brian] Boyd's that stories and other art forms hold our attention and so 'make the most of the brain's plasticity.'"[67] In other words, the theory of aesthetics as adaptation is conceptually underdetermined, the meaning of the term "adaptation" hugely variable.

This is not necessarily a decisive criticism. Evolutionary theorists frequently have to rely on providing *potential explanations* as to how, for example, insects developed wings, or why fish evolved lateral lines.[68] The difference, however, is that such explanations can draw on a wide array of corroborating evidence, from aerodynamic experiments and mathematical data to the study of the biology of contemporary fish, that enables one to discount some explanations and accept others as more probable. Evolutionary theories of art and culture, by contrast, have no such structure of argumentation, and in some cases are reduced to making even more weakly supported claims. The literary critic Brian Boyd, for example, asserts that "if art . . . offered on average no advantage in terms of survival and reproduction, many generations of intense evolutionary competition would have eliminated it."[69] In other words, because art exists, it must have had some adaptational function. This statement exemplifies the empty and circular logic that sustains many evolutionary theories. Their relentlessly reductive vision rules out from the start the possibility of nonadaptive variations. Yet for them to be persuasive, it would be necessary to show that the adaptational advantages of a particular artistic practice—and these would first have to be spelled out—were sufficiently extensive and specific to make a difference, i.e., to determine why it and not other, competing variants was retained and reproduced. This is where the adaptational thesis is at its weakest, however, for it is difficult to envisage a specific cultural institution making so decisive a difference to the survival of the group as would be required by the theory.[70]

Finally, even if the capacity for art *is* the consequence of adaptive variations, this does not mean that all artistic practices can *subsequently* be explained by reference to evolved psychological or other dispositions. Indeed, even sympathetic commentators recognize that art (and culture in general) has developed into an autonomous sphere that exerts its own selective pressures that are completely separate from those evolutionary forces that, it is claimed, facilitated the emergence of art and aesthetic taste. Even Darwin

recognized the importance of *play*; birds appear to elaborate their song for no apparent reason other than the sheer pleasure of singing, although, equally, an adaptive function has often been attributed to play itself.[71]

There are several ways in which this separation of art from its putative biological roots can be considered. One is based on the model of evolution associated with what has been termed "niche construction theory."[72] This theory takes issue with the assumed opposition between genetic mutation and phenotypic expression, which ignores the coevolution of the two.[73] Niche construction theory emphasizes that phenotypes are not simply the expression of a genetic mutation that has proved to provide an advantageous adaptation to external environmental selection pressures; it argues instead that their activity also *transforms* those environments. While niche construction theory agrees that adaptation to environments is the central engine of natural selection, it stresses that those environments are themselves shaped by the behavior of organisms. This is obvious in the case of the human transformation of the environment—it is now primarily urban and creates distinctive pressures that did not previously exist—but niche construction theory generalizes this as a thesis about organisms, arguing that no organism is ever in an entirely passive position of "adapting" to an environment created externally. Organisms thus to some degree create their own selective environmental pressures.[74]

This fact has important consequences for evolutionary theories of art and culture, for it casts doubt on the possibility of constructing a natural history of culture. While it does not fall victim to what defenders of evolutionary social theories refer to as cultural determinism, it nevertheless suggests that it is not so easy to draw a distinction between apparently universal biologically rooted traits and those that are socially acquired. The two categories can be conflated, not in the sense that the sociogenetic can be subsumed within the phylogenetic (the preferred position of sociobiology and evolutionary theories of art), but in the sense that the putatively natural environment exerting selection pressures on various cultural practices is itself *to some degree* culturally constructed.

An alternative theory with similar conclusions is Michael Tomasello's notion of the "ratcheting effect" of cultural practices.[75] Tomasello criticizes the tendency of evolutionary theories to conflate phylogenesis, ontogenesis, and sociogenesis. He is in agreement with the idea that language and culture are the result of an evolutionary shift in human cognition—specifically, the capacity to understand other individuals ("conspecifics") as intentional agents. Nevertheless, he also argues that language and cultural practices (including the construction of material artifacts) enable increasingly complex forms of

elaboration of experience that are themselves not phylogenetically given. This he calls the ratcheting effect. Thus the sense of number and the ability to count may be universal evolved cognitive abilities, but higher-level mathematical knowledge, such as algebra and calculus, is neither universal across all cultures nor possessed by all members of advanced industrial societies. Instead, it is acquired through a process of cultural ratcheting, in which cumulative cultural learning and refinement can transform and extend a biologically inherited trait.

An analogy can be found in the visual arts, and it is suggested by David Summers's monumental study of world art, *Real Spaces*. Founded on a Heideggerian principle of art as articulation of being-in-the-world, Summers's work is organized around the thesis that "art records the many ways in which the world at hand has been acknowledged in being shaped by us human beings." The central idea of this approach is that art records and articulates the embodied human experience and shaping of space, which encompasses the virtual space of the pictorial imagination, social space, and personal space. Underlying all of these is "real space," defined by the "body's finite spatio-temporality, its typical structure, capacities and relations," which transcends cultural differences.[76]

Summers pays considerable attention to prehistoric European art, which registers, he argues, the emergence of basic spatial concepts. Hence, in the earliest prehistoric art, the concept of plane has not been disentangled from that of surface. In the caves of Lascaux, for example, while the animal paintings are in profile and would imply a notional planar presentation, their arrangement and elaboration are dictated by the irregular surfaces of the cave on which they are painted. Planarity, in contrast, requires a conception of the surface as uniform at all points. This is absent in Lascaux, but the famous Paleolithic figurines of women, including the so-called Venus of Willendorf, display a concern with axial symmetry that underpins an understanding of planar relations, for symmetry is observable only on the basis of the implied axial address that views the body in a specific manner. Moreover, by the time of the Mesolithic (10,000–8,000 B.C.E.) cave paintings of Cueva Remigia in Spain, a more fully developed sense of plane is in evidence; the paintings have internal spatiotemporal relations, with relations between objects in the paintings themselves represented by a common measure.[77]

Summers's key argument, however, and the most pertinent one for the current discussion, is that art does not merely *record* such shifts in the experience of space (both real and virtual), but also provides their enabling conditions. It is through the creation and refinement of figurines that concepts of

axial symmetry first emerge; before the development of multifigure paintings in the caves of Spain and southwestern France, the notion of planarity had no meaning and was thus not possible. Summers marshals a similar argument in relation to refinement and its relation to arbitrariness.[78] Many Neolithic arrowheads exhibit a refinement of technique that exceeds the exigencies of their use as weapons. A distinction is introduced between such refined objects and their everyday counterparts; as such, they become not merely functional tools but also artifacts with a *social purpose*. This entails not merely the familiar distinction between the utilitarian and the aesthetic but also a hierarchy between the elevated and the lowly; such objects have a purpose beyond the ordinarily skillful and may have uses in situations that have higher social status or where their users have higher social rank. Refinement makes social distinctions and hierarchies visible but, crucially, also takes part in the enactment of relations of status and power and as such may have *enabled* their evolution and articulation. Thus, as the encounter with the material world becomes framed by the intersubjective domain of intentional activity, the "world of cultural artifacts becomes imbued with intentional affordances to complement their sensory-motor affordances."[79] Crucially, too, because refinement makes visible the possibility that artifacts can be *otherwise,* a space is opened up for innovation: "refinement may encourage arbitrary invention and innovation at many levels. . . . In a series of intentionally elaborated artifacts, in which elaboration is meant precisely to distinguish from the usual, innovation might be justified at any point in the series."[80]

It is only *through* art making that certain spatial experiences become possible or imaginable. To recast this point in the language of evolutionary theory, phylogenetically acquired capacities become fundamentally transformed, and new skills and forms of cognition enabled, for the first time. Another obvious example is the Renaissance invention of perspective. Discussions have tended to oscillate between the older realist view that its discovery amounted to a formalization of the facts of visual perception, on the one hand, and the contention, first advanced by Panofsky in the 1920s, that perspectival space was a construction or, as Panofsky put it, a symbolic form, on the other.[81] Few now accept the specifics of his argument, but his general *constructivist* position is an unexceptional account. What this binary opposition leaves out, however, is the possibility that perspective itself made possible new ways of experiencing and conceiving space. Panofsky argued that the invention of perspective was dependent on a number of other intellectual advances, including the concept of zero, but it was only *after* Brunelleschi's discovery that the geometric formalization of space occurred.[82] As Martin Kemp subsequently demonstrated,

the evolution of increasingly complex conceptions of space, including the devising of non-Euclidean geometries, was intimately connected with the development of more and more sophisticated forms of spatial representation in art, including multipoint perspective.[83] Indeed, perspectival representation became an autonomous practice unmoored from visual perception, and instead addressed abstractly mathematical problems. All of these cases exemplify the ratcheting effect that Tomasello identified, which renders the binary genotype/phenotype distinction—and the associated idea of adaptation—irrelevant.

EVOLUTIONARY THEORY AND THE POLITICS OF WORLD ART

As noted earlier in relation to Dutton, the grounding of art and art behaviors in human biology is also an intervention in the politically fractious debate over the universality of art. It is hardly original to note that art history has traditionally privileged the art of Europe; its exclusions and the baleful influence of European colonialism on art worldwide have been observed extensively for more than a century.[84] Interrogation of this intellectual legacy impinges not only on the geography of art but also on the cross-cultural viability of the very term *art*. It is perhaps now a truism to state that where non-Western art *has* been included in the art-historical canon, this may have been at the cost of forcing it into a European conception of art and aesthetic experience. Anthropologists of art have long been concerned with this issue. For if there has been no shortage of studies of "primitive art," from scholarly analyses to more populist accounts such as David Attenborough's BBC documentary series *The Tribal Eye*, the status of the "art" in the notion of primitive art remains in dispute. Many would agree with the anthropologist Raymond Firth's assertion that in many small-scale societies, "there are undoubtedly people with aesthetic sensibilities of considerable power, but a concept of art there is hard to disentangle from notions of technical skill on the one hand, and mystical knowledge and control on the other."[85] Yet Dutton's central contention is that for all the diversity of global artistic practices, they are not so incommensurate as to invalidate talk of art and aesthetics as universal phenomena. More than twenty years ago, Richard Anderson argued that there are recognizable art cultures worldwide that exhibit key shared features with those of Europe.[86] These include not only the high cultures of the Old World, where there was a "privileging of aesthetic sensibility relatively purified of non-aesthetic interests into which individuals are taught and trained as a cultural practice," but also smaller-scale cultures. Many classic studies now exist of the

art discourse of specific cultures.[87] Implicit in this approach is what the philosopher Donald Davidson has termed the "principle of charity," which states that difference only becomes negotiable and meaningful against an assumed common ground. In other words, while in many cultures judgments about artworks may be indistinguishable from other kinds of judgments, this does not rule out the legitimacy of talk about aesthetic sensibility. It merely means that in many different cultures such sensibility is expressed in terms that are not *immediately* recognizable as aesthetic. It may be, therefore, that, to paraphrase Davidson, different cultures are merely words rather than worlds apart.[88]

The archaeologist David Lewis-Williams has suggested that, provided we are aware of the connotations of the term *art,* it still has value, even if there is no satisfactory alternative.[89] To some extent, he is right; to debate endlessly the cross-cultural incommensurability of the concept of art leads to empty circularity. Yet the basic flaw in his position is that it can lead to failure to engage at all with the issue. Nowhere is this more evident than in the emerging field of world art studies, which has gained increasing prominence since the founding of the journal *World Art* in 2011 and is closely tied to the program of biological and evolutionary theory. As John Onians, one of its leading representatives, has claimed, "faced with the need to understand art as a worldwide phenomenon," one can either "persist in the belief that culture is autonomous and socially constructed" or accept the "evidence on the nature of the environment as revealed by geography and biology, and on the nature of man as revealed by genetics and neuroscience."[90] Yet, as the examples already examined in this chapter suggest, there is no decisive "evidence" of the kind Onians refers to, merely rhetorical assertions and inferences. Moreover, the program of world art studies as envisaged by Onians and others (including Lewis-Williams) *is* based on a strong assertion about the universal nature of art, and yet one in which "art" remains remarkably undertheorized. As one sympathetic commentator has observed, in world art studies there is "a kind of blindness, an unawareness of the relevance of the avant-garde, of conceptual art, and their conjoint critique of representational convention. . . . It is as if the description of something as art is an honorific sobriquet . . . an elevation rendered more in homage to the status of the 'masterpiece' of the Renaissance than to the more troublesome status of the Readymade."[91] It is not merely, therefore, that the relevance of Western notions of "art" to precolonial oceanic, African, and American societies stands in question; it is also that in the use of the term in world art studies, and in the evolutionary theory bound up with it, there seems to be little interest in the fact that even *within* Europe and North America, the meaning and identity of "art" has been contested for more than a century.

Alongside the questionable status of the "art" in world art, the other half of the equation, "world," is equally underdetermined. Advocates of the new world art studies have urged the need to adopt a macrohistorical perspective.[92] The implicit model here is the world systems theory of Immanuel Wallerstein, and this model is prominent, too, in Onians's *Atlas of World Art,* which tracks the global production and migration of art objects.[93] The atlas performs a valuable service in highlighting the scope of the transnational traffic of artifacts such that, in one sense, Europe, North America, China, and India become mere provinces in the world system of art. Yet its format shows the limitation of both the atlas as a medium and also the project of world art, for it rarely rises above the positivistic documentation of the fact *that* art objects circulated between, for example, the Netherlands and Japan and China, or between Cambodia and ancient Rome. Everything hangs, of course, on the analysis of the *fate* of objects, how they are understood and absorbed once they cross cultural boundaries. This is something that the atlas and much of the new world art studies do not explore, in opposition to the many studies of the cultural exchange of artistic objects that *do* focus on the semantic, conceptual, formal, and even physical transformations that arise out of the process.[94] Such a lack of specifics repeats the weaknesses encountered more broadly in evolutionary theories that restrict themselves to explaining art in terms of abstract generalizations, such as adaptation, fitness, and selectivity. It reflects the biological concern with ultimate causes, providing what are often referred to as "distal explanations" that, to recall Baxandall, treat artworks as "evidence" of a natural law of artistic creativity, or as the "deposit" of a biological process. This view from afar thereby misses what for many is the most important but also most exciting aspect of the study of art on a global scale: the negotiation of cultural difference and the embrace of the sheer diversity of practices.

Stephen Davies has recently suggested that the embrace of evolutionary theory by theorists and critics in the arts and humanities is driven by a defensive anxiety to prove their social relevance, an observation that recalls the state of affairs of a century or more ago. But there is more, for, Davies notes, "we should be sensitive to the political dimensions of the debate and to the tendency to rationalize deeply felt but untested intuitions."[95] The intuitive character of neo-Darwinist accounts has already been explored, but it is the political aspects that demand scrutiny, for evolutionary theories of art have frequently been linked to a program that seeks to bypass questions of cultural difference in the name of universals. A charitable view might understand this as a resurrection of the family-of-man ideology of the 1950s, but a less charitable one might point to the conservative and reactionary currents in

much evolutionary discourse. Joseph Carroll, for example, one of the leading proponents of Darwinism in literary criticism, has been unremittingly hostile to what he terms the "postmodern paradigm" in cultural theory, by which he means "obsolete social and psychological doctrines like those of Marx and Freud." Furthermore, he has argued, "despite the massive ideological resistance to the idea of innate characteristics, this kind of advance is virtually inevitable."[96] Dutton adopts a similar position, posing as the outsider to an academic establishment in thrall to a multiculturalism that allegedly seeks to deny the sense of common humanity. Frederick Turner, too, criticizes the intellectual tradition, "running from Kant to Mach to Wittgenstein to Derrida," that problematizes meaning and value.[97] In its place, he attempts to demonstrate how the aesthetic dimension *minimizes* cultural difference, in order to install an ecopoetics that unearths the "ur-language" of poetry and the visual arts and the universal foundations of music.

Such political positioning indicates that the stakes are higher than merely the contest for control of the field of art discourse. Indeed, it highlights the fact that for all that evolutionary theories of art seek to embrace art on a global scale, many of its representatives are motivated by a profound ideological unease with global cultures, putting in their place an essentialized vision of art.

This analysis suggests that current attempts to apply evolutionary theory to the understanding of art and aesthetics is too problematic, too reliant on intuitive assumptions and speculation, to provide a credible conceptual framework, much less a powerful alternative to the putatively "irrelevant" concerns of art historians. Where these attempts often fall down, however, is not even in the questionable nature of their working assumptions but in the banality of their insights and their inability to treat artworks as anything more than "data." An instructive example is a recent discussion of portraiture by Olivier Morin.[98] Based on comparative analysis of official Korean royal court portraiture from the late fourteenth to the late nineteenth century, Greek and Roman funerary portraits, and Italian Renaissance portrait paintings, Morin notes a cross-cultural tendency of what he calls "averted-gaze" portraits (i.e., three-quarter views) to be replaced by "direct-gaze" (i.e., full face) images. This did not occur at a uniform rate in the cultures examined; in Korea it took some three centuries, whereas in Italy the direct gaze became the dominant mode of portraiture during the course of a single century. Nevertheless, this common pattern arose, Morin argues, out of an evolved, innate "cultural attraction" to "direct-gaze" images.

Whether this is a correct summary is open to question; Morin's argument certainly grossly simplifies the history of portraiture. Of interest here, however,

is the significance Morin attaches to this phenomenon. He offers no explanation as to why, given a putatively innate attraction to the direct gaze, there *ever* were averted-gaze portraits, or why such a shift to the direct gaze occurred during a historical time span that was, in evolutionary terms, insignificant. Morin ignores the different cultural meanings of the gaze, or the fact that even within a single culture the "direct gaze" has a multiplicity of meanings, its psychological address variable from one painting to the next. His argument relies on a naïve realist epistemology, treating images as "data" with no distinction between the gaze and *representations* of the gaze. Within the terms of his argument, there is no difference between a Renaissance portrait, a Byzantine icon, a portrait photograph by Thomas Ruff, and a face-to-face encounter with another person. This preference for ultimate "distal" explanation may be entirely consistent with the disciplinary conventions of evolutionary theory and the biological sciences, but its consequence when deployed in analysis of specific artistic practices is an impoverished understanding.

Does this mean that evolutionary aesthetics has no pertinence for the analysis of art? It may be premature to dismiss the project entirely. The work of David Summers and Michael Tomasello, for example, indicates that a global "natural history" of art *might* still be possible, but on the basis of a more sophisticated sense of the relationship between biological and cultural evolution. Exponents of evolutionary aesthetics assume that since *in general* the theory of evolution is not contested, and that since, as materialists, few hold to a dualistic theory of mind, it must follow that the theory of evolution must provide the bedrock for the understanding of human cultural practices. Yet even for ontological monists it does not follow that there must be a single unified field of knowledge, unless one ignores the diverse interests that motivate inquiry. Furthermore, advocates of the evolutionary account and, more broadly, those calling for consilience seem remarkably blind to the rhetorical dimension of their own practice, which often rests on putting forward "plausible" arguments rather than on convincing evidence. Art theorists and historians, as well as interpreters of human culture in general, have long been aware of the role of rhetoric in interpretation. When advocates of "scientific" approaches to culture ignore this, including the rhetorical nature of their own calls, they only heighten the reasons for skepticism among those they most seek to persuade.

MEMES AND TREES

Art History as Evolution

The previous chapter discussed explanations of aesthetic response grounded in theories of psychological evolution. Central to these accounts was the idea that art evokes atavistic responses to, for example, landscapes and human and animal beauty, and the notion that such responses have been selected as evolutionary adaptations. Such theories also hold that the pleasure in reading or viewing fictional narratives is due to a cognitive adaptation that bestowed distinct advantages on its possessors. These accounts seek to address general theoretical questions about the nature of aesthetic experience, but, equally, they attempt to locate it in a model of historical time. Put succinctly, they operate with an implicit notion of deep time that underpins the epiphenomena of singular events (i.e., the creation and consumption of works of art). They argue that deep time is governed by the rhythms of biological evolution. Jay Appleton, Grant Hildebrand, and Denis Dutton, for example, all claim that the differences among the various historical forms of landscape aesthetics are overwritten by more general preferences that imprinted themselves on the ancestral minds of protohumans several million years ago.

This sense of time is the subject of this chapter, which discusses how Darwinian notions of variation and speciation have been used to map out the development of art history itself. How might artistic traditions (the

transmission and diffusion of artistic practices and ideas) and ruptures in the history of art be described in terms analogous to those used to analyze biological reproduction and descent? What are the methodological and philosophical stakes when art history is conceived of as an evolutionary process? Perhaps the best-known recent example of this enterprise is Richard Dawkins's theory of the meme, but before examining it in detail, it is worth exploring the historical deployment of the biological analogy.

ART AS EVOLUTION: HISTORY OF AN IDEA

The idea that the history of art could be described in evolutionary terms predates the publication of Darwin's *Origin of Species*. As early as 1849, the architectural historian James Fergusson described the development of art and architecture as an incremental and accumulative process; Gothic architecture, Italian painting in the Renaissance, bridge building in the eighteenth and nineteenth centuries, and ship building since the Norman Conquest had all shown a "gradual improvement" and a "steady, progressive aggregation of experience."[1] Darwinian conceptions of random variation, adaptation, and selection were distant from this image, but Fergusson's conception is indicative of an intellectual environment that was receptive to the theory of evolution. Thus, only three years after Fergusson, the American sculptor Horatio Greenough advanced a similar argument, claiming that the history of art and building could be seen as a progressive adaptation of forms to function and the "gradual elimination of all that is irrelevant and impertinent."[2]

Interest in biological analogy was particularly prevalent among architects and historians of architecture.[3] Eugène Viollet-le-Duc, for example, argued that Gothic architecture "develops and progresses as nature does in the creation of beings: starting from a very simple principle which it then modifies, perfects and renders more complicated without ever destroying its initial character."[4] He likewise referred to Greek architecture as a "series of experiments tending always in the same direction," the Parthenon being the outcome of "successive modifications of the Doric order."[5] Even those who were more guarded adopted the Darwinian model. Gottfried Semper, for example, criticized the evolutionary analogy and the idea of unilinear progress, observing that monuments often combine superseded historical forms and novel ones.[6] Yet at the same time, Semper drew attention to the heuristic value of the analogy; just as linguistics traces the gradual changes and developments that shape the history of languages, so, he argued, "it is perfectly proper to draw

attention to the evolution of art-forms from their seeds and roots to their transformations and ramifications."[7]

Emphasis on the cumulative effect of small-scale changes became particularly influential in anthropology and material culture. In 1875, Augustus Pitt Rivers, founder of the eponymous ethnographic museum in Oxford, delivered a lecture on cultural evolution that drew the same lessons from historical linguistics.[8] Present-day languages are connected by a sequence of incremental small changes to their prehistoric origins, and, he argued, it is likewise possible to discern the gradual transformation of material cultural forms over time. Pitt Rivers was particularly influenced by a study published the same year by the archaeologist John Evans on the relation of Celtic British to Roman coin designs.[9] Evans had stated that it was possible to construct a complete evolutionary lineage from the figurative designs on late Roman coins to the apparently abstract representations on post-Roman coinage. Successive minor deviations from or variations on the earlier version had led, over time, to substantial differences, such that the connection between the earliest and latest in the sequence was often not immediately apparent. This was a natural part of the process of copying, coupled with the fact that coin designers no longer understood the meaning of the original designs—usually images of classical deities. Pitt Rivers applied the same analysis to a range of other examples, from ceramic vessels recently excavated by Heinrich Schliemann in Troy to western European Paleolithic hand axe designs and Australian aboriginal weapons.

Possibly the best-known applications of this schema to material culture are by Henry Balfour and Alfred Haddon. In *The Evolution of Decorative Art* (1893), Balfour analyzed the evolution of ornamental designs as a genetic series, arguing that apparently abstract ornamental designs were the result of copying and recopying of original figurative representations that had slowly been transformed in a manner comparable to the variation underlying the evolution of organic species. The argument is clearly indebted to Pitt Rivers, although Balfour applied the latter's approach in a more systematic manner. Similarly, in *Evolution in Art*, published two years later, Alfred Haddon traced the life histories of the artifacts of the Torres Strait islanders, identifying the intermediate steps in sequences that revealed genetic relations between artifacts that looked completely dissimilar and that had been obscured by the "drift" brought about by incremental changes.[10] Writing about Walt Whitman and American democracy, Haddon's contemporary the literary critic John Addington Symonds claimed that "the mental progress of humanity is not affected by abrupt divisions and sudden dislocations. Every process of change implies absorption, blending, compromise, recombination. . . . To escape the

fatality of hereditary transmission is hopeless."[11] By the 1890s, this method had become a commonplace in the study of art and culture.[12]

In the same year that Balfour wrote *The Evolution of Decorative Art*, the Viennese art historian Alois Riegl's groundbreaking *Problems of Style* was published. It maps out the gradual steps whereby the acanthus leaf of ancient Egyptian art evolved into the arabesque in the art of the Islamic world. Riegl saw aesthetic volition (*Kunstwollen*) rather than unconscious variation as the engine of art history, but his account still fits into the framework of continual evolutionary progression. As such, his work was the most prominent exemplar of the "genetic method" that was a hallmark of art-historical scholarship in Vienna at that time. Riegl's successor Max Dvořák also used it as the basis of his interpretation of Hubert and Jan van Eyck, in which he argued that their work was not the miraculous product of genius, as many contemporaries contended, but rather the result of a series of gradual incremental steps that could be traced back through the fourteenth century. For "just as Scholasticism has taught us to produce logical chains of thought, so modern science has gradually taught us to translate facts into specific developmental sequences."[13]

There were other, less well known attempts to undertake a Darwinian analysis of artistic evolution. Grant Allen, a Victorian popular science writer, suggested the outlines of an evolutionary study of Italian art. Rather than study individual artists, Allen argued, the art historian should be concerned with the development of *types*, which he equated with iconographic themes, such as the Virgin and Child, the Adoration of the Magi, the Pietà, or the Visitation. As Allen put it, "we should regard any given early Italian work, not primarily as a Raphael, a Giotto, or an Orcagna, but primarily as a 'Paradiso', a 'Nativity', a 'St Francis Receiving the Stigmata', a 'Doge Escorted by St Mark to the Madonna'. We should mentally restore it to its proper order in the historical or evolutionary series."[14]

This approach had its heyday in the decades on either side of 1900. Yet by the First World War, even its most forceful advocates had turned away from it. In his later writings, Dvořák, for example, embraced an image of art history that emphasized its discontinuities, ruptures, and transhistorical correspondences, spanning centuries. Examples included the similarities between early Christian painting and expressionism, or between the art of the present and the work of El Greco, or between the situation of art in the First World War and Goya's etchings during the Peninsular War.[15]

The embrace of Darwinism was also subjected to criticism from other quarters. *The Architecture of Humanism* (1914), by the architectural historian Geoffrey Scott (1884–1929), articulated a forceful critique of evolutionary

accounts of the history of art and architecture. Specifically, Scott argued, the "biological fallacy" robbed individual artifacts of intrinsic value, interpreting them solely in terms of their place in a historical sequence. "The values of art do not lie in the sequence but in the individual terms. To Brunelleschi there was no Bramante. . . . His architecture was not Bramante's unachieved, but his own fulfilled." In addition, Scott pointed out a basic methodological problem, namely, that "we ourselves define the unit which we estimate. We have to be sure that our sequence is really a sequence, and not an accidental group." The promise of scientific objectivity is misplaced, since the evolutionary method cannot itself determine the object of analysis—a subsequently much-debated epistemological problem—and is thus always subject to the interests of the historian. Moreover, Scott argued, the evolutionary model of survival through adaptation translates poorly to the history of art, for the "power to survive is no test of aesthetic quality. . . . The mere power of an architectural tradition to survive—could we estimate it—might be a permanent quality, but not a relevant one."[16]

Other authors took issue with the idea of artistic evolution as a cumulative process and with the emphasis on formal succession. Henri Focillon, for example, writing in the 1930s, distanced himself from the evolutionary model by stressing the simultaneity of the nonsimultaneous—the fact that the history of art is replete with examples of "outmoded" artistic practices that frequently persist alongside innovations that might have "superseded" them. This image undermines the "deceptive orderliness" and "single-minded directness" of the evolutionary history of art.[17] This was a problem, too, for Focillon's contemporary Wilhelm Pinder, who tried to conceptualize the multiple temporalities of art history in terms of the conflicting horizons of different generations of artists who were nevertheless working at the same time.[18] Focillon also pointed to the problem that the model of continuous gradual change is unable to accommodate revolutionary changes in art, the disruptive impact of artistic innovators, or the discord between past and present. Alternative metaphors can be used, he argued, including those from geology and stratigraphy; the idea of art-historical fault lines, canyons, and geological strata are more suggestive of the layers of art history than the linear narrative of evolutionary development.[19] Further reservations were voiced subsequently by the artist Peter Fingesten, who noted that "mere succession in time, the appearance of new formal or spatial concepts or even technical carryovers do not constitute evidence for an evolution of art."[20] Biologists may attend to patterns of morphological development, but analysis of formal succession alone is empty, Fingesten argued, for the art historian has to identify the cultural meanings

of individual objects, against which formal similarities might mask deeper differences.

The theory of evolution also came to be deemed problematic because of the political associations of social Darwinism. Nevertheless, its influence proved surprisingly persistent. Focillon's student George Kubler was, like his teacher, critical of the biological analogy, but his best-known analysis of art-historical method, *The Shape of Time*, is deeply shaped by Darwinian concerns. These include the nature of continuity in art history, the transmission of images and designs, and how formal sequences through time can be constructed. Kubler advanced the idea of a temporal sequence of artifacts comprising "prime objects" and "replications."[21] Although he explicitly disavowed biological metaphors, evolutionary thinking provides the clear conceptual model in his definition of sequence as a "historical network of gradually altered repetitions of the same trait . . . all recognizably similar, yet altering in their mesh from beginning to end."[22]

Kubler wrote of networks rather than evolutionary trees, but his interest in "gradually altered repetitions" makes clear the lineage of this mode of thought, with its similarities to Haddon, Balfour, and Riegl. This impression is reinforced by the fact that he also referred to "mutants" in the sequence, akin to genetic variants, and such mutants, he argued, are responsible for the slow transformation of formal sequences in the process of their replication. The notion of a continuous sequential history of art was central, too, to Kubler's contemporary Ernst Gombrich. Gombrich's idea of Western art as a continual experiment in techniques of figurative representation, first explored in *The Story of Art* and then in much greater depth in *Art and Illusion*, conceived of it as a sequence of incremental steps in which established representational schemas were subject to revision and refinement. Thus "all representations can be somehow arranged along a scale which extends from the schematic to the impressionist," and the history of European art since the Renaissance is a gradual overcoming of the pull of tradition and the reliance on schemata through the correction of inherited modes of representation.[23] Gombrich's acknowledged methodological debt was to Karl Popper rather than directly to the theory of evolution, but the *manner* in which Gombrich construed Popper, using the latter's falsificationism as a model, reveals the shared evolutionary framework of both thinkers.[24] Indeed, in *The Sense of Order*, his study of the psychology of ornament, Gombrich openly employed Darwinian terminology to explain the persistence of archaic decorative motifs and the relative lack of radical innovation: "speaking in the most general terms, it may still be accepted that the principle of the survival of the fittest is a useful guideline.

Maybe motifs survive because they are easy to remember and easy to apply in diverse contexts."[25]

As this brief historical overview indicates, there was a sustained fascination with evolutionary theory as a model for the historical development of art from the mid-nineteenth century to the First World War. Sporadic efforts to revisit the idea continued for another fifty years or so. This interest may have waned partly because of the contingent fact that it was displaced by other conceptual paradigms, but the evolutionary analogy suffers from numerous weaknesses, as some of its historical detractors recognized. Evolutionary theory was particularly attractive to anthropologists concerned with stable small-scale cultures where radical change was extremely rare and where material culture could be organized into easily identifiable categories or types of artifact.[26] But its utility as a theory of historical change in larger-scale dynamic societies was more likely to be limited, as Focillon had already recognized. The criticisms of Focillon and Scott retain their pertinence, but there are other problems, too, with the analogy. These relate to the questions of agency and adaptation.

Central to Darwin's account is the notion of random variation. Darwin did not describe the mechanism underlying such variation, but since the growth of genetic science, it has come to be understood as a "mistake" in genetic replication, which may turn out to lead to advantageous phenotypic expressions. Variation is blind, and it is clear why Haddon, Balfour, and others saw parallels with the unconscious errors of copyists in traditional societies replicating inherited designs and imagery, the original meaning of which they may not have understood. Yet, as Scott suggested, the parallel is misleading, since even in the examples Haddon and Balfour examined, "copying" was always based on interpretation on the part of the copyist, determined by his or her cultural frame of reference. The gradual "drift" in the design of Roman coins toward the abstract forms of ancient British coinage was not random but was the result of successive attempts to *interpret* the inherited image.

The example of Roman coinage opens out to art historians' much broader concern with the relation to the classical tradition and the transmission of classical art and culture. The stereotypical image of the Renaissance as the rediscovery of antiquity was already being questioned in the 1860s by Anton Springer, who noted the prevalence of classical myths and motifs in the art of the postclassical and medieval periods.[27] Indeed, Springer argued, the Middle

Ages was just as imbued in the classical past as the Renaissance was, and there had been a continuous transmission of images and myths since antiquity. Where medieval art differed from the Renaissance, however, was in its disconnection from the visual world of antiquity; it reflected a lively interest in classical subjects, but they were depicted using the language of postclassical art. This issue was famously taken up by Springer's student Aby Warburg, who tried to construct a theoretical framework to explain it. Warburg is of relevance here because he devised a theory of cultural memory that borrowed directly from Darwin and also indirectly, through the biologist Richard Semon.[28] Yet the weaknesses inherent in the analogy were also a problem in Warburg's work. Semon was concerned with the inheritance of acquired characteristics, and he identified the mechanism in the electrochemical processes in cells, which ensured that stimuli left permanent memory traces—"engrams"—at a cellular level in the organism. Such engrams could then be transmitted through reproduction. It was not necessary for the organism to pass on the original engram in its entirety; some aspect of the original "complex of excitations" was sufficient. The original stimulus needed only to be evoked, and this explained why transmission and inheritance were also subject to deviation and variation. Indeed, Semon distinguished between the "atavistic" line of succession, in which the original engram had been preserved unchanged, and a process of bifurcation or dichotomization, where two or more variant forms might be produced.

Although oriented primarily toward biological inheritance, Semon mentioned numerous instances of cultural inheritance and suggested the possibility of a common framework for the analysis of genetic transmission and cultural inheritance. Warburg equated Semon's engram with what he called the "pathos formulae" of classical art—the visual lexicon of archetypal representations of human expression and emotion—and he reformulated the relationship between the Renaissance and classical antiquity in terms similar to those of Semon's notion of inheritance. Where engrams bear the marks of electrochemical change, artistic pathos formulae—Warburg also called them "dynamograms"—carry the imprint of primitive memories of the experiences that originally created them and that could be evoked again at any time. Warburg used Semon's notion of bifurcation inasmuch as the meaning of dynamograms was not constant but was subject to inversions and redefinitions. This is central to his analysis of how artists responded to the Dionysian legacy of the classical world; they either *replicated* the affective power of the original classical engrams (themselves generated by a primitive psychological disposition to irrational fear and emotional excess) or they sublimated it by

transforming the engrams into humanistic symbols and allegories. Artists can either perpetuate an atavistic line of succession or create a variation, a new line of succession.

The biological analogy of engram and pathos formula depends, however, on the notion that its originary expressive force, its "stored" mnemic charge, is available in an unmediated way. The intervening millennia of cultural mediations between the classical world and the Renaissance cannot interfere with the role of the pathos formula as a vehicle of inheritance. The difficulty with this view is that Warburg documented the numerous occasions when that force *was* seemingly lost, such as the blindness of Flemish weavers to the emotional language of classical pathos, or nineteenth-century aestheticism and its repression of the Dionysian inheritance of the classical world.[29] Warburg thus inadvertently indicated why there is a profound *disanalogy* between the transmission of chemical and physical features of the organism through reproduction and the passing on of ideas and images in the creation of a tradition: the latter is always thoroughly culturally mediated.

Such cases highlight the difficulties raised by the evolutionary model, for the *mechanisms* of biological and cultural inheritance are different in important ways. This is doubly so in cultures where there is little imperative to preserve and retain inherited traditions and where, instead, artists' ability to assert their individual identity and depart from tradition is valorized. Geoffrey Scott based his criticisms on a humanist notion of subjective creative freedom, but it is not necessary to resort to such naïve ideas to emphasize the cultural mediation of transmission. Even in conservative artistic cultures in which the agency of the artist is minimized and fidelity to an archaic prototype is the foremost value, the very valorization (or the reverse) of tradition demands interpretation.[30] The biological analogy casts next to no light on precisely what, from an art-historical perspective, may be of most interest.

Adaptation has already been examined in the previous chapter, but it merits renewed discussion here. The evolutionary histories of art considered so far can be considered "Darwinian" in only a very loose sense, for while they adhere to the idea of incremental change, the key question of why some variations turn out to be productive (i.e., are retained and form the next step in the chain of evolutionary history) and others remain dead ends (i.e., are not emulated and passed on) remains unexamined. The Darwinian explanation focuses on natural and sexual selection as the engines of biological evolution. The difficulty with this model of art and culture has already been outlined in the previous chapter in relation to the concept of aesthetic judgment; *how* art might have been adaptive, if at all, is a matter of pure speculation. The same

problems arise when the *history* of art is explained in terms of adaptation and selection, for it is impossible to identify the "test" in the history of art that would act as a mechanism comparable to natural selection.[31] Reception history can provide adequate evidence of how and when specific works of art were ignored, rejected, or emulated—but this is very far from the kinds of accounts advanced by Darwinians. This is especially so given that many works—Caravaggio's *Death of the Virgin* (1606), Goya's *Third of May 1808* (1814), and Manet's *Olympia* (1863), for example—were met with rejection but later rehabilitated and admired. There is no parallel process in evolution; a maladapted mutation—the equivalent of a rejected work of art—is not later repeated, having been in some kind of biological cold storage. It is either passed on or lost.

The social, economic, political, and cultural circumstances that provide more or less receptive environments for different kinds of artworks can be specified, but this type of explanation ends up being indistinguishable from the social history of art, and it bears little relation to Darwin. Moreover, in many cases, such as ornamentation, the absence of utility means that selection pressures would be minimal. The further a practice is removed from everyday utilitarian purposes, the less specific are the constraints of the environment (whether natural or social), and the less can its history be described as shaped by adaptation-driven selection.[32] This recalls a criticism by Marshall Sahlins originally directed at sociobiology, namely, that adaptation provides only a "negative determination," by identifying the constraining features of an environment and the limitations they impose. Such an account "does not positively specify how the constraint is realized." Consequently, Sahlins notes, "a law of nature stands to a fact of culture only as a limit does to a form, a constant to a difference, a matrix to a practice."[33] In other words, theories of adaptation mark out only the limits of the possible.

MEMES AND THE REINVENTION OF EVOLUTIONARY THEORY

One might assume that these criticisms are of mostly historical value, but in fact there has been renewed interest in the possibilities of the evolutionary model. The most prominent instance is Richard Dawkins's theory of the "meme," which attempts to provide a new framework for the analogy between cultural and biological evolution. Much criticized, the idea nevertheless has significant defenders and has spawned a considerable literature; it consequently requires attention. Dawkins coined the concept as a way of trying

to account for cultural transmission in terms comparable to the theory of genetic inheritance. "Meme" is his "name for the new replicator, a noun that conveys the idea of a unit of cultural transmission, or a unit of imitation . . . a monosyllable that sounds a bit like 'gene.'"[34] At the root of this proposal is the suggestion that cultural transmission follows the same laws as biological reproduction, for it is subject to similar environmental forces that determine the success or failure of ideas and practices. Dawkins's interest is therefore less in variation through repetition and rather more in the adaptational pressures shaping cultural transmission. His first book, *The Selfish Gene*, suggests a broadly metaphorical use of the biological terminology, but in *The Extended Phenotype*, Dawkins develops the idea in a decidedly more literal way. The meme is now a kind of "non-genetic replicator which flourishes only in the environment provided by complex communicating brains."[35] It is not to be confused with cultural practices themselves, such as language, music, images, clothing styles, or bodily gestures, for these are external manifestations, phenotypic expressions, or "meme products." Rather, it is in the brain that memes are transmitted and reproduced. Dawkins's characterization merits quoting at length:

> A meme should be regarded as a unit of information residing in a brain. . . . It has a definite structure, realized in whatever physical medium the brain uses for storing information. If the brain stores information as a pattern of synaptic connections, a meme should be in principle visible under a microscope as a definite pattern of synaptic structure. If the brain stores information in distributed form, the meme would not be localizable on a microscope slide, but still I would want to regard it as physically residing in the brain. This is to distinguish it from its phenotypic effects, which are its consequences in the outside world.[36]

Memes are reproduced through copying. Like genes, they are subject to natural selection, and while the adaptational pressures sometimes overlap with those for genes, they can also be quite distinct. Thus, on the one hand, memes that lead their carriers to jump off cliffs, to mention one of Dawkins's examples, will not be replicated, for obvious reasons (rather like viruses and bacteria that kill their hosts before they can be passed on). On the other, the success of a melody—a meme, for Dawkins—relies on its catchiness and its memorability, and this determines how well it is adapted to its surroundings.

Dawkins's initial idea, although sketchy, has been taken up by authors from a wide range of disciplines, even leading to the creation of "memetics" as a defined field of study with its own, albeit short-lived, journal.[37] It has been the subject of a number of popular books by nonspecialists, but more serious studies by established authors have also been devoted to the subject.[38] It has even generated its own canon of terms (e.g., "memeplex," "memeoid," "memetic equilibrium"), all of which are modeled on concepts from the biological sciences and are intended to bring the study of cultural transmission closer to that of biological evolution. Its advocates have been forceful in arguing for its value; as the biologists Kevin Laland and John Odling-Smee have stated, "We find compelling the psychological evidence of memes as packages of learned and socially transmitted information, stored as discrete units, chunked and aggregated into higher order knowledge structures, encoded as memory traces in interwoven complexes of neural tissue."[39]

One might discern similarities in this description with the ideas of Warburg and Semon; it has even been suggested that Dawkins is familiar with Semon's work, for Dawkins's meme clearly resembles Semon's (and Warburg's) idea of the engram.[40] Furthermore, Laland and Odling-Smee's decision to frame the issue with concepts drawn from neuroscience has echoes of Semon's and Warburg's emphasis on the physiological and chemical bases of memory. In general, however, most of those who have taken memetics seriously as a field of inquiry have been biologists and social scientists, with few in art history or the humanities showing any interest. Proponents of evolutionary theory complain that this reflects the blinkered vision of scholars of the humanities, and in some cases this may be correct, but it diverts attention from the serious problems with memetic theory.

There has been no shortage of criticisms of the enterprise.[41] The flaws and difficulties start with Dawkins's description of memes as the cultural counterpart of genes and, in order to keep the analogy alive, his characterization of cultural practices as the phenotypic effects of memes. This model represents a notable shift from earlier theories of artistic and cultural evolution, inasmuch as Dawkins attempts to transfer the genotype/phenotype pairing to the cultural domain. It is at this point, however, that ambiguities begin, for while memes are intended to function as the cultural counterparts of genes, Dawkins also talks of cultural phenomena, such as melodies or religious ideas, as if they themselves were memes. This is also how the idea of memes has become popularized, but the biological analogy breaks down, for it is not clear what the phenotypic expression of such practices would be.

To avoid this confusion, one can persist in the notion that memes constitute a memory trace in the brain and that religious beliefs and other examples are merely their phenotypic expressions. The basis of the analogy with genes comes into question once more, but in a different way, for in evolutionary biology, reproduction occurs through a chemical process of copying; it is not clear how memes, by contrast, are supposed to be transmitted. Advocates of meme theory stress the central importance of social learning through copying; as Susan Blackmore has argued, "since memes are, by definition, passed on by imitation, they must have first appeared when our ancestors became capable of imitation."[42] But in the absence of a fully worked-out theory of social learning, the mechanism of copying is not clear. In the case of biological genetics, that mechanism is the reproduction of a molecular sequence, but it is not possible to identify a counterpart in meme theory. How does one copy "memory traces in interwoven complexes of neural tissue"? At the root of the copying thesis of meme theory is the assumption that the memetic phenotypes, rather than the memes themselves, are copied, and that through the copying of the phenotypic behavior the memetic "memory trace" is reproduced. But cultural learning takes place in numerous ways, from emulation, which focuses on the *effect* of actions rather than on the actions themselves, to imitation, which not only copies the behavior of others but also draws inferences about their intentions and the purposes of the action.[43] Evans's study of coin design is relevant here, for his point was that the incremental change from Roman original to British copy was based not only on the mechanics of reproducing forms but also on interpretation of the identity of the image being copied.

There are additional problems, too, starting with the fact that a direct correspondence is assumed between a behavior and a meme. Dawkins rightly criticizes the simplistic assumption that genes can be linked directly to specific phenotypic effects—in the intervening decades this has now become a commonplace—but the same argument applies to memes. Just as there is not a gene "for" homosexuality, to use the example discussed in the previous chapter, it is difficult to maintain that there is a meme "for" religion, as Dawkins does. If the meme/gene analogy is adhered to strictly, memes would have to be sets of instructions that are copied and then causally linked to the reproduction of the meme and its phenotype in question. However, as noted above, even though copying plays an important role in cultural reproduction, this is less a copying of instructions and more an *inference* about the underlying logic and purposes of an activity based on the observation of perceptible behavior. As Dan Sperber has argued, "instructions cannot be imitated, since only what can be perceived can be imitated. When they are given implicitly,

instructions must be inferred. When they are given verbally, instructions must be comprehended, a process that involves a mix of decoding and inference."[44] Native language learners, for example, do not "copy" the rules of grammar but infer them from the linguistic utterances they hear.

One can bring this point closer to the concerns of aesthetics and art history by comparing it with Kant's distinction between copying (*Nachmachung*) and imitation (*Nachahmung*). Kant famously distinguishes between the sciences and the "mechanical arts," on the one hand, and fine art, on the other. The former function by means of the reproduction of formulae, while in fine art, "masterpieces" may be sources for artistic *emulation*, but the creative artist never merely copies them. In fine art, "the rule must be abstracted from the deed, i.e. from the product, against which others may test their own talent, letting it serve them as a model not for copying but for imitation."[45] One might not share Kant's attitude toward the applied arts or the conception of genius informing this distinction, but he nevertheless identifies a crucial consideration absent from meme theory, namely, the importance of inference about the underlying principles of a practice, which cannot themselves be seen or "copied."

Meme theory is also vulnerable to criticism on account of its central focus on replication at the level of *individual* copying of behavior. This atomized understanding is open to scrutiny; large-scale quantitative analyses may be central to the study of populations in the biological sciences, but their use in the study of cultural evolution neglects the operation of institutions and structures as well as the aggregated actions of individuals. Individual actions may be legitimized by institutions that either value or dismiss specific behaviors. Indeed, this criticism can be leveled not only at meme theory but at wider theories of evolution that emphasize the cognitive dispositions underlying cultural evolution, for they focus on the actions of individuals within populations but actively disregard the dependence of cultural transmission on generalized symbolic media, such as language and visual imagery. Accordingly, a theory of memes would need to provide an account of how practices are communicated through such media.[46] Moreover, in treating cultural variation as analogous to genetic mutation, meme theory underestimates individual agency. Where genetic mutation is a random process, cultural shifts are produced out of a dynamic reflective relationship with the past, including the fact that not only can the legacy of the past be rejected (and not merely reiterated), but earlier neglected or rejected episodes and practices can be returned to again in the future. As one study has put it, with culture, "variations emerge not randomly, but as attempts by specific individuals and/or groups to solve specific social/cultural problems."[47]

Such issues are largely ignored by meme theory, and a much-discussed further weakness is its atomistic understanding of culture as composed of memetic "units." It is not at all clear whether culture can be divided up in this way, especially in the absence of a clear definition or ontology of such cultural segments. Dawkins and others draw up lists of heterogeneous cultural phenomena, such as religious beliefs, melodies, works of art, and suicide, but in contrast to gene theory, no stable ontology underlies them. They are arbitrarily selected, reminiscent of the mental "modules" promulgated by evolutionary psychologists as ad hoc explanations for an unsystematic collection of phenomena. Dawkins's example of melody as a meme also raises the question whether the meme is the whole melody, part of the melody, or the melody in the context of the larger composition. Dawkins cites Pythagoras's theorem as a meme, but the theorem is meaningless without the larger body of geometrical knowledge of which it is part, and, conversely, it can be broken down further into the concepts of triangle, angle, hypotenuse, square, equation, and so forth.[48]

Meme theory thus breaks down on closer inspection. In its defense, some have argued that it nevertheless has its uses. The social theorist W. G. Runciman, for example, has stated that "it is a matter of simple convenience to have a word stand for whatever items or packages of information make up the messages transmitted from mind to mind through imitation or learning by which behavior in the phenotype is affected."[49] But convenience is no argument for retaining meme theory, especially given the second part of Runciman's formulation, which fails to answer the basic objection that culture does not consist of "packages of information" or "messages" of the kind suggested. As a more critical reading has suggested, memes may be little more than "a mental construct whose only defined property is to fill in the gap in an elaborate metaphor."[50]

PATTERNS OF EVOLUTION

The frequent references to the brain highlight the proximity of meme theory to evolutionary psychology, and to the notion that the transmission and acquisition of cultural practices are linked to neuropsychological processes. Indeed, an important aspect of the theory is the claim that the capacity to replicate memes—social learning—is itself a phenotypic expression of genetic adaptation. As the social anthropologist Mark Flinn has argued, "learning capabilities (and psychological mechanisms that utilize information acquired from

learning) would not have evolved if they had produced behaviors that were random with respect to biological adaptation. Organisms have *evolved* to learn in ways that maximize inclusive fitness. . . . Learning is a type of phenotypic modification."[51] The rhetoric deployed here, in which the force of the argument relies on *probability* and the inability to imagine alternatives, reminds us that we are in the domain of plausible storytelling once more. Moreover, Flinn's approach depends on the assumption that society and culture are primarily a collectivity of individual minds (or brains). Few social scientists adhere to this model, and most emphasize the central role of intersubjective networks and discursive and institutional structures. Perhaps in recognition of the pitfalls of this position, many advocates of cultural evolution have sought to identify evolutionary patterns not in the putatively adapted behavior of individual social agents but in the adaptive behavior of larger social structures, or by undertaking statistical analyses of social and cultural behavior. Their principal aim is to explore the possibility of tracing patterns of cultural diffusion by producing phylogenetic "trees" in much the same way that biologists map out the evolution of species. This approach has the advantage of avoiding the vulnerabilities of meme theory or other theories in which evolved cognitive factors are central explanatory mechanisms. It also has a long history in the humanities; as early as the 1820s, the classical scholar Karl Lachmann attempted to describe the relationship between classical manuscripts using the metaphor of the family tree, while historical linguists have long sought to classify languages (and their genealogy) using the same basic model.

The new Darwinism goes one step further, however, using a much tighter analogy with biological evolution. The basic question, therefore, is how far cultures and societies can be described as obeying the same laws of variation, selection, and adaptation as genes and their biological phenotypes. Important early systematic attempts to answer this question were undertaken by the biologists Luigi Cavalli-Sforza and Marc Feldman and by Robert Boyd and Peter Richerson, who undertook quantitative examination of the variation, transmission, and selection of cultural traits within a population.[52] They recognize that culture constitutes a distinctive inheritance system shaped by particular processes that differ from biological reproduction. At the same time, however, they accept the evolutionary model, treating culture as composed of traits distributed among a population, thereby using methods from population biology. Subsequent works have reiterated this idea, among them, not least, more recent publications by Richerson and Boyd.[53] In response to the criticism that, unlike blind biological variation, cultural transmission and variation are the work of conscious agents, they argue that individuals lack foreknowledge

of the longer-term consequences of their actions and are thus also, in important respects, "blind." As Alex Mesoudi, a more recent proponent of this argument, has stated, "Historical figures often claim retrospectively to have guided cultural change in particular directions, yet such claims may have the benefit of hindsight and be self-servingly exaggerated."[54] This is a noteworthy corrective, but its significance may be limited; the failure of cultural actors to foresee the outcomes of their actions may be less a factor in the calculus that justifies the biological analogy than something deserving attention in its own right, to be used to explain *particular* courses of action. Mesoudi, Boyd, and Richerson acknowledge this and recognize that some processes are specific to culture. Thus, while historical agents may be unable to predict the consequences of their decisions, cultural evolution is not *entirely* blind or random either. Rather, it is "guided." Variation in cultural traits (phenotypes) will be framed by the cognitive dispositions of human actors, and sociocultural factors will also shape cultural transmission in nonrandom ways. As Boyd and Richerson note, "adherence to culturally inherited beliefs often causes people to ignore the dictates of ordinary, individual learning."[55] Other factors, such as content bias (the fact that the more a variation contradicts existing norms and intuitions, the less likely it is to be reproduced), frequency dependence, and prestige bias, have all been examined as central to the process of cultural evolution, and serve to sharpen the distinction between biological and cultural reproduction and inheritance.[56]

The significance of this concession should not be overstated, however, for these scholars still argue that one can produce a calculus or statistical analysis of evolutionary patterns that takes the specificities of cultural and historical transmission into account. Although contingent, decisions by historical agents, for example, are seldom arbitrary, and it is therefore possible to identify the "decision-making forces" that guide cultural evolution.[57] Consequently, one can factor in biased transmission and guided variation, with quantitative formalizations and mathematical models indicating parallels between biological and cultural evolution. As a result, far from being discounted, phylogenetic trees can be constructed for a wide range of cultural phenomena. Indeed, phylogenetic analysis has often been of special value when other sources are lacking, for, as Boyd and Richerson argue, "the history of many biological and cultural groups is so poorly known that only by combining phylogenetic and historical or archaeological information can reliable reconstructions be made."[58]

Numerous authors have attempted this kind of analysis. The archaeologist Stephen Shennan, for example, has examined the impact of population survival and reproductive success on the persistence of cultural attributes.

For Shennan, cultural inheritance, defined as "the regeneration of phenotypic traits and processes through the direct or indirect transmission of information between entities," can be modeled using terms drawn from biological evolution and animal inheritance, including "population-level feedback" and "phylogenetic inertia."[59] This denotes the parallel between the time lag between environmental change and species' ability to adapt, on the one hand, and the conservative pull of cultural traditions, on the other. Like the delay in species' response to external changes, the force of tradition can impede or slow down cultural responses to alterations in the environment. "Population-level feedback" is a formula indicating that "the prevalence of a particular positively selected trait cannot go from zero to 100 percent immediately, but only as a function of the strength of selection and the number of occurrences in the previous population."[60] In other words, new traits may be adopted at varying rates; innovations are not immediately circulated among a population.

These examples may seem distant from the concerns of art historians, but given the primary concern with constructing cultural genealogies, there are clear parallels with the traditional engagement with issues of artistic lineage. Archaeologists have long recognized the significance of this method in a field where evolutionary theory has come to play a significant role in the analysis of material artifacts. Balfour and his contemporaries sought to arrange artifacts using fairly loose stylistic and formal criteria, but recent studies have used much more precisely specified variables and constants to construct the phylogenetic tree of a range of objects. R. Lee Lyman and Michael O'Brien, important pioneers of this approach, have made use of statistical data sets to construct phylogenetic trees ("cladograms") for objects ranging from ceramic sherds to arrowheads.[61] Other notable recent examples include the much-cited work of Jamshid Tehrani, Mark Collard, and Stephen Shennan, who have constructed cladograms illustrating the evolutionary histories of Turkmen textiles and Iranian weaving, and of basketry designs by indigenous Californians.[62]

Their work is of particular interest, for it bears on a key area of debate, namely, the extent to which culture is transmitted vertically from one generation to another, and how far it is driven by horizontal transfer or diffusion from one culture to another. The idea that horizontal diffusion offers a more accurate model of cultural reproduction was put forward by Alfred Kroeber, who questioned the relevance of the phylogenetic tree as a model for cultural evolution.[63] Kroeber's view has since become near orthodoxy, instantiated by Stephen Jay Gould's claim that "biological evolution is a system of constant divergences without subsequent joining of branches," and that "transmission *across* lineages is perhaps the major source of cultural change."[64] In cultural

theory, its most recent incarnation is Gilles Deleuze and Félix Guattari's notion of the rhizome. As a means of conveying the idea of multiplicity and hetero-geneity—and contesting the dominance of the arborescent metaphor across the human and natural sciences—the rhizome is predicated on the argument that "evolutionary schemas may be forced to abandon the old model of the tree and descent . . . going from the least to the most differentiated." In its place, Deleuze and Guattari describe a rhizomatic process "operating immediately in the heterogeneous and jumping from one already differentiated line to another."[65]

Such criticisms, formulated to counter teleological biological analogies, are less forceful than one might think. Darwin himself claimed that transmission across species was observable.[66] The rhizome may ultimately only *confirm* the argument for the parallels between cultural and biological evolution, and defenders of the phylogenetic method have argued that a sufficiently cali-brated phylogenetic tree can take into account convergence and transmission across lineages, whether biological or cultural.[67]

The claim for the priority of horizontal diffusion has been often made but seldom subjected to empirical examination.[68] Tehrani and Collard's research on central Asian textiles aims to undertake just such an examination in order not only to establish the value of phylogenetic analysis, broadly speaking, but also to ascertain the relative importance of, on the one hand, vertical trans-mission (phylogenesis) from one generation to another, and, on the other, horizontal borrowings between cultural groups (ethnogenesis). At the heart of their investigation is the mapping of the design vocabulary of Turkmen woven artifacts before and after 1881, the date when the Turkmen of central Asia came under tsarist rule. This involves constructing a phylogenetic tree of the textile designs associated with five closely related but distinct Turkmen cultural groups. The analysis involves a number of steps. The first is to com-pile a lexicon of recurring design motifs and then to record their presence/absence in each artifact. The results are then subjected to a "permutation tail probability test," using the principle of parsimony. In other words, a quanti-tative analysis converts the data into a cladogram based on the assumption that the greater the statistical convergence of motifs between different textiles, the more recent the bifurcation that marked them off from one another; and, conversely, the fewer correlations of motifs between individual examples, the earlier they diverged from a common ancestor.[69]

This technique has long underpinned the construction of phylogenetic trees for a wide variety of phenomena, from biological species to language families. Lineages can be reconstructed by ordering artifacts according to their

similarity, the assumption being that the more features they share, the closer they should be placed in the order, and, conversely, that the fewer they have in common, the further apart they should be placed on the phylogenetic tree. The rule of parsimony is crucial, too, since "this form of analysis identifies the cladogram that requires the smallest number of ad hoc hypotheses of homoplasy to account for the distribution of character states among a group of taxa."[70] In other words, the rule of parsimony attempts to take into account and distinguish between similarities that are the result of the vertical transmission of designs *within* an individual group and those that can only be explained as the result of borrowing from one of the other groups (homoplasy). The conclusion is that the history of Turkmen textiles can be explained primarily as the result of phylogenetic branching, rather than cross-cultural blending, which can only explain some 30 percent of the shared features. Even after the 1881 imposition of tsarist rule, which led to considerable social, political, economic, and demographic disruption, phylogeny remained the dominant pattern of transmission; intertribal borrowings increased, but still accounted for only 40 percent of the resemblances. In other words, while ethnogenesis played a part in the evolution of Turkmen textile designs, local cultural traditions transmitted from one generation to another remained remarkably tenacious and persistent.

The textile analysis yields a further notable finding, namely, that the pattern of phylogenetic inheritance in the case of Turkmen textiles is statistically similar to that for biological inheritance. Or, to quote Collard, Shennan, and Tehrani, "the fit between the bifurcating tree model and the cultural data sets is little different from the fit between the bifurcating tree model and the biological data sets. Not only are the averages similar, but also the ranges are comparable."[71] Analyses of other examples, such as Neolithic pottery or the material culture of New Guinea, show similar results.[72] The same three authors use the same technique to trace the evolution of Iranian weaving—in particular, the relations between the traditions of Turkic- and Iranian-speaking groups.[73] As with the other examples, phylogenetic descent turns out to have been more decisive than horizontal borrowings *between* groups.

This conclusion encounters an initial difficulty, however, for it contradicts accounts in written sources that suggest a far greater degree of cross-cultural transfer. This discrepancy need not be as problematic as might first appear, however, for while the groups studied are differentiated primarily by linguistic criteria, language use and ethnic identity are not necessarily to be equated. Languages are often adopted owing to political pressures; the cladograms thus indicate patterns of *cultural* transmission that continued regardless of the

linguistic affinity of the groups. Language use may change while other cultural practices persist, and vice versa. Moreover, given that traditions of weaving are passed from mother to daughter, the differences between oral histories and the pattern reconstructed by the cladogram may indicate the different histories of men and women: "there are often differences in the migration histories of males and females in these populations, which can occur as a result of some patrilines expanding into others' territories and then marrying with local females. The complexities of human genetic and cultural histories here and elsewhere mean that in most cases there will not be a single phylogeny for either populations or their traditions." This has wider implications, for it suggests that any one culture may be the product of multiple lines of phylogenetic descent, each relating to different aspects of the culture in question. As Tehrani, Collard, and Shennan conclude, "linguistic and ethnic identities are often based on a group's political affiliations, rather than its actual historical origins. . . . In the absence of genetic data, we cannot be certain that language and oral history provide an accurate reflection of group histories. Instead, they and the weaving traditions may represent different 'packages' of cultural inheritance whose descent histories differ from each other and from the 'true' population history of the tribes."[74]

CRITICAL ISSUES

The studies by Tehrani, Collard, and Shennan constitute sophisticated attempts to test the value of evolutionary models against empirical examples. The suspicion that the construction of phylogenetic trees produces drastically oversimplified and misleading accounts of cultural history is allayed by their acknowledgment of the work of interpretation that necessarily follows. In their work, a picture emerges of culture as a multilayered complex of practices that may have overlapping but also diverging lineages. Their analysis of Iranian textiles is also an important intervention into debates about the nature of cultural tradition, for it answers the charge that the image of the "Persian rug" as the product of an age-old continuous tradition is nothing but an Orientalizing fantasy about Islamic cultures.[75] Although the notion of a timeless culture remains a myth, their findings suggest that continuity may well be the definitive feature of cultural practices. The questions remain, however, whether the broader criticisms of evolutionary studies of culture can be countered, and, more generally, what benefits accrue from the adoption of this model.

There are a number of points for debate. First, the examples chosen to "test" the phylogenetic analysis tend to be highly delimited practices located in cultures that are known, historically, to have been largely sedentary. It is perhaps not surprising that Iranian and Turkmen weaving traditions of the nineteenth century, or native Californian basketry of the same period (to cite a similar study), show that vertical transmission within the same culture is dominant over horizontal diffusion across cultures. The attraction of such case studies is clear enough, in that they make it possible to work on a narrowly defined body of artifacts. Can broader conclusions be drawn from such examples? Would they be relevant to others, such as weaving in fifteenth-century Burgundy, for instance, where there is well-documented evidence of the cross-cultural diffusion of traditions, ranging from technical issues of manufacture to iconography, composition, and formal style?[76] And how would this model apply to more recent cases, such as Gothic revivalism in the nineteenth century, or the diffusion of impressionism or fauvism in the twentieth? Given what is known from historical sources about cross-cultural borrowings in such examples, the results of a permutation tail probability test are likely to differ considerably from those generated for the Turkmen case. Hence, even if one accepts that there are statistical correlations between cultural inheritance and biological evolution in the cases analyzed, it is a considerable leap to transform such results into a generalizable thesis about cultural development. Instead, they might merely offer important caveats for those who deny *any* correlation between the two. There are, however, more fundamental issues at stake, and they concern assumptions about values and method.

Those who have argued most strongly for the adoption of the principles of evolutionary biology in the study of culture have based their claims on the notion that they provide a scientific rigor significantly lacking in the traditional humanities. As Mesoudi, Whiten, and Laland have claimed, "The purpose of this comparison is primarily to stimulate a more progressive and rigorous science of culture. Although evolutionary biology has become enormously productive since Darwin's theory of evolution was formulated, the discipline that professes to be most directly engaged in the study of culture—cultural or social anthropology—has been much less demonstratively productive over the course of the same time period, particularly in terms of establishing a secure body of data and theory."[77] Others have made similar assertions, with the implicit claim that the arts and humanities, with their preference for qualitative interpretative explanations, are weakened by the absence of a properly "scientific" method.[78] Such claims are strongly wedded to notions of scientific exactitude, in which the purpose of inquiry is to establish quantifiable data.

Mathematical formalization was central to the work of Boyd and Richerson and Cavalli-Sforza and Feldman, and the arguments of Tehrani, Collard, and Shennan revolve around the statistical data generated by their analysis.

The ideological investment in this position is visible in the tenacity with which its exponents promote and defend it. As one of them has written, "deviations from the biological case such as this do not necessarily invalidate an evolutionary approach to culture; they merely require novel treatments of cultural phenomena within a general evolutionary framework."[79] In other words, rather than bring the framework into question, the failure of cultural practices to fit into the model suggests the need for adjustments to ensure that they do. Tehrani and Collard produce a battery of statistical data to support their arguments, but the process is based on the identification of a lexicon of visual motifs that is itself not scientifically determined. No judgment is made, for example, about whether any specific decorative motif is more significant than any other, and whether it should consequently be given some kind of "weighting" within their method. Furthermore, the phylogenetic method exhibits the same atomistic view of culture as Dawkins's meme theory. In this respect, it is comparable to the positivistic iconography of authors such as Émile Mâle, who conceived of the method as an encyclopedic documentation of symbolic motifs but without any interpretative analysis of their significance in individual works.[80] Thus visual motifs are quantified in isolation, with no thought for whether a particular *combination* of motifs may be of significance. It is hardly revolutionary to state that innovation in art and design often consists of novel arrangements and configurations of *existing* symbols, which lend them new aesthetic and semantic significance. Equally, the introduction of new items into the visual lexicon can give a false impression of change, when underlying compositional arrangements in fact persist. The phylogenetic method has no means of capturing such nuances, since they are not easily reducible to quantifiable data. Moreover, the interpretation of the data by Tehrani and his collaborators draws on a wider range of "nonscientific" approaches, including gender studies, political history, sociolinguistics, and anthropology, which reflects the fact that at a certain point the evolutionary method has to give way to other approaches.

A similar criticism can be made of another, better-known application of this method: Franco Moretti's analysis of literary survivals. Moretti sought to apply quantitative and cartographic methods of analysis to the understanding of literature, involving the presentation of information about the novel in the form of graphs and maps.[81] His attempt to use phylogenetic methods is of most interest for the present discussion, in particular, his vision of literary history

as driven by the process of variation, selection, and survival/reproduction. The imperative is to "take a form, follow it from space to space, and study the reasons for its transformations: the 'opportunistic, hence unpredictable reasons of evolution.'"[82] Moretti has subsequently restated his aim in reference to the idea of world literature, describing it as a "theory that takes as its central problem the multiplicity of forms existing in the world; that explains them as the result of historical divergence, and that bases their divergence on a process of spatial separation: here is what evolutionary theory has to offer to literary history. Many different forms, in a discontinuous space: not bad, as an idea of world literature."[83]

Moretti has famously analyzed the detective novel using this method, attributing the evolutionary success of Sherlock Holmes to Conan Doyle's use of the clue as a trope, and in particular to the combination of rendering clues necessary, visible, and decodable parts of the plot. In contrast, he argues, Doyle's competitors in writing detective fiction, such as Guy Boothby, Clifford Ashdown, and Catherine Pirkis, either failed to incorporate clues or used them in less skillful ways.[84] Yet the use of clues in detective novels as the basis for determining evolutionary variation and selection may be little more than an ad hoc construction.[85] While Conan Doyle's specific treatment of clues may be a *possible* explanation for the success of the Sherlock Holmes novels, clues are not the only possible candidate for the mapping of differences and survival. It is instructive to compare Moretti's account with that of Ernst Bloch, who identifies other features as central to the genre. Bloch acknowledges the rise of evidentiary criteria—clues—as a distinctive aspect of modern criminal investigations, but he argues that detective fiction is oriented around three interrelated themes: "the suspense associated with guessing," "unmasking and discovering," and the "bringing to light of the pre-narrative or unnarrated state" (i.e., the murder that took place outside the narrative itself).[86] Clues are just one element of detective fiction, and it may be that the success of Conan Doyle was as bound to these and other factors—including, most obviously, the compelling nature of Holmes as the central protagonist—as it was to Moretti's chosen point of comparison. Moreover, while an essential aspect of Holmes's character is his ability to reach conclusions inductively on the basis of clues, for Hercule Poirot, as successful an example of detective fiction as the inhabitant of Baker Street, detection is a matter of intuition, rather than the inductive method associated with Holmes.

The issue of atomism surfaces again. By focusing solely on one "variable," the evolutionary method is blind to the possible significance of the way the use of clues is combined with other devices and themes. Bloch's counterexample

suggests this clearly, for it suggests that it is the *relationship* between suspense, dénouement, and disclosure of the prenarrative murder that may be decisive, not any one of them on its own. The point here is not to become embroiled in a debate about the construction of detective fiction but to highlight the arbitrariness of Moretti's decision to choose clues as the organizing principle of phylogenetic analysis. This criticism does not in itself devalue the method per se, but it does question the scientific status that proselytizers of evolutionary methods claim. The method of analysis, for all its rigor, cannot be used to justify or support the object choice underlying it. This point recalls the earlier criticism of Tehrani, Collard, and Shennan; the allegedly scientific method is no less (and no more) arbitrary than an analysis based in the qualitative approaches of the humanities.

Finally, although Tehrani, Collard, Mesoudi, and others avoid the central Darwinian theme of adaptation and natural selection—in its place they substitute mechanisms of *cultural* selection—the strength of the claim that the biological model should be the basis for analysis of cultural transmission must rest on the pertinence of adaptation. Otherwise, the idea of cultural evolution amounts to little more than a vague analogy and a means of constructing a positivistic map of artistic or cultural development. The previous chapter explored the difficulties associated with the idea of adaptation in relation to aesthetic values; similar problems arise when it is deployed in relation to the phylogenetic analysis of larger-scale cultural and social phenomena.

Few have offered such an account, but it is central to one of the most ambitious attempts to devise a Darwinian social theory: that of Walter G. Runciman. In *A Treatise on Social Theory*, Runciman attempts to construct an evolutionary historical sociology based on the core claim that the driver of social and cultural development is competition between social practices that take place within specific bounded environments.[87] "The proper starting point," he claims, "is, rather, the unarguable proposition that social evolution is historically continuous with biological evolution. . . . There must be a psycho-physiological repertory by which the range of behavior of the human species as such is both made possible and also constrained. . . . Societies as we find them [are] the outcome of some kind of process of competitive selection."[88]

This theory is grounded on the claim that cultural traits are adaptive or maladaptive, and Runciman examines sociohistorical innovations—or "mutations," to employ his evolutionary terminology—and measures their "fitness" or "adaptedness" to the particular environment. The adoption of the *pantalon rouge* by French infantry in the nineteenth century, for example, was adaptive, in that it produced an *esprit de corps* that generated group loyalty in the

army. Later, in the First World War, the very same practice turned out to be maladaptive, making French infantrymen easy targets for German machine gunners. This led to a quick change in the uniform, to a more "adaptive" design that made French soldiers less visible to the enemy. Likewise, military drill, which according to Runciman evokes a universal biologically evolved aptitude for rhythm, is an adaptation that permits formations of soldiers to fight in a more effective, coordinated manner.[89]

There is an affinity here with functionalist design theories, and such individual examples may or may not be persuasive, but the *general* difficulty is that any number of practices could be read as adaptations or maladaptations; indeed, *any* cultural practice, by virtue of the fact that it endured over a period of time, can be argued to have been adaptive. Equally, it is always possible to identify *something* by virtue of which a particular cultural practice can be argued to have been adaptive. Similarly, the fact that most cultural practices change—and even vanish—over time would mean that *all* cultural practices can potentially be labeled maladaptive, a point that in its universality explains very little. To return to the example of military drill, it has served many purposes, few of them linked to the practicalities of fighting; drills have more to do with the rhetoric of bodily display. The rushing pace of French military drill was intended to connote dynamism and energy in battle; the British army, in contrast, cultivated slower and more measured drill to communicate self-control and discipline. The body-contorting marching and ceremonial style favored by the Soviet armed forces was meant to convey acrobatic vigor, while the goose-step of the Nazi regime signified strength and virile dominance. These examples, and there could be many other types of military drill, go far beyond the basic idea of a biological attunement to rhythm to suggest the different communicative functions it has had in specific cultures.

We can link the example of military drill to the study of art if we take a specific example: Nazi aesthetics.[90] The Nazi regime mobilized a variety of archaic ideological artistic formations—including the promotion of "völkisch" architectural forms, sentimentalized genre painting, and a pared-down terroristic classicism. Should these be regarded, as Runciman suggests, as a final "flash in the pan" of memes about to be selected against, or as a cultural mutation? Moreover, what does it mean to refer to Nazi aesthetics as a "mutation"? In the case of biological evolution, it is easy to define mutation as an error in the copying of a gene. But since cultural traditions are transmitted but not "copied," it is not helpful to talk of innovations as "mutations." One can widen the focus to consider other art-historical examples. How might one describe the relationship of Manet's *Olympia* (1863), for example, to Titian's

Venus of Urbino (1538)? Is Manet's painting a mutation in a tradition of faithful copies of the Titian painting, which could be regarded, perhaps, as a prime object? If so, where is the tradition of nonmutated copies? The weakness of the analogy lies in the fact that *every* work that draws on the *Venus of Urbino* is an *interpretation*, not a replica; thus every work would have to be regarded as a mutation. The same can be said of Titian's painting itself, which could be described as a mutation of Giorgione's 1510 painting *Sleeping Venus*. At this point, the notion of mutation becomes emptied of meaning.

∼

The attempt to map the evolution of a practice is the latest in a long tradition of thinking that, as Reinhart Koselleck has argued, goes back to Thucydides.[91] Specifically, it operates on the basis of a distinction between the immanent material forces of nature and the space of historical experience. Its logic is based on the assumption that history is governed by nature; there may be historically variant practices, a co-presence of the noncontemporaneous, but they still obey the law of biological evolution. This notion appeared early in the historiography of art in Winckelmann's schema of the cycles of art and the inevitable growth, maturation, and decay of artistic styles.[92] The reluctance of scholars of the humanities to embrace evolutionary models stems in part from the fact that they resemble a throwback to that earlier stage of historiographic thought; they run counter to the generally held view that history is "no longer deducible from natural conditions" but instead comprehends the "interdependence of events and the inter-subjectivity of actions."[93] The evolutionary model overlooks the point that while a view of history focused on events (in art-historical terms: individual works of art) is myopic without a concept of structures, giving due place to those structures cannot come at the price of erasing the singularity of the individual event or practice. To continue the Kantian analogy, preoccupation with structures and patterns runs the risk of empty formalism; to discern the enabling conditions of a particular phenomenon or event does just that and no more. To quote Koselleck again, "the before and after of an event contains its own temporal quality which cannot be reduced to a whole within its longer-term conditions. Every event produces more and at the same time less than is contained in its pre-given elements: hence its permanently surprising novelty."[94] This point parallels Baxandall's distinction between treating a work of art as the historical document of an action—the latter being the main focus of attention—or as an artifact that is itself a historical agent whose effects are the subject of analysis.

When a new method or approach demands attention, it is reasonable to ask whether it generates new insights. Does it provide new interpretations, and

does it lead to reflection on and revision of the objects of study? Art history provides numerous examples of such fundamental innovations; postcolonial theory has completely redrawn the map of art, provincializing Europe and displacing it from the central place it once occupied; feminism and Marxism not only introduced new methods of interpretation but also presented fundamental challenges to the value judgments sustaining art-historical inquiry. It is a moot point whether evolutionary accounts contribute similarly to questions of object choice and value. There has been no reassessment of the object domain of art history (or of any particular discipline in the humanities). The analysis of longer-term patterns of behavior or of formal configurations helps little in the exploration of meanings and relations that are so central to the cultural and social functions of art. This is evident in the extent to which many of the authors discussed here have resorted to auxiliary theories to introduce interpretative nuance to their statistical data.

But it would be misguided to dismiss such analyses out of hand. Although vulnerable to a number of criticisms, Tehrani, Collard, and Shennan, for example, raise potentially important issues about the nature of cultural transmission and artistic tradition that may have wider validity beyond their chosen cases. Although open to critical scrutiny, they have also devised a method for subjecting wide-ranging claims about cultural diffusion to some kind of empirical examination.

It nevertheless remains to be proved that the evolutionary approach can or should *displace* traditional research in art history. Some of its most prominent exponents have argued that it should, adding that the reluctance of humanities scholars to embrace the new paradigm is due to an ideologically motivated disdain for the natural sciences. In some instances this may be so, but there are other good reasons for such resistance. Aside from the reservations articulated in this chapter, perhaps the most significant reason is that the evolutionary model does not address the kinds of questions that are of interest to scholars of the humanities in general and, more specifically, of art history. The concern with constructing diachronic lines of genealogical descent has long ceased to be a central topic of inquiry in the art-historical profession. Georges Didi-Huberman, drawing on the work of Aby Warburg, has attacked the model of history implicit in this approach. Warburg's interest in the transhistorical and transnational migration of images undercuts the model of an orderly art-historical succession by offering the prospect of an "impure" time of images governed by the unpredictable survival (*Nachleben*) of images. As Didi-Huberman states, "the concept of *Nachleben* should transform our idea of tradition. No longer imaginable as an unbroken river, where accruals are

carried from up- to downstream, tradition should, after Warburg, be conceived as a tense dialectic, a drama that unfolds between the river's flow and its whirling eddies."[95]

This comment may exemplify what advocates of evolutionary theory dismiss as mere rhetorical assertion, yet Warburg himself offered numerous empirical studies of the circulation of images that could not be fitted into the neat order of a phylogenetically constructed tree or lineage. This will continue to be a subject of debate, but it highlights the fact that evolutionary accounts are often an answer to a question or set of questions that are of little use to most researchers in art history in particular and the humanities in general. The basic question remains whether evolutionary theory offers a new answer to traditional questions, or whether it attempts to dictate the kinds of question it is legitimate to ask in the first place.

BRAINS, CAVES, AND PHALANXES

Neuroaesthetics and Neuroarthistory

Between 1990 and 1999, the Library of Congress and the National Institute of Mental Health sponsored a variety of activities and publications to coincide with President George H. W. Bush's declaration, in July 1990, that the 1990s would be the "Decade of the Brain." Presidential proclamation 6158 declared the vital importance of promoting research on the brain as a means of investigating a wide range of disorders ranging from degenerative conditions such as Alzheimer's to such other afflictions as schizophrenia, autism, and speech impairments. The prestige of brain research has continued to grow since then, with neuroscientific discoveries the focus of widespread interest far beyond the world of professional science.

Given its enhanced status, it is hardly surprising that there has been lively interest in the potential contribution of neuroscience to the understanding of art and the aesthetic. Since the 1990s, two related fields, neuroaesthetics and neuroarthistory, have gained increasing prominence. Claiming to be able to identify neural processes underlying aesthetic response, as well as the brain structures involved in creative practice, these new fields can be seen as one more attempt to bridge the division between the arts and science.

Neuroaesthetics and neuroarthistory take many forms. Some cases consist of general speculative accounts that attempt to link cultural practices to

their putative material neurological base.[1] Personal formative development, for example, is rooted in the phenomenon of brain plasticity that was popularized by Gerald Edelman in the 1990s.[2] Others have advanced more specific theses. Ellen Spolsky, for example, links the allegedly modular nature of intelligence to the "configurations of neural connections" and "brain pathways" that make up the discrete systems of the brain and perception.[3] Still others have tried to devise a program of empirical aesthetics and art history that includes reliance on neuroscientific experimental data, including data garnered from functional magnetic resonance imaging (fMRI) scans.[4]

Neuroscience has revolutionized medical and psychological research, but it remains an open question whether the same can be said for neuroaesthetics and neuroarthistory. This question impinges on two issues, one philosophical and the other methodological. The philosophical question concerns physicalism and the relation between the body—specifically, the brain—and the mind. The methodological question is whether, even *if* the physicalist thesis is accepted—in other words, even if consciousness *can* be traced back to the brain—that knowledge can make an insightful contribution to the understanding of art.

This book is not an inquiry into the philosophy of mind and, for perhaps obvious reasons, this chapter does not intervene in this philosophical debate. Rather, its focus is on the *significance* of various theories of mind, and in particular of neuroscience, for aesthetics and the history of art. Neuroscience has been used in discussion of a wide range of examples, from prehistoric art to Renaissance architecture, from the works of Constable to the paintings of Ad Reinhardt. In all of these cases, the question is: what changes in our understanding of artistic practices occur when we consider the findings of neuroscientific investigations of the mind? The remainder of this chapter is an attempt to answer just this question.

ORIGINS: THE BRAIN IN THE CAVE

In 2013, the British Museum staged the exhibition *Ice Age Art.*[5] It was one of the most ambitious displays ever organized of Paleolithic art. The Venus of Willendorf may not have been on display, but with other well-known examples of prehistoric sculpture, including the "oldest known portrait of a woman," its absence hardly detracted from the exhibition's impact. As one observer noted, "not the least truth of this great exhibition is that art arrives in the world fully formed. Potent, subtle, imaginative, brilliantly skilled: ice age art stands equal with what follows."[6]

Debates over the concept of prehistoric "art" notwithstanding, the skills of its makers have compelled most modern viewers to wonder in astonishment at its aesthetic qualities. The British Museum did little to discourage such a response; the artifacts were displayed in carefully lit cases that heightened their visual impact. However, the most important aspect of the exhibition was its attempt to advance an argument about the role of prehistoric art as a measure of human neurological and cognitive evolution. The subtitle of the exhibition, *Arrival of the Modern Mind*, made this clear, for it exhorted the visitor not merely to admire the exhibits but also to understand them as visual indices of the emergence of a new structure of cognition that was, in its basic outline, indistinguishable from that of contemporary humans. This claim was not new in itself; Steven Mithen had already put forward a similar argument in his study of the origins of human creativity, *The Prehistory of the Mind*. The exhibition was, however, the first time that such ideas were conveyed to a wider public.

The exhibition and writings by authors such as Mithen are the latest in a long line of attempts to interpret prehistoric art, its function, and its origins. Local histories and antiquarian writings had documented these curiosities since the fifteenth century, and by the late 1800s prehistoric art had become the object of sustained attention following the discovery of significant numbers of cave paintings in Spain and France.[7] Initially greeted with considerable skepticism—for many, the paintings' naturalism meant that they could only be modern forgeries—the discoveries of further cave sites, culminating in Lascaux, in 1940, made such views less and less tenable. The cave paintings posed significant interpretative conundrums, for they contradicted the widespread belief that art of such antiquity should be more obviously "primitive."[8] A further issue was the assumption that the origins of art lay in ornament and decoration. A long philosophical tradition from Friedrich Schiller onward had held that the "propensity to ornamentation and play" is one of the "visible signs of the savage's entry into humanity."[9] Gottfried Semper, too, described ornament as the most basic artistic form and as the expression of a fundamental instinct: the impulse to decoration.[10]

In the face of the contradictory evidence of Paleolithic cave paintings, numerous alternative interpretations were proposed. One was that prehistoric art was the sign of an aesthetic sensibility that had emerged following attainment of a certain level of material well-being; it reflected a Paleolithic cult of *l'art pour l'art*, wrenching prehistoric humanity out of the grasp of animal immediacy and dreary work.[11] An alternative viewed prehistoric art as linked to religious and magic practices. The images of bison, antelope, and horses

were totemic representations that gave a clue to forms of prehistoric social organization and religious practice.[12] This view, dominant for much of the twentieth century, also proposed that the images were magical instruments; animals were painted to ensure success in the hunt and to evoke magical powers of control over them.[13] A further explanation was advanced by André Leroi-Gourhan, who stressed that the animal figures were organized around a binary masculine/feminine opposition, an arrangement that suggests that they were emblems of a prehistoric metaphysics.[14]

A more recent interpretation, and one of particular interest for the present discussion, is that the images were intimately linked to prehistoric shamanism. Its principal advocate is David Lewis-Williams, whose early research was concerned with San rock art in South Africa, and who has subsequently seen parallels with the Paleolithic imagery of southwestern Europe.[15] Lewis-Williams propounds this thesis in numerous publications, but it is his 2002 book *The Mind in the Cave* that has garnered the most attention.[16] The thesis is pertinent because he grounds his argument in certain assumptions about the brain, perception, and the relation between the brain and visual representations. It therefore provides a useful point of entry into the wider discussion of neuroaesthetics and art history.

Lewis-Williams identifies notable commonalities between San rock art and the paintings of Lascaux, Altamira, and other European sites. Most obvious are the images of animals, which, he argues, seem to be generated by states of altered consciousness associated with shamanism. The use of the rock surface as an integral element of the imagery is also a common feature. The bison, deer, and horses are thus not depictions of prey to be caught in the hunt, he argues, but representations of dream animals belonging to another world to which the shaman has exclusive access. In support of this thesis, Lewis-Williams points to the ethereal quality of the figures; they are not placed in any identifiable setting and appear to enjoy a completely free-floating existence: "These characteristics are exactly what one would expect of projected, fixed mental images that accumulated over a period of time. Mental images float freely and independently of any natural environment."[17] The cave surface is a membrane between this world and another, or a portal to this other world, hence the interest in its physical features as elements of the images. Numerous handprints on the cave walls demonstrate, too, the special significance accorded to physical contact with the rock surface. Rather than revealing an interest in the depiction of hands, these prints are the traces of a practice in which hands touching the wall were "sealed in" with paint to ensure contact with the spirit world.

In addition to the depiction of animals, there is a striking parallel in the use of abstract designs, which are broadly similar across all sites, from South Africa to Spain, and which, Lewis-Williams argues, seem to correspond to geometric mental percepts. This observation touches on Lewis-Williams's interest in neurological explanations, but before examining that aspect of his argument in detail, it is necessary to consider some of the broader difficulties with his account, for it depends on a number of questionable assumptions. The parallels he draws are reminiscent of nineteenth- and early twentieth-century ethnographers' view of contemporary small-scale societies as preserved fossils of earlier stages of human development. They thereby resonate with the colonial associations of the earlier concept of prehistoric art, which understood it as an exotic species of "primitive art."[18] This observation does not in itself discredit Lewis-Williams's account, since it could be right *even if* it has uncomfortable ideological overtones. However, doubt may be legitimately expressed when it becomes apparent that his interpretation of San rock art is based not on firsthand evidence but on the testimony of European observers of the 1870s, the linguists Wilhelm Bleek and Lucy Lloyd.

Like much theorizing about prehistoric art, the work of Lewis-Williams is also highly speculative. As he acknowledged, speculation is in some sense unavoidable, for it is difficult to identify *any* empirical evidence to support an interpretation. While the ongoing discovery of additional archaeological data has yielded valuable insights into the techniques of image production, this alone cannot explain the possible meanings and functions of prehistoric images. It is the argument that Lewis-Williams used to defend his thesis of shamanism that merits the most interest, however, for it rests on the claim that shamanic practices involving trances and altered states of consciousness have a universal character, in that they are the product of a basic human neurological inheritance. This "includes the capacity of the nervous system to enter altered states and the need to make sense of the resultant hallucinations within a foraging community. There seems to be no other explanation for the remarkable similarities between shamanic traditions worldwide."[19]

In order even to *begin* arguing about whether these images were tools of Paleolithic shamanism, Lewis-Williams has to be able to show that the latter was comparable to historically attested instances of shamanic practices, and it is the putative relation to basic neural processes that allows him to claim that shamanism is a universal and transhistorical phenomenon. His account then develops into a broader set of propositions about art and the human brain. He fits a number of phenomena into this framework. For example, he highlights the prevalence of abstract marks in the cave paintings, such as striated parallel

lines, dots, zigzags, and grids, which seem to bear no relation to the animal figures and which have mostly been overlooked by other scholars. These are, he argues, visual records of "entoptic phenomena" and are of crucial significance to his claim that the parietal imagery can be interpreted in the light of universal features of human cognition.

The term "entoptic phenomenon" was originally coined by Hermann von Helmholtz to denote visual effects produced by the physics of the eye.[20] Lewis-Williams employs it in slightly modified form, however, to refer to visual experiences, raw, uninterpreted percepts that are produced by altered states of consciousness rooted in the brain. Some of these are culturally mediated, but at a basic level, he argues, they are the outcome of neurological functioning and therefore are universal. The abstract patterns and shapes of Paleolithic art are, accordingly, the visual transcripts of basic neurological processes. To substantiate his point, Lewis-Williams refers to laboratory experiments with contemporary Western subjects who experienced phenomena comparable to those transcribed in the cave paintings of southwestern Europe or the rock art of South Africa. He builds on this notion by proposing a scale of imagery ranging from basic neural percepts, to images that are interpreted as related to familiar objects, ideas, and emotions, and, finally, to iconic representations of recognizable phenomena from everyday experience. A central part of Lewis-Williams's account is thus the idea that Paleolithic images are documents of a range of subjective states, from dreams to trance visions induced by psychotropic substances.

A NEUROLOGICAL REVOLUTION?

Lewis-Williams offers an original thesis and tries to embed it in a theory of human neurology and cognition, rather than relying on the vague ethnographic analogies deployed by previous interpreters. He thus has much in common with the theorists of evolutionary psychology discussed in the previous chapters. Earlier commentators explained prehistoric art by reference to religious and magical ritual, but they failed to explain why it emerged when it did. In other words, why did human beings experience what one influential commentator has called a sudden "creative explosion" around thirty-five to forty thousand years ago?[21] For Lewis-Williams, the decisive shift was not the invention of images but the evolution of the capacity for mental imagery. Paleolithic art marked a decisive evolutionary advance in human cognition and the brain: the development of higher-order consciousness. In particular, he suggests, cave

art was the expression of a newly acquired capacity to reflect on and interpret the meaning of such conscious experiences. In other words, "recognition by a thinking subject of his or her own acts or affections" embodies a "model of the personal, and of the past and future as well as the present."[22] The absence of comparable imagery from earlier periods indicates that before the creation of the cave paintings, human cognition stood at an earlier evolutionary stage. Others have likewise attempted to ground analysis of Paleolithic art in brain science.[23] Barbara Olins Alpert, for example, has argued that the paintings of Chauvet and the prehistoric sculpted figures of central Europe have aesthetic resonance today because they are the product of a modern brain. In this, there is a crucial distinction with the brain of Neanderthals. The common image of Neanderthals as primitive creatures who became extinct once they had to compete for resources with the modern humans who arrived in Europe forty-five thousand years ago has been corrected thanks to recent archaeological finds that indicate a level of cultural sophistication not previously acknowledged.[24] It has even been suggested that Neanderthals had a musical capacity superior to that of the modern humans who replaced them.[25]

What differentiated the two species is that while Neanderthals had a domain-specific intelligence, unlike modern humans they were not able to combine different domains.[26] This distinction is based on the now familiar metaphor of the modular mind of evolutionary psychology.[27] As Mithen and others have argued, while hominids developed a modular intelligence, the evolutionary breakthrough of modern humans was to be able to connect the different domains of intelligence, something Neanderthals never achieved.[28] The ability to combine such different domains of intelligence allowed modern humans to draw analogies and make metaphors, and gave them the capacity for reflection, self-awareness, and what Dan Sperber has termed "metarepresentations," in other words, the ability to have a concept of the mental representations of others.[29] Crucially, this ability to combine distinct domains of intelligence underlies artistic production too, which involves a combination of technical, communicative, and symbolic cognition.

Such cross-domain capacities have also been seen as connected to the rise of shamanism, but before examining the shamanic proposition, it is important to note that the notion of the modular mind is itself contentious and much disputed.[30] Ironically, one of its foremost critics has been Jerry Fodor, who advanced the theory in the first place. His objection is that while *aspects* of human cognition may be modular, this is far from stating that the human mind is completely, or "massively," modular. The latter theory, he argues, cannot explain "how the mind manages to represent things in ways that

determine which modules get excited."[31] To use a much-discussed example, Leda Cosmides and John Tooby argue for the existence of an evolved cheat-detection module that enables an individual to know when others engaged in social exchanges are doing so dishonestly.[32] The problem with this idea is that in order to mobilize the module, it is necessary first to determine that a specific situation is a social exchange rather than something else, and this is something that neither a social-exchange module nor a cheat-detection module can determine itself. Equally, Fodor argues, it is not entirely clear what "general intelligence" is, in contrast to the modular mind of the prehistoric ancestors of modern humans, or indeed what the idea of "combining" distinct domains really means.[33] But Fodor does not go far enough, for if the mind is conceived as modular, then there is no default form of cognition against which the "cheat-detection" module could be set. Consequently, there would have to be separate "sincerity-detection" or "honesty-detection" modules, or indeed "irony-detection" and "parody-detection" modules, since all kinds of social interactions are, according to the theory, linked to the development of specific modules, and even basic forms of social interaction, such as winking (to use a much-cited example), are open to multiple interpretations as to their purpose.[34] The possibilities for arbitrary proliferation and ad hoc identification of putative modules are clear, as are the absurdities of some of the implications of the theory, for one would have to show that each form of interaction bestowed an evolutionary advantage.

In addition to criticisms of its theoretical presuppositions, the ethnographic validity of Lewis-Williams's thesis is also questionable. One area of debate has been the use of the very term "shamanism." Although it is often upheld as a cross-cultural practice, many have contested its validity, for while many cultures globally may have practiced shamanism at some time in their history, this does not justify concluding that all do, or indeed that art in cultures that practice shamanism is about shamanic experience.[35] Furthermore, while, cross-culturally, shamanism may be based on trance experiences and other altered states of consciousness, their meaning must be read in the context of specific cultural mythologies and cosmologies.[36] Apart from the question of whether a diverse array of practices and beliefs can be subsumed under the general term "shamanism," we need to determine whether shamanism really does involve induced states of altered consciousness.[37] Not only are there few instances of shamanic practice that include the ingestion or inhalation of drugs, but a shamanic "trance" is frequently a performance in which the shaman behaves *like* an animal and *acts out* a variety of encounters with animals.[38] This last point is of central significance, for it undermines the argument that

Paleolithic rock art provides a record of neurological states; even if that art *is* connected to shamanism, it may simply be linked to shamanic performance.

In the context of the current discussion, perhaps the most pertinent debates relate to the use of neuroscientific data and ideas, because this has been equally disputed. Little evidence has been adduced to support either the model of altered consciousness or the account of entoptic phenomena that are central to the theory.[39] It has even been suggested that the abstract geometric figures to which Lewis-Williams attributes pivotal significance may be little more than doodles.[40] Yet despite such objections, the thesis continues to attract adherents.[41] Jill Cook, the curator of *Ice Age Art*, expresses caution about the shaman argument, noting that it may be "as specious as comparisons with Greek mythology," but she exercises no such hesitance in adopting the broader neurophysiological framework. Regarding the famous "lion-man" figurine found in Hohlenstein-Stadel, for example, she states that the significance of this piece is its hybrid form, "indicative of a mind capable of imagining new concepts rather than simply reproducing real forms. . . . Such a mind must indicate the activity of a complex super brain like our own, with a well-developed pre-frontal cortex." A "simple mental image of a person or cat does not necessarily require a pre-frontal cortex, but it is essential to conceive a part human–part animal representation. From the start the universal laws of art devised by neuroscientist Professor Vilayanur Ramachandran are in use."[42] Leaving such putative laws to one side, it is worth recalling that hybrid figures of the kind instantiated in the Hohlenstein-Stadel figurine are open to quite different interpretations. In his *Lectures on Fine Art*, Hegel, for example, dealt with the phenomenon of hybridity in Indian and Egyptian art but regarded it as illustrating that they stand at the threshold of rational thinking, in which the Idea remained dialectically *undetermined*; nature and humanity had not been disentangled. "In their confused intermixture of finite and Absolute, therefore, since the order, intelligibility, and fixity of everyday life and prose remains totally disregarded, [the ancient Indians] fall, despite all their exuberance and magnificent boldness of conception, into a monstrous extravagance of the fantastic which runs over from what is inmost and deepest into the most commonplace present in order to turn one extreme directly into the other and confuse them."[43] Hegel was operating in a specific and distinct philosophical framework, of course, but his point stands that the Hohlenstein figure is open to an entirely different reading, one that stands completely at odds with some basic assumptions about its role as a visible symbol of the evolution of cognition.

The methodological limits of the neurological framework merit closer inspection, for it is apparent that the neurological approach is not able to provide

a history of prehistoric art *after* the evolutionary leap of the modern mind. For all its referencing of a neurological shift, *Ice Age Art* in fact demonstrates the reverse: a slow development from crudely incised marks to decorative schemes of increasing technical, aesthetic, and conceptual sophistication.[44] Indeed, others have mapped out the development of figurative representation over thousands of years, from roughly drawn and carved depictions to artistic masterpieces, which has even led some observers to identify prehistoric period styles.[45] The neurological model offers no framework for analyzing *those* features. Rather, it provides at best an explanation for the *emergence* of figurative representations. In other words, it is tailored to account for a singular historical phenomenon that was intimately coupled with a specific evolutionary event: the development of the modern mind. While the formation of the modern mind—and of its ability to combine domain-specific intelligences—*may* provide a convincing explanation for the appearance of sophisticated figural representations, it does not identify the relevant factors that drove the subsequent iconological and formal development of prehistoric art during the following millennia.

The neurological explanation may be even more limited in scope than this, however, for many of the characteristics it points to are specific to cave paintings in France and Spain, rather than to the mobile art of the kind exhibited at the British Museum. If this restriction is accepted, it raises more profound doubts about the assumption that Paleolithic art is the document of an evolutionary shift. First, if the thesis is really about art in a specific geographical locale, then it cannot possibly be about an event of species-wide significance, and must be interpreted instead as a cultural innovation that spread through various processes of diffusion. Whatever they may have been, these processes would then have had nothing to do with the species-wide evolution of the brain. On the other hand, if there was a creative explosion simultaneously and on a global scale, this is equally unlikely to have been a matter of evolutionary significance, because it is highly improbable that the brains of different human populations dispersed across the landmasses of Eurasia and Africa would have evolved in the same way at the same time. Indeed, if working in a Darwinian framework, one would expect diversity rather than uniformity, given such geographical dispersal and the different environmental pressures in the locations where such art has been discovered. If, by contrast, the creative explosion *is* to be understood as an evolutionary event, it would have to be placed much further back in history, to the time *before* humans exited the African continent. This, of course, predates the cave imagery and rock painting by a hugely extended period, and it is difficult to

posit a causal link between the evolution of the brain and the genesis of image making. Finally, substantial archaeological evidence suggests that, globally, the origins of symbolic mark making and representation can be traced as far back as 300,000 B.C.E.[46] At first glance, this might make the link with cognitive evolution plausible, except that the kind of mark making in question—simple incised patterns, lines, and dots—is very different from the cave painting of southwestern Europe. The whole idea of a creative explosion is thereby rendered questionable, given that what is really at stake is a process that may have occurred over a period of more than a quarter of a million years.

A NEUROLOGICAL ART HISTORY

The thesis of the origins of Paleolithic art is part of a larger embrace of ideas about brain development by art historians and theorists. Of particular interest has been the discovery of so-called mirror neurons. Clinical experiments in the 1990s suggested that the brain activity in monkeys observing the actions of others was exactly the same as that in the monkeys performing the tasks.[47] Action execution and action observation appeared to involve the firing of exactly the same neurons; these neurons "mirrored" in the observer those of the executor. These experimental results have been used in the analysis of two interrelated categories: mimesis and empathy. An important exponent of this approach has been David Freedberg, who has collaborated with Vittorio Gallese, one of the scientists who first postulated the existence of mirror neurons. In an earlier study of image response, *The Power of Images*, Freedberg noted the array of different historical forms of emotional engagement with images that surpassed that of the idealized dispassionate and disinterested spectator of the aesthetic tradition. Freedberg's historical analysis was largely empirical and lacked any theoretical framework, and he and Gallese have since used neuroscience to provide what was missing in his earlier work. Their basic thesis is that empathic engagement, the situation in which "beholders might find themselves automatically simulating the emotional expression, the movement or even the implied movement within the representation," reflects the workings of mirror neurons.[48] Basic mechanisms are triggered by the viewing of artworks that offer "visible traces of goal-directed movements" such as gestural brushstrokes, dripped paint, and finger marks on sculptures. Empathy is thus a kind of involuntary embodied simulation, a formula that can also be used to explain artistic mimesis. The implications of this idea are amplified in a subsequent clarification of their original article in which Gallese

and Freedberg not only reiterate that empathy is an automatic process but also claim that "no esthetic judgment is possible without a consideration of the role of mirroring mechanisms in the forms of simulated embodiment and empathetic engagement that follow upon visual observation. . . . Such processes might be precognitive and not always dependent on perception informed by cognition and cultural stock."[49]

In an article on Franz Kline, Freedberg and his collaborators provide an illustration of the application of this method. The article examines the brain activity of observers of paintings by the abstract expressionist, and compares it with the brain activity of observers of "modified" versions of Kline's works, in which the dynamic, expressive brushstrokes of the original are replaced by a copy with simplified geometrical versions of the same forms. The aim is to test the hypothesis that "observation of brush strokes, as visible traces of goal-directed movements, are capable of activating the cortical representation of the same hand gesture in the observers' brain." Unsurprisingly, the subjects reveal different patterns of activity, and this leads to the conclusion that viewers of the Kline paintings are replicating the same cortical motor activity that the artist did when he executed the works and, further, that "an empathic relationship is established between the beholder and the artwork, based on the activation of both mirror and canonical neurons."[50]

This line of investigation has an art-historical lineage of which Freedberg himself is all too aware: the concern with empathy theory by authors such as Aby Warburg and Heinrich Wölfflin. Drawing on the materialist psychologies of late nineteenth-century theorists like Robert Vischer, Wilhelm Wundt, Gustav Fechner, and Hermann von Helmholtz, Warburg and Wölfflin tried to explain aesthetic response in terms of empathic projection on the part of the viewer. For Warburg, the viewer's empathetic projection was evident in the way that representations of the motile body could evoke a wide range of emotional responses that often undercut rationalistic and disinterested contemplation. Wölfflin focused on how architectural form not only provided a set of expressive corporeal metaphors but also prompted identification on the part of viewers through analogy with their own embodied experience.[51]

The turn to neuroscience thus appeared to provide an older art-historical preoccupation with a sound scientific basis; the speculation about empathy was now confirmed by experimental results in the laboratory. This is certainly how many scholars have interpreted the significance of this work; indeed, in *Neuroarthistory*, John Onians traces its genealogy back through the art-historical tradition to even earlier authors. The parallels with Warburg are particularly striking. As Gallese has noted, "Empathy is the result of a *direct experience*

of another person's state (action, emotion, sensation), thanks to a mechanism of embodied simulation that produces within the observer a corporeal state that is—to some degree—shared with the person who expresses/experiences that state. And precisely the sharing of some of the corporeal states between observer and observed allows this direct form of understanding, which we can define as 'empathic.'"[52] This statement mirrors—pun intended—Warburg's notion that ancient images of fear and trauma, such as Orpheus being torn apart by maenads or monstrous astrological creatures, reawaken in the viewer the original emotional state that underlay their creation. It was this phenomenon, he contended, that explained why images served as such powerful vehicles of social memory.

Yet Warburg never managed to resolve the fact that his own historical research contradicted his theoretical position, for he carefully documented the numerous instances in which such originary qualities were either missed or deliberately subverted or sublimated. In addition, Wölfflin recognized that there were limits to what the theory of empathy could explain. While he claimed that "we interpret the whole outside world according to the expressive system with which we have become familiar from our own bodies," he also stressed that architecture is never merely a matter of the externalization of raw perceptions; rather, it is an "ideal enhancement" of bodily feelings expressed through the medium of *style*.[53] Style, he argued, expresses wider human aspirations, beliefs, and ideas, and visual styles are consonant with other cultural practices and conceptions. Thus he claimed that Michelangelo's sculpture and architecture are comparable to Torquato Tasso's *Gerusalemme liberata* and to the religious fervor of the Jesuits. Given the multiple forms of "sensory input" they require—optical, auditory, olfactory, tactile—the most determined neuroarthistorian would be hard put to demonstrate that reading Tasso, listening to Claudio Monteverdi, and viewing Bernini's *Saint Teresa* or Rubens's paintings involve the same neural processes, much less, given the impossibility of collecting empirical evidence, that these activities replicate those of the original makers.

In part, of course, these are practical obstacles, but there are more theoretical objections, too, and they relate to the notion of mimesis deployed in the use of empathy theory, for, as Jennifer Gosetti-Ferencei has argued, the neuroscientific account only becomes plausible given a highly restricted notion of mimesis as the mirroring of empirical reality.[54] Mimesis works on a number of levels, involving not only the reflection of "actual" reality (however that might be defined) but also "reality in its possible manifestations," as well as the idealized world of entirely fictional imagined worlds. Our immersive

engagement with works of art is thus not limited to their specific features but transcends them as we imaginatively engage with how they point beyond themselves. When we view Grünewald's *Isenheim Altarpiece* (1512–16), for instance, which depicts the body of Christ on the cross as if he were a plague victim (it was painted for a monastery devoted to the care of plague sufferers), we may shudder at the sight of his physical wounds and plague-ravaged body, and this may invoke an empathic projection or, alternatively, a violent wish to distance ourselves from it. But at the same time, the lesions and pockmarks on Christ's skin encouraged identification between plague victims and Christ's suffering and held out the prospect of divine redemption, even if only after death. The painting's unremittingly bleak background, in which a sketchily depicted desolate landscape opens out onto the blackness of the sky beyond, provides a powerful imagining of metaphysical horror at the moment when Christ seems to have been abandoned by God. Yet this scene of despair is accompanied by John the Baptist on the right asking us to bear witness to the significance of what is happening—it is not a meaningless death—while on the left the Virgin is supported by John as she collapses, a representation not only of an individual woman but of grief in general. One could continue in this vein, but the key point is that viewing this painting is remote from macaque monkeys viewing actions performed by others, inasmuch as this is a depiction not of actual observable actions but of possible and ideal configurations of the world.

In defense, it might be objected that the object of empathy is not the *content* of artworks but rather the expressive properties that function as indices of action, hence the significance of the example of Kline. Moreover, Gallese and Freedberg have protested that empathy is by no means the whole story of aesthetic response, but rather a crucial element. These responses are problematic, however, and for fairly obvious reasons. If aesthetic response is not *exhausted* by the neuroscientific theory, it must then be asked how significant the account is, given that central aspects of the way viewers (and listeners and readers) engage with works of art are left out of consideration. Hence, it *may* be the case that part of our reaction to images is an involuntary universal biological mechanism, and that this is of interest to neuroscientists. As students of human culture, however, art historians and critics might prefer to inquire into the relation *between* that automatism and culturally shaped understandings, and to ask how responses may vary from one culture to another. To return to the issue that Warburg was not able to resolve, they will be interested in how responses to one and the same work may oscillate wildly depending on the time and place. Moreover, if it is the case that Gallese and Freedberg are

primarily interested in works such as Kline's, which are a visible deposit of the artist's hand, they turn out to be concerned with a narrow set of artifacts—modernist painting and sculpture—and have little to say about works, such as the paintings of Ingres, where gesture has been reduced to a minimum.

A MATTER OF RAW PERCEPTION

The discussion of Kline betrays the fact that neuroarthistory has an undeclared intellectual ancestry in modernist art theory. The tradition of aesthetic thought that Todd Cronan has recently referred to as "affective formalism" sought to bypass all notions of cultural mediation in order to ground aesthetic response in raw perception. A well-attested instance of this preoccupation is the theory of the expressive properties of color, which Matisse and his fauvist contemporaries Vlaminck and Derain valued for its ability to break representational conventions, and thus for its subversive qualities.[55] The origins of this theory can be located in romantic philosophy and poetics, but of more relevant interest for the present discussion is the relation between the idea of pure sensation and aesthetic experience, and the fact that this idea enjoyed a remarkable revival in the 1970s. It was revived by Julia Kristeva in her analysis of Giotto's Arena Chapel, for example, in which she argues that color—in particular, Giotto's use of azure blue—expresses bodily drives in an unmediated manner, in a way that language is unable to do.[56] Color disrupts the symbolic register, Kristeva argues, and for this reason color plays an important role in artistic revolutions. Alongside Kristeva can be placed what Cronan calls "*October* aesthetics" in reference to Rosalind Krauss, Yve-Alain Bois, and others associated with the art journal. Their reading of modernism is suffused with references to the unmediated affective impact of the avant-garde. Of paintings by Matisse, for example, they write that "the viewer cannot gaze at their pullulating arabesques and color flashes for very long. . . . The viewer feels compelled to look at everything at once, at the whole visual field, but at the same time feels forced to rely on peripheral vision to do so, at the expense of control over that very field." Matisse practiced an aesthetic of blinding such that "figure and ground constantly annul each other. . . . Our vision ends up blurred, blinded by excess," an experience that can only be explained in terms of his paintings' ability to overwhelm the human sensorium and act directly on the nervous system.[57]

One of the best-known instances of this position is the aesthetic theory of Gilles Deleuze, whose analysis of Francis Bacon embraces the painter's

commitment to the violence of pure sensation: "Color is in the body, sensation is in the body, and not in the air. Sensation is what is painted. What is painted on the canvas is the body, not insofar as it is represented as an object, but insofar as it is experienced as sustaining *this* sensation." Like Krauss and others, Deleuze is analyzing a specific moment in art, but the idea of raw perception is also a central component of the Deleuzian aesthetic, apparent in his general comments on art, which, he states, "acts immediately on the nervous system." Even empathy theory makes a reappearance, for Deleuze notes that, "as a spectator, I experience the sensation only by entering the painting, by reaching the unity of the sensing and the sensed."[58]

This emphasis on raw perception is the culmination of a tradition in which, as Jacques Rancière has noted, "the destiny of the modern work of art [is] tied to that pure sensible, exceeding the schemas of the representative doxa."[59] As such, it has strong connections to the neuroarthistorical theories of Freedberg, Mallgrave, and Onians. These scholars may lack the rhetorical sophistication of Bois and his peers, but there are parallels in their efforts to circumvent the traditional art-historical emphasis on the work of representation and cultural mediation. Mallgrave and Onians seize on a number of ideas from neuroscientific research, including the fact that certain kinds of visual experiences, such as color and horizontal and vertical lines, can be linked to activity in specific areas of the brain (or to the coordinated activity of several areas of the brain), and the fact that research has demonstrated the extreme plasticity of the brain, whereby different kinds of stimuli and environments may have a substantial impact on brain development. Spatial awareness relies on the cooperation of a particular network of neurons; thus, Mallgrave suggests, architects who for reasons of professional training and practice have developed a heightened sense of space may have distinctive brain types.[60] Drawing on research by the neuroscientist Semir Zeki, Mallgrave suggests that artworks build on the evolutionarily adapted predilection of visual perception to search for the typical and the constant in the environment. Thus the preference among early Renaissance architects, for example, for the simple geometries of squares, circles, and rectangles, their search for Platonic forms, and their concern with the golden mean were, Mallgrave suggests, visual inflections of this basic aspect of perception.[61]

The same can be said, Mallgrave argues, of the insistent concern of artists such as Mondrian or Malevich with primary forms: "in seeking what they themselves described as the essence of form and color, [they] were in their own way functioning as neurologists, probing how the brain puts together a perception." The preference for visual order expresses the fact that art

capitalizes on and responds to perceptual and neurological dispositions that are the result of a combination of evolutionary adaptation and social training. One might observe here the outlines of a neuroscientific history of modernism that identifies two conflicting trajectories: on the one hand, the aesthetics of blinding associated with Matisse, and, on the other, Mondrian's search for the primary building blocks of vision—except that for Mallgrave the ambiguity and uncertainties of Matisse are a source not of trauma but rather of pleasure. Rehearsing alternative perceptions—which are never resolved—produces a kind of cognitive quickening, again with neurological origins. Conversely, Mallgrave suggests, when presented with constant and predictable forms, the brain suffers fatigue and boredom, and ambiguity counters fatigue and boredom by fulfilling the brain's need to "enrich or enhance its neural efficiency."[62]

It is difficult to assess what it means for an organ to become bored, but a weakness in this idea becomes apparent when it is contrasted with Rudolf Arnheim's use of Gestalt psychology to analyze the experience of similar formal features. In *The Dynamics of Architectural Form*, Arnheim criticizes precisely this kind of identification of isolated features without reference to their expressive, functional, or semantic context:

> There is no point in evaluating the harmony of pleasant relations between forms "in themselves" when these forms are meant to embody a functional theme, such as receiving, containing and dispensing. The particular dynamics of each shape and each relation between shapes is influenced by that of function. Perceptual appearance varies accordingly. The neck of an amphora may look elegantly slender when it is seen as the channel through which wine is poured, but the same relative size may look humorously stocky when it is seen as belonging to a human neck. . . . Different standards of relative size apply to the function of being the stem of a head than to the function of being a duct leading to an opening.[63]

This is not to advance Gestalt psychology as an alternative approach, but Arnheim has identified something of central importance that the neurological explanation loses sight of: the semantics of vision. The key point is that we never do perceive "lines" as Mallgrave's neurological model suggests; visual forms are encountered in specific contexts; we attribute cultural meanings and functions to them, which in turn feed back into how we perceive them. Whitney Davis makes a similar point in terms of the relation between vision and visuality. On the one hand, he argues, vision as raw biological perception

is distinguished from visuality, which consists of being attuned to the "forms of likeness that things have in a particular historical form of life—the visible *and* invisible aspects that things come to have in a network of analogies constituted in that form of life." This opposition assumes that one can appeal to a visual brain *outside* the processes of acculturation, but even Mallgrave argues that the brain is socially shaped through the phenomenon of plasticity. Consequently, Davis argues, "it is logically impossible fully to specify the neural correlates (if any) of visuality *specifically as a question of the neuropsychological capacities and adaptations of the visual brain*," for this is a purely biological, noncultural brain that does not exist even within the terms of neuroarthistory.[64]

Similar difficulties emerge in Onians's work. Even before publication of the book that gave prominence to the idea, Onians produced a number of studies that sought to introduce neuroscientific themes. Writing on Greek temples, for example, he claimed that their formal structure should be regarded as the objectification of neural patterns specific to Greek culture, which were themselves the consequence of environmental influences. Central to this suggestion are two interrelated ideas. The first is that common cultural practices and language were far less significant determinants of artistic form than the neurological structures underpinning mental activity. The second is that the Greek brain was directly shaped by shared environmental experiences and influences, such as "a landscape of fertile river-valleys flanked by rocky mountains . . . changing temperatures and humidities and alternating waves of sun and rain." Behind this image is Onians's longer-term engagement with the tradition of German *Kunstgeographie* that had emphasized the role of environmental constants and the *longue durée* of art history, but he transforms this tradition by couching the discussion in terms of the brain. Thus we learn, for example, that "the brain's genetically driven predisposition to pay attention to things that secured or threatened its survival" meant that the phalanx was a source of particular pleasure, and that the planimetric arrangement of Greek temples, which evoked the phalanx formation, was no mere cultural metaphor but the reactivation of conditioned neural networks. For "the Greek brain has been so modified by experience that . . . the object of supreme desire is not a human individual but a formation of cavalry, infantry or ships."[65]

Onians takes a similar approach to other examples, among them what he terms "Renaissance aesthetics," by which he means a preference in the quattrocento for clear geometries, "straight lines meeting at right angles." He argues that this aesthetic is the consequence of neural adaptations that have been shaped by external factors. In this case, exposure to the urban structure of Florence, "with its river, straight as a canal, its quadrilateral Roman core,

and its medieval periphery built around a network of straight roads," lies behind such crucial developments as Brunelleschi's invention of the perspective system. With neural networks shaped to process the visual experience of receding orthogonals, Florentine artists and architects were consequently "better prepared to apply existing theory on the geometry of optics to the representation of pictorial space."[66] This orientation stands in contrast to Rome, a disorderly jumble of ruins, or Venice, where the sweeping curves of the grand canal were most likely to order the neural structures of Venetian artists and architects in a totally different way.

The idea of a disposition to certain visual forms recalls Baxandall's notion of the period eye, and Onians singles him out as a fellow traveler.[67] Yet when he introduces the notion, Baxandall makes clear that the attunement of vision to geometrical forms is the product of a culturally shaped mode of *attending* that reflects the practical dealings and interests of the mercantile culture of Florence.[68] Even if one accepts Onians's claim that an environmentally shaped neurological structure underlay such a predisposition, Baxandall's account differs in suggesting why such forms were given significance, and were thus copied and reproduced by subsequent generations of artists. Onians, in contrast, is reduced to asserting that artists sought to reproduce a certain visual experience. Apart from the naïve realist assumptions underpinning this idea (e.g., that an image is a "transcript" of a visual experience), there is still a large gap between growing up in an environment marked by the legacy of Roman urban planning and Brunelleschi's invention of single-point perspective in the early fifteenth century.

It might also be asked why Florentine artists (or even Greek architects) wished to *replicate* a certain visual experience, even assuming that one could quantify it as such. For Onians, such replication was a source of pleasure, but *why* it was a source of pleasure remains unexplained. This rather large omission repeats a problem already encountered in Dutton's and Hildebrand's claim that an image evoking memories of a distant remembered environment would become an object of aesthetic appreciation. The flaws in this theory become all the more evident when one tries to use it in concrete art-historical analysis. For example, if the invention of perspective in Florence was linked to that city's unique visual environment, Onians would have to demonstrate that there really was no other town *anywhere* that presented a similar range of visual experiences. Given the large number of towns in Italy that preserved the geometries of Roman urban planning, it is highly unlikely that, in this respect at least, Florence was unique. And even if Florence *was* unique, Onians's explanation only pushes the *explanandum* back in time, for then the question

would be why Florence was built in *that* way, assuming that there was no prior environment that would have shaped the brains of the town's builders and planners so as to make them predisposed to the neat geometries of the city's eventual aspect. It has to be explained, furthermore, why Brunelleschi's construction was adopted and spread so quickly across Italy. Why, for example, did artists elsewhere find "pleasure" in the perspectival representation of space, since it apparently did not reproduce anything that they had grown up with in their own visual environments?

There are numerous possible answers to these questions, but not within the terms of analysis provided by neuroarthistory. Thus acknowledgment that artists from other towns in Italy with, presumably, different neural structures saw value in perspective and adopted it *despite* their neurological differences suggests that the evolution of perspective *after* Brunelleschi's invention occurred for different reasons. Onians's thesis consequently faces a problem similar to that encountered in the study of prehistoric art: just as the theory of neurological (r)evolution might have provided a plausible explanation for the emergence of art but not for its subsequent development, so, likewise, even if neuroarthistory can account for the invention of perspective, it is unable to provide commentary on its subsequent history.

A more general question might also address the putative benefit gained from description of the environmental influences on art in terms of the shaping of the brain. Onians pays particular attention to neuroplasticity—in other words, the fact that the brain is not composed of a fixed set of neural networks but rather is in constant flux. New neural pathways are laid down and unused ones disappear, and he stresses that this is due to the brain's incessant interaction with the environment. This is now a commonplace in neural science, as noted earlier. Mallgrave suggests that the neural development of architects may show specific features not shared with others. In similar fashion, Onians explains the differences between individual artists and writers in terms of neuroplasticity. Their brains, he argues, have developed in different ways owing to the varying stimuli to which they have been exposed. Of Ruskin, for example, he claims that "by the time he was a young man Ruskin will have seen more landscapes and more art than most of his contemporaries. As an artist he will also have repeatedly tested his skills of observation in front of different scenes. As a result his neural networks will have increasingly predisposed him to reflect on the relation between art and the environment."[69]

The most notable feature of this simplistic formulation is that while couched in terms borrowed from neural science, it makes an elementary point about the formative role of upbringing. This raises the obvious question: what

is added to the understanding of Ruskin by characterizing the roots of his creative and intellectual formation in this way? What insights are generated into his work beyond those of conventional discourses of biographical, social, and cultural history? Even if the theoretical armature is accepted, there is little to allay the suspicion that reference to neural networks merely describes in a different vocabulary what are already unexceptional ideas. Regardless of its theoretical cogency, the onus is on neuroarthistory to demonstrate that it produces innovative interpretations or knowledge. Otherwise, it runs the risk of redundancy, adding a veneer of scientism to the already familiar. Indeed, neuroarthistory arguably provides an impoverished account of art, for in all of the examples discussed, from Paleolithic images to Greek temples, it merely provides a theory of causes.[70]

THE CLAIMS OF NEUROAESTHETICS

Mallgrave, Onians, Cook, Lewis-Williams, and others base their arguments on ideas culled from popularized versions of neuroscience, but, in addition, they reference writings from the more specific field of neuroaesthetics. A number of writers have tried to spell out what that might involve, but the most prominent are Vilayanur Ramachandran and Semir Zeki.[71] As noted earlier, Cook views various Paleolithic artifacts through the lens of the putative universal laws of art formulated by Ramachandran.[72] While he identifies eight so-called laws, Ramachandran lays special emphasis on the way art mobilizes the "peak shift effect," the phenomenon whereby animals learn to respond more readily to increasingly exaggerated versions of stimuli associated with rewards. Art builds on this response mechanism, which is supposedly built into the evolved neural structures of the brain, and hence the essence of art is the creation of "superstimuli" or caricature in order to "titillate the visual areas of the brain." Thus art produces idealized or amplified forms, and Ramachandran identifies various means whereby art achieves such amplification, including the isolation of a single visual modality or "contrast extraction." A prominent example is the use of the line as a medium of amplification; thus "an outline drawing or sketch is more effective as 'art' than a full colour photograph," since it works with the limitations of the brain's "allocation of attentional resources."[73] This also explains the role of contrast extraction, in other words, the heightening of contrasts within an image through the use of color, texture, and line, which all allow for the amplification of figures or achievement of the peak shift effect.

These claims will be examined in due course, but it is worth comparing them with Zeki's ideas. Zeki's much-cited *Inner Vision: An Exploration of Art and the Brain*, an almost standard point of reference in neuroaesthetics, advances the thesis that "the function of art and the function of the visual brain are one and the same, or at least that the aims of art constitute an extension of the functions of the brain."[74] According to this argument, art is an externalization of the cognitive functions of the brain, and, concomitantly, the aesthetic effects of artworks can be gauged by examining how they stimulate a range of specific brain functions.

An important point for elucidation is what Zeki means by brain function. In this context, he is not referring to the brain in general but only to the brain as the organ of visual perception and, in turn, to the role of vision as the seat of cognition of the external world. He describes visual cognition in terms of the relationship between the brain's interest in "the constant, non-changing, permanent and characteristic properties of objects and surfaces . . . which enable it to categorise objects," on the one hand, and, on the other, the fact that experience reveals a world in flux. The brain, claims Zeki, is thus involved in a constant process of abstraction, comparing previously acquired information about objects with the present so as to distill an essentialized knowledge of the world.

The key issue is whether this process also motivates artistic creation. Zeki concludes that "the function of art is thus an extension of the function of the brain—the seeking of knowledge in an ever-changing world," and, further, that art is concerned "to represent lasting, essential and enduring features of objects, surfaces, faces, situations and so on, and thus allow us to acquire knowledge not only about the particular object, or face or condition . . . but to generalise from that to many other objects."[75] Zeki supplements this account with an outline of neurological research into the localization of visual perception in the brain, central to which is the primary visual cortex (so-called V1), although he describes a number of other areas that are involved in vision, such as the area known as V5, which accounts for the perception of motion.

These ideas feed directly into the neuroarthistorical work already discussed, but before scrutinizing them, it is necessary to explore various other claims, starting with Zeki's discussion of constancy. By "constancy" is meant the search for essentials, and Zeki sees this search exemplified in the paintings of Vermeer. He gives particular significance to ambiguity in Vermeer's works, by which he means their ability to "represent simultaneously on the same canvas not one but several truths, each one of which has equal validity with the others." In Vermeer's *Lady at the Virginals with a Gentleman* (1662–65), for

example, "several truths revolve around the relationship between the man and the woman. There is no denying that there is some relationship between them. But is he her husband, or her lover, or a suitor, or a friend? Did he actually enjoy the playing or does he think that she can do better?"[76] Alongside these questions one could list, he notes, many other possibilities that the painting does not answer conclusively.

Such highlighting of semantic indeterminacy would not be out of place in many art-historical interpretations, but Zeki's understanding of the significance of this indeterminacy is strikingly different, for he concludes that Vermeer's painting is an ideal or "species" representation, and that its power resides in the fact that it embodies what Zeki calls "situational constancy," i.e., a generalized idea of certain *types* of situation. Accordingly, it is able to "evoke many situations, not one. . . . It has the capacity to stir a great deal in the brain's stored memory of past events."[77] What Vermeer's painting supposedly instantiates is the basic search for constancy underlying visual cognition. Zeki is unclear about the relation between aesthetic experience and everyday visual cognition, however. On the one hand, he sees art as replicating and prompting normal processes of cognition, while, on the other, setting these cognitive processes in opposition to one another. Vermeer's painting may be characterized by its ambiguity, but in every visual cognition, we, or "our brains," do not dwell in indeterminacy; we try to identify what we are looking at.

Zeki cites other examples where art mimics neural processes, among them cubism. Following Daniel-Henry Kahnweiler's notion that Picasso and Braque were concerned with trying to capture the appearance of an object from many distinct points of view simultaneously, he argues that such paintings as *Les Demoiselles d'Avignon* and *Man with a Violin* (1911–12) mimic the way in which the brain synthesizes multiple views of the same person, situation, or object.[78] Of *Les Demoiselles* Zeki notes, "it is as if Picasso had walked 180° around his subject and had synthesised his impression into a single image."[79] In many cases, of course, the painting ends up being unintelligible; the viewer's ability to recognize *Man with a Violin* as a representation of its subject depends on being prompted by the title. Consequently, Zeki concludes, cubism was a heroic failure. Relying on a now rather dated understanding of cubism, Zeki does not consider that it might have been the *difference* between visual cognition and pictorial representation that lay at the heart of the cubist enterprise—now a commonplace in interpretations of this work—and that the grounds for its alleged "failure," its lack of visual intelligibility, may have been precisely what was most successful about it.

Zeki's discussion of a number of other examples also merits attention. The first is his reading of the significance of the line in the nonobjective work of artists such as Kazimir Malevich, Alexander Rodchenko, Piet Mondrian, and Ellsworth Kelly. As Zeki correctly observes, this work was frequently accompanied by fundamentalist rhetoric; in other words, the artists in question frequently described their work as concerned with the search for fundamental forms.[80] This rhetoric drew on Platonic notions of ideal objects and raised once more the issues involved in the search for essentials, but the importance of the line is what attracts Zeki's attention here. Why, he asks, was the quest for essential form so bound up with a preoccupation with linear forms? The answer, he claims, lies in neurobiology. Specifically, he says, those parts of the visual cortex responsive to lines and linear orientation are the same as those responsible for producing synthesized, complex forms. Lines and linear orientation are also the building blocks of visual cognition. It is thus no accident, he argues, that so many artists resorted to the line as the basic unit of their visual vocabulary. Their work was thus a kind of "applied neurobiology."

Zeki also explains the preference for squares and rectangles on the part of such artists as Malevich, Josef Albers, and Ad Reinhardt, for this preference, he argues, mimics the receptive field of the cells in the various visual cortices of the brain. By "receptive field," Zeki means the part of the visual field that is sufficient to stimulate a visual cell, and he notes that the receptive field of the visual cell is usually square or rectangular in shape. Given that vision is a composite of tiny rectangular pixels, the brain is thus particularly responsive to squares and rectangles. Zeki is too cautious to argue a causal relation between the structure of vision and, say, Ad Reinhardt's decision to paint *Red Abstract* (1952), but he does assert that such paintings are "admirably suited to stimulate cells in the visual cortex, and the properties of these cells are, to an extent, the pre-existing 'idea' within us," adding that "when we look at the paintings of Malevich, many cells in our brain with the characteristics illustrated above will be responding vigorously."[81] Yet this formulation is a way to avoid stating what the precise relation *is* between paintings by Malevich or Reinhardt (or indeed Mondrian) and the structure of vision. Given that the receptive field of individual cells lies below the threshold of perception, it is improbable that its rectangular form is of any significance at all when considering the viewing of works of art. Indeed, it is doubtful that rectangular form has any bearing at all on understanding the phenomenology of vision, for a rectangle, like all shapes, is a relationship of elements. The receptive field therefore has a rectangular form only for an external observer, not for the perceiving subject, for whom it is the minimal visual stimulus.

The final example to consider before engaging in a more critical analysis is Zeki's discussion of portraiture, in particular, Titian's *Portrait of Gerolamo (?) Barbarigo* (ca. 1510), in the National Gallery in London. Zeki prefaces his discussion with some general comments about portraiture. Specifically, he argues, portrait painting became a prominent genre in Western art because "the brain has devoted a whole cortical region to facial recognition, itself a sign that the face carries a very great deal of interesting and important information for the brain."[82] It is a commonplace to note the conventions used here—the placing of the sitter's body sideways to the viewer, the subject looking askance, his arm acting as a barrier to the viewer—to enhance the sense of the sitter's self-assuredness.[83] Yet it is not enough, Zeki argues, to state that Titian deployed common conventions of sixteenth-century portraiture. His portrait also captured that now familiar quality: constancy. For "it has captured the essential feature of haughtiness and arrogance in the brain's record, the Platonic ideal or the Hegelian Concept, that transposed to any face, will convey the same psychological portrait. It not only conveys information about that particular person but about all persons with similar features."[84] Titian's painting thus has an ideal typical character that externalizes the process of visual cognition.

Although the most influential example, Zeki's study is not the only exercise in neuroaesthetics; others have drawn on similar material but have reached slightly different conclusions. Helmut Leder and Benno Belke, for example, have also suggested that art presents prototypical features and objects, familiarity with which is the source of aesthetic pleasure.[85] Yet they argue that this aesthetic experience is rewarding because perception is *challenged* rather than merely confirmed. Ramachandran and Hirstein's focus on the "peak shift effect" leads to the conclusion that art does not present experiential constants but *exaggerates* typical features of visual perception. Martin Skov, in contrast, has argued that art is distinctive inasmuch as it uses materials in order to "deviate from ordinary objects or materials in a specific way and therefore to provoke a cognitive cycle of defamiliarization-reconceptualization processing on part [*sic*] of the beholder."[86]

Such differences, although of little apparent significance, are revealing, for all of the authors concerned—Zeki, Skov, Ramachandran, Leder, and Belke—adhere to a view of art that is neither borne out nor contradicted by the neuroscientific data they can provide. As with the claims regarding evolutionary adaptation, there are limits to what empirical findings can reveal, especially because neuroaesthetics has no concept of art or of representation. As John Hyman has argued, the theory makes no distinction between a work of art

and the kind of object it represents. This is evident in Ramachandran's discussion of the proportions of a twelfth-century Indian sculpture of the goddess Parvati. Ramachandran takes her accentuated bust and exaggerated hips as confirmation of the theory, but the difficulty with this, which Hyman terms the "*Baywatch* theory of art," is that "the theory is not really about art at all. It is really a theory about why men are attracted to women with big breasts. . . . The fact that the Indian sculpture is a work of art is completely irrelevant to this theory. It could just as well be a theory about Pamela Anderson."[87]

Putting to one side the sexist undertone of this comparison, the serious point is that neuroaesthetics is not an aesthetic theory, and neuroarthistory is not a historical discourse of art. It is perhaps easy to critique these authors, for their arguments are crudely formulated, but similar ideas populate the work of considerably more sophisticated thinkers, among them Barbara Maria Stafford, whose *Echo Objects* attempts to map out the "cognitive work of images." In contrast to Zeki, Ramachandran, and Skov, Stafford undertakes a wide range of close analyses of visual images, and addresses topics that are closer to the concerns of theorists and historians of art and visual culture. These include formal complexity, visual interpretation, mimesis, the perception of patterns, and the relation between unconscious and conscious in visual cognition. Her study provides some subtle and suggestive readings of individual examples, but her basic approach is similar to Zeki's. Concerned to challenge the logo-centric privileging of discourse over image, Stafford argues for the cognitive importance of visual representations.[88] Such representations organize the manifold process of perception—through composition, line, color—and not only undertake important work in the training of human cognition but also provide an externalization of the neurological mechanisms of the brain. Mimesis rests on the activity of mirror neurons, which underlie the processes of copying and empathic projection. The perception of works of art consists of a combination of conscious direction of attention and unconscious undirected attention, which is, again, due to the way that sensory data are processed by the brain.

Familiar problems emerge, however. On the one hand, Stafford marshals examples—from installations by Günther Uecker and Anne Wilson to seventeenth-century *emblemata* and the paintings of Caspar David Friedrich—to illustrate the neurological operations described. Yet, since the neuroscientific claims relate to the brain operations underlying perception, no image is any more relevant than any other as an illustration of these operations. To claim that the examples chosen are particularly apt, it would be necessary to give evidence—perhaps fMRI scans or some other empirical data—that supported

the distinctiveness of the neurological response to *these* images and not to others. The argument would also need to describe *how* and in what significant ways these works differed from others.

This is perhaps a methodological quibble, less significant than the more basic question, which pertains to the kind of knowledge generated by the use of neuroscientific theories in the analysis of images. When Stafford contends, for example, that Friedrich's paintings "stimulate an ongoing back and forth, perceptual as well as cerebral juggling in the beholder," and that "each distinctive aspect of a natural feature—whether solitary oak tree, the ruined abbey of Eldena or a rock outcrop in the Riesengebirge—is processed by a different micropart of the visual brain," the reader is given little more than a description of aesthetic response endowed with a semblance of scientific analysis.[89] For those concerned with the cultural and social meanings of Friedrich's paintings—in other words, the vast majority of historians and theorists of the image—it is difficult to discern what *relevant* insights are generated by such theorizing.

THEORETICAL QUESTIONS

The discussion so far has focused on the issue of domains of knowledge and the status of neuroscience for art history. My basic contention is that at best it merely adds an additional discursive layer; familiar aesthetic concepts are redescribed using the vocabulary of neurology. A test of its capacity to do more than this would lie in its ability to compel a rethinking or reformulation of existing art-historical interpretations. There are, however, theoretical objections to the use of neuroscience, and it is to these that the discussion now turns.

Underlying the use of neuroscience is a crude materialist theory of mind, which has been critiqued in the name both of dualist theories of mind and also of more complex nonreductive materialist theories. This is not the place for an extensive discussion of the intricate arguments regarding the problem of brain/mind identity or for a full assessment of the criticisms of the biologistic assumptions of neurophilosophy. Some salient points do merit comment, however, starting with the observations of Raymond Tallis, who focuses on the claim that because there is a correlation between certain conscious experiences when viewing a Malevich painting, for example, and specific brain events detectable by an fMRI scanning device, the two must be identical. This is a common assumption that Stafford, Zeki, Onians, and others repeat, but it raises more questions than it answers. Given that neural activity consists of a complex electrochemical process, the linking of certain subjective experiences

to brain activity is beset with ambiguity. Tallis asks, "Is 'neural activity' some-thing that is delivered to a certain place in the brain? Or is it the sum total of what is happening in several places of the brain? If so, where is the summing and totalling taking place? Does consciousness reside in the travelling of nerve impulses along neurons or its arrival at a synapse?" The definition of "neural activity" is also open to multiple interpretations. A nerve impulse, Tallis points out, can be conceived of as "an influx of sodium ions . . . followed by an efflux of positive ions," or as "a change of the potential difference between the inside and outside of the membrane [in the neuron] at a particular place," or as a "wave moving along the neuron," or as a "wave arriving rather than travel-ling."[90] Each of these definitions is important for how one might understand the meaning of neuroaesthetics and neuroarthistory, but they have not been explored.

The attempt to link neural activity and subjective conscious activity suf-fers from other fundamental difficulties, too. Even if the meaning of "neural activity" were settled, what does it mean to state that there is a correlation between neural activity and certain subjective experiences? How can one be sure that the subjective experiences are the same in all subjects, even if recur-rent patterns of neural activity can be detected? The only external evidence for the nature of the subjective experience is the subject's description, but of course *how* the subject describes that experience will depend on a huge variety of factors, such as age, gender, social class, educational background, culture, and so forth.

The neuroscientific approach also commits a basic category error, for it conflates the observed *correlation* between neural activity and subjective experience with the idea of a *causal* relation. But there is nothing to warrant such a leap; even if it were agreed that there *is* a correlation, the nature and significance of that correlation would still need to be determined. One way to avoid this error is to argue that conscious experiences and neural signals on an fMRI scan are different aspects of the same phenomenon.[91] But this assertion does not hold up under scrutiny, in that conscious experiences and neural signals on a scan are *both* representations, and the notion of "aspects" presupposes an external observer and something *of which* they are aspects. There is nothing in this model, moreover, to justify the assumption that *one* of these supposed aspects (i.e., neural activity represented in an fMRI scan) stands in a causal relation to the other, or that it has some kind of ontological priority.

Another point of criticism concerns the artificiality of the environment and context in which some crucial experiments on the brain have been

conducted. A well-known experiment by the neuroscientist Benjamin Libet shows that neural activity associated with a particular action precedes conscious awareness of the decision to perform that action by up to five seconds.[92] The implication of this finding is clear; consciousness is an epiphenomenon that succeeds the brain's operations, and this suggests that the latter stand in a causal relation to the former. However, as Tallis argues, this does not problematize the idea of free will in the way that Libet and others imagine, for the experimental situation in the laboratory is isolated from the much larger intentional nexus within which the experiment is situated—a nexus that includes not only the events and actions immediately preceding the experiment but also the original decision of the experimental subject to participate in the experiment, with all the considerations associated with such a decision.[93]

This problem raises a much larger difficulty, namely, that neuroscientific approaches to the arts and humanities are often based on an image of art and culture as a sequence of private events taking place within the mind/brain of the individual.[94] This is also a central axiom of the evolutionary theories of culture discussed earlier; authors such as Mesoudi, Laland, Tooby, and Cosmides all operate on this same assumption. Yet even if one accepts their broadly materialist or physicalist view of the mind, this premise may be of little relevance, for art, as a social and communal practice, takes place in the intersubjective space *between individuals*—however that might be conceived—using symbolic media. To attach importance to fMRI representations of brain activity that may or may not be correlated with certain mental events is to invite speculation as to the brain states of individuals. The irony, of course, is that such brain states, and speculation about them, are accessible to others only through articulation in public discourse.

There are other theoretical questions, too, that the project of neuroarthistory and neuroaesthetics struggles to answer. The issue of ambiguity provides a useful point of discussion in this context. Zeki recognizes the importance of indeterminacy and ambiguity in Vermeer's painting, concluding that it derived from the way Vermeer's painting embodies constancy. This reading overlooks an important distinction between everyday cognition, in which, if we are to follow Zeki, the brain is constantly categorizing experiences (and revising its categories), and our experience of the painting, in which we are aesthetically moved by its resistance to such categorization. For Zeki, the brain is stimulated by and gains pleasure from Vermeer's painting precisely because it enlivens the search for essentials, but Zeki does not explain why this is not a source of irritation rather than pleasure. More important, he draws no distinction between the viewing of artworks and visual perception in general.[95]

What is the difference between everyday facial recognition and the viewing of a portrait? For Zeki, there is none; in his discussion of portraiture, he examines the phenomenon of prosopagnosia—the inability to recognize faces due to damage to a particular area of the brain—and then posits that prosopagnosics would not be able to read a portrait such as Vermeer's *Girl with a Pearl Earring.* This claim may be correct, but it would need to be investigated, especially given the possible objection that being able to recognize a portrait involves a different set of skills, based on familiarity with traditions of portraiture and with pictorial conventions.

The visual stimulus to which we respond when viewing Vermeer's portrait is not at all the same as the stimulus prompted by looking at a face. Our response to the painting involves a complex process of emotional and cultural engagement that includes, for example, responding to the fact that it is a *painted* portrait, a work of art (with all the connotations of the word), even a *Vermeer*, rather than, say, a family snapshot or a selfie. Zeki opens up the possibility that works of art present very particular kinds of experience, only to close it down again. This criticism can be generalized. A line in a Malevich painting is never just a line on a flat surface. It is part of a modernist or avant-garde *abstract* work rather than a work in the figurative tradition of Western art, and this fact shapes how it is perceived. Whitney Davis, drawing on Richard Wollheim, has recently emphasized the aspectual nature of perception—we never simply see; we see objects, lines, surfaces, etc. *as* something, and this seeing *as* becomes doubly complex in works of art, where we are dealing with culturally encoded artifacts and images that are entangled in a complex web of expectations and values.[96] This is also why a line in the nonobjective painting of the first half of the twentieth century was *never* just a line; it was a visual symbol of dynamism and revolution or of quasi-Platonic order and timelessness, of masculinity (when vertical) or femininity (when horizontal), of speed or stability, or indeed a symbol of many other things.

A defense against this criticism might be that neuroaesthetics and neuroarthistory are simply interested in the neurological mechanics underneath such considerations. I have already indicated that the usefulness of such a concern may be extremely limited, but in any case the criticism is not so easily dismissed, for a crucial problem lies in Zeki's description of constancy. In the description of visual cognition, a central role is given to the brain's capacity to synthesize different visual experiences in order to construct an abstracted model of the external world. Yet we never just "compare" two objects, surfaces, memories, or stimuli, and draw conclusions. Relevant *aspects* are identified

for comparison on the basis of a *tertium comparationis*. Even if we do follow Zeki's emphasis on the brain's search for constancy, we are still confronted with the aspectual nature of visual perception and the fact that the identification of *which* aspects are to be compared is not given by the image but determined by the interests of the viewer.

In response, it might be argued that some of these objections are based on an outmoded humanist attachment to the idea of art. In contrast, neuroscience and neuroaesthetics demonstrate that when viewing art, certain *general* neural mechanisms are mobilized, and it is this that demonstrates the cognitive importance of art. Clearly, the aesthetic response to art does draw on certain general capacities, but the tradition of thinking since Kant has been concerned to articulate the very particular ways in which it does so, so as to distinguish between aesthetic and other kinds of experience. Neuroaesthetics offers no such account, and given that it also shows no interest in art as a cultural activity, it may be asked why Zeki and others write about art at all. In neurobiological terms, since there is nothing specific about art, there is no difference between viewing a pedestrian road crossing and a Bridget Riley painting. Nor can neuroscientific explanations offer grounds for making judgments about and distinctions between works of art. It is worth citing here Jennifer Ashton's criticism, which summarizes the basic difficulty of neuroaesthetics:

> If we are interested in giving a good account of the meaning of any work of art, then focusing strictly on what kinds of emotional or instinctual or bodily triggers move its maker, or on what kinds of responses the work in turn triggers in its receivers focuses us on inputs and outputs in a way that simply cannot compel our interest in any given work over any other given work—or for that matter, in art as opposed to anything else that might yield similar results. If what I care about is what my brain does when certain social information makes me anxious or filled with love or with loathing, it's not clear why a novel of manners (or a poem or a painting) would be any more [a] privileged object of study than a middle-school cohort.[97]

The same weakness that besets the evolutionary theory of landscape response—its inability to provide the basis for critical distinctions between specific individual landscape paintings—can be seen here. As Ashton argues, what compels our interest in the one or the other is the particular form it takes, the particular *ways* in which "social information" or visual percepts are worked out.

Proponents of neuroaesthetics argue that artists act out a kind of applied neurobiology, but beyond a vague analogy between certain aspects of cognition and certain formal aspects of works of art, this assertion is never explained. Zeki claims that he is not advancing some kind of causal relationship between art and the brain (a curious disavowal since, in terms of agency, he argues that the brain *is* the cause of artworks), and yet he puts forward crudely mechanistic parallels between brain operations and artistic forms, the meaning of which, if not meant as causal relations, is totally unclear. This becomes apparent when specific examples are considered. For example, he argues that Reinhardt's painting *Red Abstract* reflects and parallels the structure of the receptive field. Assuming that he is not suggesting that Reinhardt was somehow able to "see" the structure of his vision, or could somehow discern the individual pixels that made up his field of vision, this leaves two possibilities: *either* that there is some kind of automatism at work, that the brain is representing itself on the canvas in spite of the conscious agency of Reinhardt (whatever "conscious agency" might mean), *or* merely that there is a curious similarity, which may indeed be of passing interest, but which is not an argument for anything in particular.

<p style="text-align:center">∼</p>

This chapter began with a discussion of the arguments over the function and significance of western European prehistoric art, considering the ways in which neuroscientific theories and data have been used to support the shamanic reading of cave and rock art. The particular debates on prehistoric cave painting led to the much more general application of neuroscientific ideas to the analysis of visual art. The emergence of this approach constitutes a major new development in the study of art, and almost every aspect of this project has been subject to criticism, from the casual use of "shamanism" to the reliability of the neurological data marshaled in support of a range of theoretical claims. It is important to scrutinize the accuracy of these claims, but the principal concern here is the *value* of such neuroscientific discourse, especially since its advocates claim that it has opened up new depths of insight. The analysis here suggests that any gains are considerably more modest, and in many cases more difficult to identify, than the proponents of neuroaesthetics and neuroarthistory would like to believe. It may be plausible that the sophisticated figurative representations of animals and humans in the caves of southern Spain, southwestern France, and southern Moravia are indices of a cognitive revolution some forty thousand years ago. Yet as soon as one begins to map out the history and development of such representations, neurological theory has to give way to rather more familiar techniques of analysis. It

lacks the conceptual armature to make the kinds of fine-grained distinctions between individual objects and images that are needed to make the study of prehistoric art into the analysis of the first stages in the formation of cultural identities and representations.

When applied to more recent history, the limitations of neuroarthistory are exposed even more painfully. Owing to its inability to account for the cultural production, consumption, and circulation of art, it offers little more than an additional layer of commentary on artworks, one with limited relevance. The failure of neuroarthistory should nevertheless not be taken as an argument for the complete incommensurability of inquiry in the humanities and the sciences. What it does make clear is the need to recognize that different domains of inquiry have distinct aims, values, and purposes. Failure to take such differences into account leads to the kind of vulgar and shallow interdisciplinarity evident in the writings of the authors discussed here.

SELF-ORGANIZING

EVOLUTION

Art as a System

Theories of evolution are generally understood as offering a model of genealogical descent, their concern predominantly with the diachronic modification of species due to natural selection. Central to what is commonly referred to as the evolutionary synthesis that crystalized in the 1930s and 1940s is a causal understanding of the relations between the external environment, the genotype, and the genotype's phenotypic expressions. The unit of selection is the individual organism, but it is at the level of populations that evolution occurs, since it is the distribution of genotypic and phenotypic variations that is measured to gauge the development of species.

This model underpins the numerous attempts to apply Darwinian theory to art. In some cases, the focus of attention has been the putative evolved cognitive dispositions alleged to determine the response to art. Thus Dutton, Mallgrave, Pinker, and others speculate as to how the response to art is shaped and constrained by the evolutionary cognitive inheritance. For other writers, it is the allegedly socially adaptive function of art—its ability to enhance social interaction and thereby provide a particular social group with a competitive advantage—that is of primary importance. Still others have argued that evolutionary theory helps open up awareness of how art mobilizes deep-rooted biological and evolutionary impulses. The most prominent of these arguments is

the claim regarding the intimate connection between art and human sexuality; aesthetic preference is related to sexual reproduction and the determination of the "fitness" of prospective mates.

This is not the only theory of evolution, however. An important alternative is rooted in systems theory and its emphasis on the organism as a self-regulating system. It is most commonly associated with the work of the biologists Humberto Maturana and Francesco Varela, who coined the term "autopoiesis" to designate the self-stabilizing "organization of the living." Describing living systems as "units of interactions . . . characterized by exergonic metabolism, growth and internal molecular replication all organized in a closed causal circular process," Maturana and Varela argue that evolutionary variation and selection are the result of the *internal* operation of the biological system rather than of its interaction with the external environment.[1]

The description of the organism as a living system predates their work by some decades; the idea that systems thinking was relevant to biology was first proposed by Mihajlo Mesarović in 1968, and in the same year the philosopher Ludwig von Bertalanffy published his now famous general theory of systems.[2] Bertalanffy argues that the "organism . . . is an open system in a (quasi)steady state, maintained constant in its mass relations in a continuous change of component material and energies, in which material continually enters from, and leaves into, the outside environment."[3] Systems biology has since become an established field, comprising the study of organizational properties at the molecular and cellular level and also larger-scale phenomena ranging from the nervous system to animal social systems.[4] Its significance for the present discussion lies in the fact that Bertalanffy and systems theorists after him sought to expand its scope beyond biology to the study of culture. At the same time, they formulated a rival model of evolution that critiqued the central role that Darwin and his followers had accorded to natural selection and adaptation. Although they acknowledge that natural selection is an important factor, it is not, they argue, the only one; instead, one must take into account the internal operations of the organism as a system, which are not necessarily directed by their relation to the external environment. As Bertalanffy notes, "The stimulus (i.e., a change in external conditions) does not cause a process in an otherwise inert system; it only modifies processes in an autonomously active system." The key evolutionary ideas of variation and selection continue to be prominent, but in contrast to the synthetic theory, the homeostatic functioning of the biological system, and not adaptation to an external environment, drives selection. An organism exists in a state of dynamic equilibrium, and its ability to adapt to "external disturbances," as well as to the phenotypic consequences

of genetic variation, is a consequence of the self-organizing and regulating nature of systems.[5] Transferred to the analysis of art and culture, this approach signifies a theory that regards them as autonomous, an issue that has been a contentious point of dispute in the Darwinian account examined so far.

The emphasis on autonomy led Maturana and Varela to develop a critique of adaptation. All organic systems are, they argue, already "adapted" inasmuch as they are alive and functioning as systems, rather than dead. Thus "different evolving systems would differ only in the domain in which they are realized . . . and not [in] whether they are adaptive or not."[6] This idea is reiterated in their popular account of biological systems, *The Tree of Knowledge*, where they write, "as long as a living being does not disintegrate it is adapted to its environment. . . . Its condition of adaptation is an invariant." As a result, evolution is a consequence merely of "the conservation of an identity and the capacity to reproduce"; Maturana and Varela also dispute the possibility that there can be degrees of adaptation, that some organisms can be better adapted than others.[7] Either an organism is autopoietically stable and is adapted, or it is not and it disintegrates. Linked to this account is an epistemological position that views the system's interactions with the environment (its "cognitive domain") not as fixed but as defined by the system, which draws its own boundary with its environment. Consequently, "its cognitive domain is necessarily relative to the particular way in which its autopoiesis is realized."[8]

These ideas are central tenets of systems theory; autopoietic systems interact with their environment, but the *nature* of that interaction is determined by the internal organization of the system.[9] The importance for evolutionary theory has been explored by a number of biologists, most prominent among them Rupert Riedl and Franz Wuketits.[10] As Wuketits has argued, reliance on the idea of environmentally caused external selection pressures must be countered by emphasis on what he terms "internal selection." Selection is not driven merely "from outside the organism (external selection) but in addition—and this is decisive—the regulatory, feedback and control mechanisms within the organism have a selective effect on it."[11] Wuketits is particularly interested in the evolution of cognition, and in contrast to accounts that explain cognitive advances solely in terms of their superior adaptivity to the challenges of the external environment, his point is that the organism *selects* information from the environment in keeping with its internal systemic operations: "Information processing in organisms presupposes an interaction between organisms and their environment. . . . The ability of adaptation is defined not by the environment but by the living system itself."[12]

This attempt to reframe approaches to evolution might be of tangential interest for the current study except that it has informed ambitious attempts to apply the theory of systems to the understanding of art. As the title of his *General Systems Theory* indicates, Bertalanffy is concerned to widen the scope of systems theory beyond biology and to develop it into a general cultural theory. This includes the study of art, for he sees parallels between his work and that of certain art historians, including Alois Riegl. Describing Riegl's *Late Roman Art Industry* as a "very learned tedious treatise," Bertalanffy nevertheless stresses its importance in that he sees affinities between his own emphasis on the system-bound nature of conceptual categories and Riegl's concept of the "*Kunstwollen*" as a culturally bounded aesthetic imperative.[13] For all the suggestiveness of its arguments, however, *General Systems Theory* fails to do anything more than sketch an outline of what a general theory of systems might look like. It does not answer some basic questions, such as, for example, what do the internal operations of a culture consist of? If a system is based on interaction between elements, what are the basic elements? Others, however, have constructed more detailed accounts; one significant attempt is by Bertalanffy's contemporary Gregory Bateson. Having established his reputation through his anthropological fieldwork in New Guinea, Bateson came, in the later stages of his career, to develop a cybernetic theory of culture, or an "ecology of mind" that viewed all living beings as part of a single mental system.[14] By "mental," Bateson does not mean conscious thought but rather the processing of information (defined as a "difference that makes a difference") by a self-corrective cybernetic system, which could range from computers to human deliberation or biological functioning.[15] For Bateson, the living human body is a complex, cybernetically integrated system, and he extends this idea to include art, which he characterizes as a system for the communication of meaning through the transformation of media.[16] Committed to the model of biological systems, Bateson is also critical of evolutionary notions of adaptation, rehearsing a now familiar argument that "no ongoing process of evolution can result only from successive externally adaptive genotypic changes."[17] Instead, as for Wuketits, Varela, and Maturana, the internal organization of the organism is of primary importance.

Widely admired, Bateson nevertheless failed to construct a coherent theoretical position.[18] Many other scholars have explored the possibilities of systems theory for the understanding of social and cultural practices. Perhaps the most significant social theorist to draw on systems theory was Talcott Parsons,

whose action theory was focused on the structural and systemic function of human action.[19] But the study of social systems is associated above all with the German sociologist Niklas Luhmann (1927–1998). Luhmann is of particular relevance because he provided systems theory with much greater conceptual depth, including definition of the basic operations of social systems and their elements. He also examined the meaning and function of evolution as a term of theoretical analysis and, crucially for present purposes, wrote extensively on art.[20] Drawing on a wide and eclectic range of authors, including Edmund Husserl, the mathematician George Spencer-Brown, Bertalanffy, Maturana, and Varela, he saw himself as the heir to Talcott Parsons, and his theory of social systems was conceived as a counter to the tradition of critical theory.

Luhmann first came to prominence with a work jointly published with Jürgen Habermas in 1971, *Social Theory or Social Technology: What Can Systems Research Achieve?*[21] In the late 1960s and early 1970s, the study of systems was still oriented primarily toward the study of organizational, administrative, and technological systems. It is a major preoccupation in Bertalanffy's *General Systems Theory* and in other works by leading advocates of social cybernetics such as Norbert Wiener.[22] This was the case, too, for artists and art critics immersed in systems thinking. In his writings on contemporary art, the American critic Jack Burnham, for example, highlighted the fact that late modern society was no longer oriented toward material objects but rather toward modes of organization and the instrumental concern of maximizing organizational efficiency and utility.[23] This is visible in the rise of systems thinking in military planning and the decision-making apparatus of the Pentagon, but above all it is instantiated in the penetration of everyday life by the computer. The computer is the augury of a profound social and cultural transformation, and it affects art, too. Burnham notes that "the computer's most profound aesthetic implication is that we are being forced to dismiss the classical view of art and reality which insists that man stand outside of reality in order to observe it, and, in art, requires the presence of the picture frame and the sculpture pedestal. The notion that art can be separated from its everyday environment is a cultural fixation as is the ideal of objectivity in science. It may be that the computer will negate the need for such an illusion by fusing both observer and observed, 'inside' and 'outside.'"[24] Luhmann was of the same generation as Burnham, but he was less concerned with the specific impact of computer technology than with the larger project of a renewal of social theory on the basis of systems thinking, and he came to write specialized theoretical accounts of systems phenomena as diverse as the law, religion, love, the mass media, risk, and, of course, art and literature.[25] One of

Luhmann's central preoccupations was the nature of the modern, and it was an axiom of his thinking that the theory of social systems was primarily an account of modernity, which he saw as functionally differentiated from earlier premodern segmented or stratified social formations, where social systems did not even exist.

Luhmann rehearses some of the now familiar criticisms of the synthetic Darwinist view of evolution. However, unlike most of the authors discussed earlier, he makes evolution a central term in his analysis. Indeed, his systems theory was conceived as dealing primarily with the *evolution* of social systems, including art. His major work, *Art as a Social System*, is concerned with the emergence of the modern art system, and he claims that "the description of art, the emergence of a new concept of culture, the cultivation of art as culture ... must be understood as a result of evolution."[26] Before examining this issue in detail, it is necessary to explore Luhmann's general theory of social systems, since this theory is intimately bound up with the concept of evolution.

THE IDEA OF A SOCIAL SYSTEM

Whereas biological systems consist of electrical signals, chemical interactions, and energy exchanges, social systems, according to Luhmann, are constituted by communication, specifically, individual communications. "Society is a meaning-constituting system," and its basis is not social subjects but the recursive network of communications *among* them.[27] The operations of a social system should be seen as "nothing more than events. They cannot persist, nor can they be altered. They emerge and vanish in the same instant, taking no more time than is needed to fulfil the function of an element." Moreover, a social system has no reality except at the level of elemental events. It rests, Luhmann argues, on the "ongoing dissolution of its elements, on the transitory nature of its communications, on an all-pervasive entropy."[28] In contrast, therefore, to social theories that emphasize the role of institutions or structures that frame individual social acts, Luhmann insists on the primacy of basic elemental communicative events.[29]

Such events are uncoupled from the conscious actions of human agents, and this uncoupling stems from the fact that human consciousness is a separate system—the psychic system "lies outside all social systems"—thus it is only by means of communication that individuals can become participants in the social system.[30] This does not mean that the individual is socially irrelevant; the social and psychic systems have co-evolved and are mutually

dependent. Indeed, it is precisely because the psychic system is separate from the social system that there is an impulse to communicate. As Luhmann puts it, "Because operative closure locks the door to the inner life, imagination and thoughts of the other, the other holds us captive as an eternal riddle. This is why the experience of other human beings is richer than any experience of nature."[31] Nevertheless, neither humans, nor their brains, nor their conscious minds communicate. "Only communication can communicate," and communication is generated in a recursive relation to other communications.[32] Thus communication is never a window onto the inner self and is consequently always open to subversion, misunderstanding, and suspicion. This introduces a central theme in Luhmann's work, namely, the failure or disruption of meaning, for "once embroiled in communication one can never return to the paradise of innocent souls. . . . Sincerity is incommunicable because it becomes insincere by being communicated. . . . Therefore communication unleashes a subversive, universal, irremediable suspicion."[33] In this respect, both Luhmann and commentators on his work have observed similarities with the thought of Jacques Derrida, in which meaning and the presence of the Other are problematized, albeit from a slightly different perspective.[34]

This suspicion is not only produced by the fact that the Other remains closed; it is also structurally linked to Luhmann's conception of meaning. Drawing on the communication theory of Claude Shannon and Warren Weaver, Luhmann uses a very specific definition of meaning as a surplus of references to other possibilities. In other words, a meaningfully intended object stands at the center of attention, but at the same time all other possibilities (as well as their negation) are indicated as a horizon, an "and so forth" of experience, as Luhmann describes it. Because the horizon of possibilities always contains more than is possible at any one moment, a selection has to be made; for Luhmann, therefore, the structure of meaning forces a next step, a selection, but at the same time this means that meaning is never settled. To quote Luhmann, "meaning equips an actual experience or action with redundant possibilities," and, as a result, "meaning can gain actual reality only by reference to some other meaning."[35] The fact that there can always be other possibilities introduces a further theme: improbability and contingency. A different meaning could always have been selected, and this fact underlies Luhmann's understanding of art, for "the artwork directs the beholder's awareness toward the improbability of its emergence. If attention is drawn to poetic constructions then it is only because they do not seem very likely." It is this restlessness that drives communication, for a selection must be made, even if the range of choices is between simple affirmation and negation. Indeed, even

the latter is part of the reference system of meaning. Negation is just one of the possibilities of selection, and does not have any higher significance, for "meaning always refers to meaning and never reaches out itself for something else. Systems bound to meaning can therefore never experience or act in a manner that is free from meaning."[36] Meaninglessness is therefore a special kind of meaning, for the *negation* of meaning is always meaningful.

It is the primary role accorded to selection in Luhmann's theory of meaning that makes the theory of evolution a central issue. As for most social theorists, one of Luhmann's central preoccupations is how society produces and reproduces itself, and he frames this issue in terms of evolution, in which there is variation (the surplus references presented by the horizon of possibilities), selection, and then stabilization (i.e., the repetition of a particular selection). However, in using this analogy, Luhmann also explicitly discounts the way in which many social scientists (especially social Darwinists) have used the theory of evolution, namely, as a theory of origins. Instead, in re-using the triad of variation-selection-stabilization, Luhmann formulates the task of evolutionary theory as accounting for how selection and stabilization happen. Specifically, "evolutionary theoretical analysis of history . . . rests on a specifically theoretical formulation of a problem . . . how to account for the high degree of structural complexity that develops once a continuous rather than sporadic and repeatedly interrupted communication has been secured." Related to the theme of improbability, this means that the task of evolutionary theory, and of systems theory in general, is to explain how the improbable becomes increasingly probable. The theory does so by exploring the recursive interactions within the system that gradually impose more and more restraints on the contingent possibilities of being otherwise. Thus even the most premeditated action—such as the creation of a work of art—starts with an arbitrary "cut" in the world, but as the work begins to take shape, further decisions "tighten" the work and restrict one's freedom when the next step is taken.[37] This argument recalls the notion of path dependency in classic evolutionary theory, in which the range of possible variations is constrained by the prior state of the genome or organism.

Luhmann's critical stance toward evolution as a term of historical analysis is evident in his methodological statements about the relation between the two.[38] Whereas history is concerned with causal explanations and temporal sequences, "evolution theory describes systems that reproduce themselves from moment to moment in many individual operations. . . . All this happens in a present and in a world that exist simultaneously . . . such a system has no need of history."[39] The theory of sociocultural evolution makes no reference

to beginnings, and it offers no assertions about the "causal laws of 'the' historical process of social change." Instead, "evolution should be conceived of as a form of transformation in systems, consisting in the differentiated functions of variation, selection and stabilization, which are then observed and combined by means of various different mechanisms."[40]

Luhmann provides a response to what I have suggested are misconceived attempts to explain historical phenomena by means of evolutionary arguments. Indeed, he explicitly discounts the idea that evolution is about origins, for "variation presupposes a prior state that, as a result of evolution, is stable enough to absorb variation."[41] Aside from the argument that the timescale envisaged by evolutionary theory does not map easily onto the historical framework of art historians, Luhmann implies here that to view history (and the history of art) through the lens of evolution is to misunderstand evolution's purpose, for the "prime concern of a theory of evolution is to account for discontinuities and structural changes that suddenly erupt after extended periods of stagnation or incremental growth."[42] Evolutionary theory may account for the burst of Paleolithic creativity, for example, but not for the subsequent development of visual art, because that is beyond its scope.

Like other systems theorists, Luhmann is critical of the notion of adaptation. Echoing Stephen Jay Gould, he argues that innumerable variations have no adaptive function at all. In addition, apparently "adapted" forms coexist with others that seem to have undergone little change: "It has also been irritating that some species of living beings can apparently exist unchanged for millions of years while others evolve under the pressure to adapt." Evolutionary theory, he argues, would have to provide an explanation as to why some organisms have been impervious to the environmental selective pressures that have seemingly driven the evolution of others. Nor is the theory of natural selection through adaptation able to account for the emergence of seemingly "maladapted" forms and practices. The crucial point here is that "maladaptations" *can* be explained in terms of their role in the operation of the system of which they are part: "No steadily improving adaptation of survivors is hence to be expected from evolution. . . . More and more daring disadaptations can thus arise—as long as autopoiesis of the system is not interrupted." Indeed, citing the resistance of some insects to DDT, Luhmann argues that some "adaptations" seem to have taken place *before* the environmental pressures arose to which they proved well suited to respond.[43]

At the root of these criticisms of Darwinian evolutionary theory is the basic premise of systems theory, namely, that systems are constituted by their autopoietic operations, and that while they interact with their environment,

the nature of this interaction (which Luhmann terms "hetero-reference") is determined by their internal operations.[44] Thus, for example, he argues that "the evolution of art is its own accomplishment. It cannot be caused by external intervention—neither the spontaneous creativity of individual artists nor a kind of 'natural selection' by the social environment, as Darwinian theories would have to assume."[45] This is a position already familiar from Bertalanffy, although Luhmann elaborates on it at greater length. The environment of a system may be other systems, and a given system may interact with other systems (the law, for example, with the political system), a phenomenon described by systems theory as "structural coupling," but the difference such a coupling may make to the internal operation of a system will be determined by the system itself. Thus the psychic system and the social system are structurally coupled, but consciousness contributes no operations to communication.[46]

MODERNITY AND THE EVOLUTION OF THE ART SYSTEM

The concept of evolution is central to Luhmann's thinking.[47] Yet with his critical stance toward adaptation, his emphasis on the role of the autopoietic operation of systems, and his distinction between evolution and history, there are fundamental differences with the evolutionary theories examined earlier. The key issue is the significance of evolutionary theory when applied to the specific issue of art. What role does evolution play in Luhmann's theory of art?

In order to answer this question, it is important first to consider Luhmann's theory of social systems as a theory of modernity and to examine the place of the art system in that broader theory. His fundamental thesis is that modern society comprises a series of functionally differentiated systems, such as art, education, science, politics, and the law. This is the consequence of the emergence of a functionally organized modernity out of the previously stratified nature of European society. The term *function*, in keeping with the theory of social systems as *communicative* systems, is primarily a semantic term. Specifically, Luhmann says, "A function is nothing other than a focus for comparison. It marks a problem . . . in such a way that multiple solutions can be compared and that the problem remains open for further selections and substitutions."[48] In other words, each social system has a specific theme—Luhmann refers to it as a "code"—that provides a network of communications with coherence. A code constrains the process of selection, preventing communication from being a random process, and thereby obtains a structural value.

Given that art is one of the systems of modern society, a question of central importance is how it differentiates itself from other systems. Luhmann's answer is that art differentiates itself by thematizing the problem of meaningful communication and, specifically, the relationship between the noncommunicative domain of conscious perception and the communicative domain of society. In other words, art interrogates and foregrounds how conscious subjects participate in social communication. To do this, "art uses perceptions and, by doing so, seizes consciousness at the level of its own externalizing activity. The function of art would thus consist in integrating what is in principle incommunicable—namely, perception—into the communication network." Art achieves this end in a variety of ways. Most immediately, it involves a disturbance of perception, for under normal conditions perception operates on the basis of an economy of vision, "omitting things from view. Seeing is overlooking." Art directs perception toward the overlooked, for "once we are warned we start paying attention." While this claim seems most immediately relevant to the visual arts, it also applies to literature, in which the medium is words. Thus in poetry, connotation dominates over denotation, and the poem communicates not through verbal propositions but "by virtue of the ornamental structure of mutually limiting references that appear in the form of words." This occurs through combinations of meaning, sound, and rhythm in which the sensuous perceptibility of words plays a central role. By such means, literature "aims at disrupting automization and delaying understanding."[49] Techniques of representation thereby become an end in themselves, in a process intended to achieve a disruption of automated patterns of meaning.

Luhmann's account of art is primarily a theory of modern art, and it revolves around contingency. All social systems are contingent, but the distinctive feature of modernity—and of modern art—is reflection on its own contingent status. This orientation is evident, too, in Luhmann's valorization of the new. It is not enough, he argues, for the art system simply to repeat earlier communications; if this happens, it breaks down into merely "general social communication about artistic quality, prices, the private life of artists, their successes and failures."[50] Instead, new communications, something artistically new, must be produced that convey information not only in themselves but also in relation to other communications, other artworks. Although it was only in the twentieth century that such self-reflection became the decisive feature of art, there were, by Luhmann's reckoning, numerous precursors in the eighteenth and nineteenth centuries that led to the emergence of art as a functionally differentiated system. Romanticism in particular offers a powerful example; the focus on the noncoincidence of consciousness and

communication can be found in the romantic philosophy of the symbol, he argues, or the aestheticization of the self, from the Georgian dandy to the modernist aesthete.[51] The epistolary novel is also an important illustration of this principle, because it presents "writing as a form in which absences . . . can be present," thereby uncoupling discourse from the presence of the speaker as the source of its immediate truth. The epistolary novel thus presents "passing feelings that cannot be united with reason," highlighting the noncoincidence of the psychic and social systems, symbolized in the public medium of written correspondence.[52] The foregrounding of contingency is visible in the romantic fascination with the doubling of reality, i.e., positing the possibility that reality could be *otherwise*, and this is expressed in the figure of the doppelgänger, from which "the informed reader could infer that the author had split himself into two different personae that communicate with one another. As Schlegel puts it: 'Nobody can know himself unless he is both himself and another.' . . . Under such conditions one could exploit the dissolution of identity in order to represent both the difficulties and the failure of the ego's self-reflection as a problem of communication."[53]

The importance of fiction for art and literature is also a central aspect of Luhmann's theory. Fiction is not simply a matter of adding something to the world. It has a very particular relation to the real, for "every decision to fix something diverts one's gaze . . . and draws attention to what might still be done or attended to."[54] In other words, the fictional draws attention to what is excluded, and consequently, "art points out that the scope of the possible is not exhausted, and it therefore generates a liberating distance from reality."[55] In particular, Luhmann claims, "the imaginary world of art offers a position from which something else can be determined as reality. . . . Without such markings of difference the world would simply be the way it is. Only when a reality 'out there' is distinguished from fictional reality can one observe one side from the perspective of the other."[56] More is at stake, however, than the idea that art simply presents imaginary alternatives to the present, for such fictionality and doubling are intimately connected to art's social function:

> The art system realizes society in its own realm as an exemplary case. It shows things as they are. It shows what society entered into when it began to differentiate individual functional systems and abandoned these systems to autonomous self-regulation. Art exemplifies a situation in which the future, no longer guaranteed by the past, has become unpredictable. Operative closure, the emancipation of contingency, self-organization, polycontexturality, hypercomplexity

of self-descriptions, or simpler and less accurately formulated: pluralism, relativism, historicism—all these trends offer no more than different cross-sections of the structural fate of modernity.[57]

Such doubling has other consequences, too. Since *meaning* is driven by the difference between actuality and nonactualized possibilities, the doubling of reality is built into the structure of meaning. Moreover, "because every horizon occasions this doubling, the world trails off into the endlessly large and the endlessly small. In the modern worldview this appears as the sublation of all external boundaries and as the dissolution of all elements, of all the points where this dissolution might stop"[58]—hence the particularly modern preoccupation with the category of the sublime as a point of dislocation of the subject. This thematizing of contingency stands in opposition to art in the premodern era, which took the world and its representations as givens. Renaissance perspective exemplifies that older ontology, Luhmann argues, for Brunelleschi's invention was merely intended to replicate how viewers normally see the world, and it is an "(invisible) means to seduce them into doing so."[59] Only later did perspective itself become an object of reflection, with the self-aware image, as Victor Stoichita calls it, foregrounding perspective as artifice. There are parallels here with the discussion of perspective in the first chapter, in which the emphasis was on the way perspective became an autonomous system; even if it initially mirrored perception—a much-debated point—it then came to provide opportunities for perceiving *otherwise*.

Luhmann's discussion of art is illustrated with numerous concrete historical examples, but it cannot be considered a work of historical sociology because Luhmann limits himself to the analysis of structural shifts and discontinuities. This is in keeping with his conception of evolutionary theory. Hence, the aim of *Art as a Social System* is not to provide a social history of art and literature since the eighteenth century, but to account for the emergence of the art system, with specific works of art and literature functioning primarily as indicators of this deeper systemic shift. A number of unresolved tensions and contradictions in Luhmann's use of evolutionary theory require further analysis. One particular issue that lays him open to the charge of inconsistency is his discussion of so-called pre-adaptive advances, or enabling conditions that preceded the emergence of the social system of art. Special significance is given to ornament as a precursor of the emergence of the art system: "A habitual pattern cries out, so to speak, for variation. A small alteration yields consequences; it requires further elaboration and supplementation, or else it must be eliminated as inappropriate—and this

happens repeatedly in numerous attempts that might succeed or fail, establish a tradition or perish." Even before the concept of autonomous art, Luhmann argues, ornament demands a process of recursive self-observation oriented around the question "How do I go on?" that cannot be answered by reference to the environment, and this is linked to the fact that "the artwork demands decisions concerning what fits (is beautiful) or does not fit (is ugly) for which there is no external orientation." Luhmann also offers rather more traditional sociological explanations for the rise of the art system. The stratified society of medieval Europe was favorable to the emergence of a functionally differentiated art, he argues, because it allowed for the social elevation of the artist. In addition, competition between rival courts and republics in the Italian peninsula of the fifteenth century, and the splitting off of Protestantism from Catholicism, altered the relation of art to the revealed truths of religion, and thereby favored the rise of an art world as something distinct from and no longer subservient to the church.[60]

For all his disavowal of historical explanation, however, these appear to be historical explanations, and this is also where the difficulties begin. For Luhmann claims not to be offering a causal account of the origins of the art system and merely to be identifying its enabling conditions. But it is not clear what is meant by the idea of "enabling conditions." How did such conditions make it *more* probable that the art system would emerge? Why were *these* and not others the enabling conditions? His theory provides no answers to these questions, and at times appears to offer little more than observations about correlations between certain general sociocultural phenomena and the emergence of the art system.

One may be reminded here of Sahlins's criticism of evolutionary theory, for it appears that Luhmann's explanation offers little more than identifying the possible and the limits of the possible. Moreover, he does not indicate the relationship *between* the enabling conditions. For instance, it is not clear whether any of them was more significant and decisive than any other. This clearly limits the explanatory capacity of his approach. It is also difficult to establish how systems theory offers *new* readings of a familiar subject. The argument, for example, that the stratified nature of Renaissance society enabled the rise of art reiterates an art-historical commonplace, albeit couched in different terminology.[61] Many of the other factors he lists would equally be expected to feature in standard surveys of Renaissance and post-Renaissance art.

There are other difficulties. In drawing a distinction between systems theory and history, Luhmann relies on a strong binary logic; either there is a system or there isn't, and this is linked to the broader critique of adaptation

outlined earlier: either the system is adapted and it operates or it is not and it dissolves. As Luhmann states, "Autonomy allows for no half-measures or gradation; there are no relative states, no more or less autonomous systems. Either the system produces its elements or it does not."[62] It may evolve, redraw its boundaries (and thus redefine its environment), or undergo structural changes, changes of code and program, but a system cannot exist halfway or in an interim stage. Luhmann insists on an absolute difference between system and nonsystem. There is a rigor and consistency to this approach, and it recalls the comments of Wuketits and Varela on adaptation, but given Luhmann's careful exploration of the various "pre-adaptive" advances, it raises the obvious question: at what stage can one talk of art as a fully autonomous social system? What was the tipping point at which such pre-adaptive advances converged into a functioning system? How does one distinguish between the various favorable social factors that enabled autonomous art and the art system itself? These are more than merely rhetorical questions, since they go to the heart of the viability of systems theory as a conceptual framework for historical analysis. Luhmann provides no clues as to how they might be answered. He states on various occasions that the rise of the art system occurred "around 1800" and was linked to romanticism, but he does not identify any factor that constituted a decisive break.

One candidate could be the publication of Kant's *Critique of Judgment* (1790), which not only fits into the proposed time frame but also draws a crucial conceptual distinction between aesthetic judgment and pure and practical reason. Luhmann does see the German aesthetic tradition as providing an important theoretical articulation of art's autonomy, but, equally, he places importance on the pre-critical aesthetics of Hutcheson and Shaftesbury.[63] Moreover, since it is primarily through artworks that the system operates, Kant's *Critique of Judgment* would not answer the question. When it comes to identifying the point at which works of art functioned as elements and productions of an autonomous art system, matters become even more blurred. For example, the paintings of Caravaggio or Tintoretto could arguably be seen as exemplifying art's self-awareness, a crucial feature of the system inasmuch as they not only depict religious truth but also interrogate the artistic means of doing so. Equally, however, they might be regarded merely as precursors, in that their art is still subordinate to the task of revealing religious truth. In order to decide where they belong structurally it would be necessary to provide a heuristic for differentiating between these two aspects of their work. It might be the case, for example, that since they were exceptional artists who went against the grain of artistic practice, it would be premature to talk of an

art system, when there were so many other features of art that were rooted in the still stratified society of Renaissance Italy. At the same time, however, since there never are entirely clean breaks, such a solution would suggest that the identification of system rests on a quantitative calculus. On such a view, an art system (or indeed any system) would have emerged only once a critical mass of communications of the right kind took place. We might also inquire as to the status of artworks that remain anchored elsewhere. It is not clear how to categorize the innumerable altarpieces in provincial churches across Europe that continued to be made as pious depictions of the saints, the Virgin, or Christ, and that were motivated by none of the concerns of autonomous art. Left behind by the emerging social system of art, they became, following the logic of Luhmann's argument, socially irrelevant—a highly questionable conclusion, in that it relies on an implicitly teleological image of social development.

The stress on the absolute difference between the system and the state prior to its emergence represents a significant departure from Darwinian notions of evolution. Whereas Darwin described evolution as a continuous process of change in which small-scale variations could, over time, achieve a large-scale cumulative effect, Luhmann insists that the emergence of systems cannot be understood as the result of such a process. In this respect, his thought shows certain affinities with the biological works of Niles Eldredge and Stephen Jay Gould, who, with their notion of punctuated equilibria, envisioned evolution as occasionally undergoing periods of rapid disruptive change—saltationism.[64] But there are important differences, too, for Gould's primary concern was with the *pace* of evolutionary change, whereas it is implicit in Luhmann's account that there are certain changes that cannot be accommodated within an evolutionary framework. Systems evolve, but the process leading to the emergence of a system is not governed by evolution, since it lies outside the operations of any individual system. Luhmann does not spell out what this process is. In this sense, his theory suffers from the weaknesses of other social and cultural authors, including Foucault and Bourdieu, who conceive of historical change in terms of rupture and the displacement of one paradigm by another.[65] A more productive point of comparison might be Thomas Kuhn's notion of paradigm shift. Most critical attention has tended to focus on the much-misused notion of the paradigm in the history of science, but the crucial issue here is Kuhn's argument that paradigm shifts are generated internally when a certain tipping point is reached. On this account, the accumulated body of empirical insights and observations gathered as part of "everyday" science becomes impossible to

accommodate within the existing paradigm, no matter how many auxiliary theories are summoned to shore up existing bodies of knowledge.[66] This theory presents a possibility as to how evolutionary variation, selection, and stabilization relate to the para-evolutionary process of systemic change; for example, the sheer quantity of variations might overwhelm the ability of the system to select and restabilize. But Luhmann does not explore this option, and his account of evolution is undermined by unresolved weaknesses as a result.

One final basic issue requires critical interrogation: the nature of selection. Luhmann builds his systems theory on the evolutionary pillars of variation and selection. Social systems produce, through the sheer quantity of communications, variant forms, many of which may be trivial but some of which may alter the structure of the art system, *if* selected for repetition. Luhmann's rejection of adaptation severely restricts the explanatory capacity of his approach. He states unequivocally that "the evolution of art . . . cannot be caused by external intervention—neither the spontaneous creativity of individual artists nor a kind of 'natural selection' by the social environment."[67] The result of this uncompromising position is a reduction to the observation *that* there are selections, without a theory of why certain variations may have been selected over others.

Luhmann's critical attitude toward adaptation ensures that he is spared the criticisms leveled at the various theories of cultural adaptation discussed earlier, but his alternative offers no account of the kinds of factors that would be responsible (in a causal fashion?) for certain possibilities being selected over others. As John Mingers argues, "It is one thing to say analytically that communications generate communications, but operationally they require people to undertake specific actions and make specific choices."[68] Because people provide a nexus between different systems, the reasons for particular selections may lie outside the system itself. Thus artworks may be made for a number of religious, moral, aesthetic, and political reasons; in addition, they may be made because of certain operations of the psychic system (i.e., personal and psychological dispositions of individual subjects). The key point is that the reasons for their creation do not reside within the operation of the system itself. It might be objected that Mingers is simply trying to hold on to a philosophy of the subject, precisely what Luhmann wants to jettison. But the price for Luhmann's theoretical consistency, his insistence that systems theory is not intended to provide causal explanations, is that it offers a positivistic registration *that* there are selections among the countless variations of any social system, but without any further analysis.

Until now, I have focused on Luhmann as the most theoretically sophisticated representative of the systems-theoretical analysis of art. There is no shortage, however, of comparable attempts. Many of these have been in literary theory and criticism, but others have been more directly concerned with the visual arts.[69] The most ambitious has been Beat Wyss, who has drawn a schematic outline of the emergence of the art system, reiterating many of Luhmann's basic ideas. Wyss identifies a threefold history of the visual sign—cultic symbol, rhetorical icon, mechanical index—and tries to map this history onto the emergence of art as an autonomous social system. The latter came into existence, Wyss argues, when art developed self-consciousness as a tradition and its primary point of reference—the network of art—gained precedence over its function of presenting divine revelation and truth. Indices of this shift can be identified in the emergence of the concept of the artist and the decline of the guild system, together with the rise of a self-consciousness of style. The first instance of this new self-consciousness, he argues, was the influx into Europe of images from Byzantium in the early twelfth century. "The step from Byzantine to Byzantinism made it possible to see images as images"; their alterity drove a consciousness of artistic difference, and hence "the acquisition of an alien pictorial formula stands at the origins of the art system."[70] The details differ from Luhmann's account, in that Wyss places the emergence of the art system a century and a half earlier than Luhmann does, and some of his other examples vary, but in its general outline this is the same basic narrative, albeit with the inclusion of Hans Belting's ideas about the history of representation.[71] Wyss sketches a periodization that circumvents traditional art-historical divisions. While the Renaissance remains an important feature of the artistic landscape, he suggests that it lacks the epochal significance usually attributed to it in that the art system only fully emerged considerably later, while its enabling factors can be traced back some 150 years earlier.

The art-historical significance of systems theory and, in particular, its potential for rethinking the structural principles of art's history have also been examined by Kitty Zijlmans.[72] Zijlmans focuses on the fact that in Luhmann's theory of communication, each social system is identified by the particular binary communicative code, with negative and positive terms, that drives its communications. The economic system is thus organized around the communicative theme of payment/nonpayment, the legal system around that of justice/injustice, and the art system around that of beauty/ugliness.[73] This last distinction is not a retreat into a problematic formalism; it is simply

Luhmann's shorthand reference to the fact that the art system is structured around *aesthetic* binaries rather than, say, moral ones. Zijlmans takes up this emphasis on the binary structure of the code but amplifies it by reference to the way in which other binary oppositions, such as those between high and low, civilized and primitive, figurative and nonfigurative, art and kitsch, played equally important roles in guiding communications within the art system.[74] The key point for Zijlmans is that in place of the problematic periodization by style (or indeed by other poorly defined sociopolitical criteria), a systems-theoretical approach may organize art around the binary distinction operative at any particular time.

Other commentators have focused on the significance of systems theory for the understanding of modern art in particular. The cultural theorist David Krieger has argued that with the rise of modern art, the autopoiesis of the art system is apparent in the fact that art no longer represents something else; it no longer "refers to a subject beyond the work of art."[75] Instead, in a strikingly Greenbergian reading, Krieger argues that art points toward the limits of its representational possibilities, toward the capacities of a certain medium, or "channel."[76] Thus "painting, sculpture, music and poetry articulate the possibilities of their respective channels."[77] Following Luhmann's valorization of the *new*, Krieger also argues that art's systems-theoretical function is the creation of new forms: "In western culture the production of information is termed 'creativity' or 'innovation.' In our culture there is a novel division of cultural labour, whereby the task of bringing forth novelty is assigned to a particular social realm. That realm is called 'art.'"[78] In an information society, the central purpose of art is the transformation of identities, and, conversely, identity politics is inescapably coupled with the art system. This claim is borne out, Krieger argues, by the way that identity has come to be configured in dynamic performative terms, replacing a world marked by immediacy, plenitude, and the stable, self-present subject.[79] More recently, Francis Halsall has pointed toward the parallels between systems theory and the ideas of the art world of Arthur Danto and George Dickie.[80] According to this argument, there are strong affinities between Danto's description of the network of practices and institutions of the modern art world (including artworks, artists, dealers, galleries, critics, and museums) and the art system.[81] Danto's much-cited Hegelian discussion of Warhol's Brillo boxes, which views Warhol as signifying the dissolution of art into the philosophy of art, prompts comparisons with Luhmann's emphasis on the priority of the communicative function of art over its material properties.[82] Yet, Halsall points out, a systems-theoretical analysis can also inform the reading of the formal and iconographic features

of a work of art. Drawing on Luhmann's foregrounding of the role of contingency in the systems-theoretical definition of art, Halsall examines how the drip paintings of Jackson Pollock instantiate this contingency, for "the identity of the work itself is fluid rather than static, ambiguous rather than definitive," and it presents the challenge of "having to construct meaningful content in the face of a work of art that not only lacks a clear meaning but also fails to suggest any single and obvious strategy for determining any such meaning."[83]

The relationship between art and subjectivity is explored in a more recent work by Sabine Kampmann, who has emerged as one of the leading advocates of systems theory in art theory and criticism.[84] Focusing on Christian Boltanski, Eva and Adele, Markus Lüpertz, and Pipilotti Rist, Kampmann examines the particular questions these artists raise about the nature of authorship in the context of Luhmann's larger systems theory, including his casting of the artist figure as a function of the art system. Thus Boltanski's presentation of obviously fabricated memories, for example, calls into question not only the reliability of remembering but the very idea of personal identity. In addition to their questioning of gender identities, Eva and Adele also question the distinction between the public performative self and the domain of private experience.

Such readings indicate the extent to which artistic and personal subjective identity are interrogated in contemporary practice, and one can only concur with Kampmann's judgments. However, while she provides the outline of a Luhmannian theory of authorship, her detailed readings make their substantive points without reference to the wider theoretical framework she spells out. Nor do they need to; her points would not look out of place in a traditionally semiotic, feminist, or cultural materialist reading. This observation points to a broader issue in the wave of systems-theoretical analyses of art: the use of systems theory does not appear to make a *difference*; rather, it mainly provides an additional layer of theoretical terminology. This problem is evident in Wyss's work. Couched in the terminology of systems theory, it repeats what are now orthodoxies of art history about the emergence of a notion of artistic and aesthetic value that was no longer dependent on the theological role of art, coupled with the rise of the self-conscious profession of artist and the heightened significance attached to exemplary masterpieces. Likewise, Halsall's analysis of the art system repeats but does not significantly expand existing theories of the art world, and while his characterization of the interpretative conundrums presented by Pollock's work may be apt, there is nothing about it to suggest that systems theory provides a stock of interpretations unavailable to other approaches.

Such criticisms focus on pragmatic issues, but for all its sophistication, Luhmann's thinking has also been subject to some fierce theoretical criticisms. One of the most trenchant critics has been Jürgen Habermas, for whom Luhmann offers little more than an ideological defense of bureaucratic reason and procedure.[85] Famously, Habermas has described Luhmann's approach as relying on two images, the first being "the flow of official documents among administrative authorities," and the second "the monadically encapsulated consciousness of a Robinson Crusoe."[86] The reference to administrative authorities is an allusion to Luhmann's early career as a civil servant, but there is more to this image than a merely personal jibe, for Habermas's point is that the emphasis on the functional basis of rationality (conceived of as communication within the bounds of any one system) deprives Luhmann of the ability to identify the point at which it becomes a tool of oppressive means-ends reasoning—a cornerstone of critical theory since Adorno and Horkheimer published their *Dialectic of Enlightenment* in 1944. In addition, Habermas argues, the view of communication as external to the psychic system, in which "the achievement of linguistic symbols is exhausted by articulating, abstracting and generalizing prelinguistic conscious processes and meaning connections," severely limits systems theory's analytical capacity.[87] Systems theory can no longer account for the socialization of subjects *through* language, nor does it have the tools to analyze consensus or conflict about the validity of linguistic utterances, or of intersubjectively shared contexts of meaning and reference. Habermas also argues that Luhmann's atomized image of communication (as composed of innumerable individual ephemeral events) renders it incapable of accommodating higher-level forms of communication and discourse, of which the most important arena is the public sphere. Finally, with communication defined solely in terms of its role in maintaining individual systems, there is no means of evaluating discourses—ideologies—in ways that go beyond considering their merely functional role.

Defenders of systems theory can claim that the positions of Luhmann and Habermas are so incommensurable as to make Habermas's criticisms irrelevant.[88] His utopian visions of an ideal speech situation or an ethics of discourse would be, for Luhmann, instances of a lingering desire for a lost center that is no longer tenable in a polycontextural world. Yet Habermas's criticisms retain traction, particularly when it comes to the use of systems theory in the humanities. Systems theory may be appealing because of the apparent rigor and universality of its concepts, but its refusal to adopt normative

positions restricts its value as an interpretative method.[89] In contrast to feminism, Marxism, or postcolonialism, which not only comprise methods of analysis but also interventions into the formation of the literary and artistic canon, systems theory is unable to contribute to debates over the nature of the field. Object choice is a matter of indifference to systems theory, as a result of which systems-theoretical approaches accept the cultural canon as a given. This is evident both in Luhmann's own writings, which, as noted earlier, unquestioningly accept art-historical orthodoxies, and also in the fact that the growing body of systems-theoretical approaches to art and literature routinely focus on well-established classics. Luhmann's own acceptance of such norms has led some observers, most notably Fredric Jameson, to accuse him of being little more than an apologist for capitalist modernity.[90] Thus, although *Art as a Social System* covers an impressively wide range of examples drawn from the history of art, music, architecture, and literature, they are canonical works, and the book's strength as a work of historical analysis lies in its ability to subsume them in a synoptic view. For all its promise, Luhmann's work frequently offers little more than a "redescription" of familiar topics. Indeed, Luhmann openly refers to his work as providing just that, an acknowledgment that, if it does not invalidate the project, at least demands analysis of its purpose and value.[91]

This weakness is akin to a more general basic difficulty in evolutionary accounts of art. It may well be that facial recognition has deep evolutionary origins, that the response to landscape depends on atavistic memories of optimal Pleistocene environments, or, indeed, that abstract geometrical paintings stimulate neural networks, but acknowledging this does little to help interpret the significance of individual images and artifacts. This is why evolutionists either fall back on traditional understandings and interpretations, or identify general correlations with broader "distal" origins, but little more. This failing reflects the abstract nature of evolutionary theory and recalls Habermas's complaint that the theoretical armature "stemming from the natural sciences [is] too remote from everyday experiences to be suitable for channelling distantiating self-descriptions into the lifeworld in a differentiated manner."[92] Directed at the various attempts to view the history of art and literature through the lens of systems theory, this observation has a far deeper pertinence, for it illustrates the broader problems of the project of evolutionary art and cultural history.

One might object that such criticisms are misplaced, that it is not Luhmann's goal to provide the kinds of empirical insights that they demand. Yet they nevertheless reveal the weaknesses of systems theory as a discourse of historical analysis. The work of Kampmann and Wyss illustrates this clearly. On the other hand, it may be premature to dismiss Luhmann entirely. Recall

his concept of autonomy and its relation to the theory of meaning. At first glance, this notion appears to be heavily formalistic and, given Luhmann's emphasis on the role of art in disrupting perception and meaning, tied to a high modernist conception of art. On further inspection, however, his theory of meaning suggests why autonomy is not so easily overcome. His reading of the experimental performance art of Fluxus, the use of readymades, and the Dadaist program of anti-art contends that it was the very effort of these practices to break out of the restrictions of the category of art that betrayed their status as artistic practices. This raises new analytical possibilities and casts new light on, for example, the failure of Dada or constructivism to negate the category of art.[93] In the case of Dada, this can be seen in Tristan Tzara's move to the magazine *Littérature* in 1921 and his turn away from the political practices of the Zurich performances toward an aestheticized poetics. Likewise, constructivism degenerated into an aesthetic style in the hands of, for example, Naum Gabo and Ben Nicholson. In place of the critique that views such examples as a turn away from the radical vision of the revolutionary and wartime avant-garde, this confirms, for systems theory, the status of anti-art as an operation of the art system rather than a radical departure from it. The negation of art and of meaning was locked into the binary code of the system (art vs. non-art), and in its definition of non-art as the forms of popular culture, it performed nothing more than a standard procedure of any system, namely, drawing a boundary between its operations and those of its environment. The subsequent retrieval of Duchamp by artists in the 1960s—the "Duchamp effect"—also underpins this reading, for it indicates the extent to which Dada has come to figure in the art system's construction of its own past.[94]

Comparisons can also be drawn with the fate of more recent forms of institutional critique by such artists as Michael Asher, Hans Haacke, and Andrea Fraser. As Fraser has acknowledged, such critique has itself become institutionalized; it has become an accepted part of the contemporary art world and is promoted and sponsored by art galleries keen to demonstrate their progressive self-critical credentials.[95] A politically committed analysis might read this as an instance of institutional recuperation, facilitated, too, by the ease of commodification of such artworks—including performances by Fraser herself. But a systems-theoretical reading would, in contrast, regard the institutionalization of critique as originating in the logic of the art system. Institutional critique in this sense can only ever be an immanent critique.

All of this suggests, paradoxically, that it is the stability or *persistence* of art as an autonomous system, rather than the intrusion of external forces, that

explains the failure of the avant-garde. Another instance of such counterintuitive reasoning can be found in Luhmann's reading of the art market. In his view, commodification, far from negating the autonomy of art, strengthens it. Indeed, according to Luhmann, the rise of the art market was one of those "favourable conditions" that underlay the emergence of art as a differentiated system. The art market arose when traditional patterns of patronage rooted in a stratified society gave way to remote forms of patronage exercised through mediators (connoisseurs, dealers), and "market yields became a symbolic equivalent of an artist's reputation." Market values "replaced oral recommendations . . . they substituted for the tedious personal negotiations with a patron, which always included irrational values such as aristocratic generosity and symbols of the artist's reputation." Financial speculation in artworks grew, with growing discrepancies between the market prices of different works, yet this drove the autonomy of art further; the heightened stakes involved in the emergence of art as a commodity, including the proliferation of copies and forgeries and the attendant risks involved in investment in art, produced the need for experts were who able to distinguish between genuine works and fakes, make qualitative judgments about works of art, and identify works by masters (as opposed to those by lesser artists). Thus "the patron no longer defined himself by social rank and aristocratic generosity but based himself instead on his expertise, that is, on function-specific capabilities."[96] The financial insecurities produced by the art market were then internalized by the art world (or, in Luhmann's terminology, there was a reentry of a specific relation between the art system and the economic system into the art system) through, for example, the unmooring of art criticism from universally agreed upon criteria. Through such artistic recoding of economic operations, the art system maintained its autonomy.

The systems-theoretical approach also casts fresh light on what Zygmunt Bauman has referred to as the "using up" of art—the exaggerated transience of contemporary art, which has become reliant on "highly publicized, carnival-like" exhibitions in a system increasingly oriented toward a "sensation by definition short-lived and until-further-notice."[97] Reiterating a well-established attack on the impact of commodification on art—the waning of affect—that Greenberg had already articulated, Bauman is concerned about the temporality of art, which seems to have internalized the logic of fashion and consumerism. A Luhmannian reading, by contrast, would suggest that the speeding up of art is a function of the autonomous evolution of the art system, rather than of a co-opting of art by late capitalist consumer culture. In opposition to Lash and Urry's influential claim that "in the shift from organized to disorganized

capitalism the various subjects and objects of the capitalist economy circulate
... at ever greater velocity ... [and] objects as well as cultural artefacts become
disposable and depleted of meaning," a systems-theoretical reading would
object that such disposability is a function of the system itself.[98]

~

Systems theory raises important issues for traditional evolutionary theory and
its assumed relation to history. Guided by ungrounded hypotheses about ori-
gins, evolutionary explanations of artistic and aesthetic practices have proved
deeply problematic, unable to move beyond the observation of abstract and
undifferentiated correlations between biological and cultural phenomena.
Luhmann's redefinition of evolution in terms of the operations of individual
systems deflects critical attention from the adaptationist speculations that
have characterized much of the writing examined elsewhere in this study. Yet
numerous unanswered questions remain. Luhmann frequently cites Gregory
Bateson's well-known definition of information as a "difference which makes
a difference."[99] It may be asked of Luhmann's systems theory whether it does,
in fact, make a difference. For all the conceptual and rhetorical brilliance of
his writing, *Art as a Social System*, like the numerous essays he has published
on art, has done little to expand, challenge, or revise the existing landscape
of art-historical analysis. The reasons for this are varied and range from
Luhmann's insistent rejection of the normative framework of critical theory
to the abstract nature of his thought. The crucial point is that while advocates
of a systems-theoretical approach to art and culture have proclaimed its revo-
lutionary significance, it is open to the charge that it has changed very little, if
anything. Indeed, its intervention into the reading of contemporary art raises
the suspicion that systems theory offers little more than passive acceptance of
the status quo, a skeptical dismissal of avant-garde critiques as merely empty
gestures of protest.

CONCLUSION

On the Multiple Cultures of Inquiry

In his Darwinian polemic of 1995, *Darwin's Dangerous Idea*, Daniel Dennett famously refers to the theory of evolution as a universal acid: "it eats through just about every traditional concept, and leaves in its wake a revolutionized world view, with most of the old landmarks still recognizable, but transformed in fundamental ways."[1] Not only does Darwin's theory dismantle old biological hierarchies, Dennett argues, but it also has important consequences for the understanding of a variety of aspects of human existence. These range from cognition and perception to language and ethics. If human biological makeup is a consequence of natural and sexual selection, it follows, he argues, that cultural practices are themselves the product of evolution. Dennett is critical of what he terms the "greedy reductionism" of sociobiology, in which all aspects of human behavior and culture are held to be directly traceable to their biological and adaptive functions.[2] Indeed, he pointedly rebuts the tendency of sociobiologists to assume that apparent cultural universals must have a genetic and evolutionary origin.[3] Yet despite such caution over the uses of evolutionary theory, the aim of Dennett's work is similar to that of sociobiology, namely, to formulate a naturalistic account of humans that encompasses the biological and cultural domains. Unless one resorts to an untenable dualism and draws a hard ontological distinction between mind and body, he argues, there is no alternative to viewing the mind and its activities—cultural and social life—in a framework that also incorporates human biology.

This book has been concerned with the various attempts to construct just such a framework. The starting point was E. O. Wilson's project of "consilience,"

Wilson's approach to overcoming the institutional and intellectual gulf dividing the natural sciences from the arts and humanities. In outline, this may be a laudable goal, but when the details are examined more closely, it turns out to be deeply problematic. First, the call for consilience turns out to involve anything but a meeting of equals. Rather, the rhetoric deployed by its keenest advocates suggests a determination by evolutionary theorists to attain mastery over the field of knowledge, subordinating other domains to their own concerns. An unambiguous illustration of this point can be found in Edward Slingerland's assertion that "the place of the humanities in the larger world of human knowledge is a bit like that of present-day North Koreans: having lived in jealously guarded isolation for so long it is going to be much more difficult for North Koreans to adapt to and learn about the modern globalised world."[4] The seemingly innocuous title of the book in which Slingerland makes this assertion, *What Science Offers the Humanities*, masks his aggressive advocacy of the proposition that "science," by which Slingerland means neo-Darwinism, should take the place of humanities research. The latter, he argues, is held up by "mysterianism," an untenable ideology of mind-body dualism, and its practitioners are driven by a defensive *ressentiment* toward the superior claims of the theory of evolution and the biological sciences. Other representatives of consilience have been even more outspoken. Steven Pinker, perhaps the best-known popularizer of evolutionary psychology, has said of literary studies that "the field's commitment to the dogma that the mind is a blank slate and that all human concerns are social constructions has led it to focus on cultural and historical particulars, banishing the deeper resonances of fiction that transcend time and place. And its distrust of science (and more generally, the search for testable hypotheses and cumulative objective knowledge) has left it, according to many accounts, mired in faddism, obscurantism, and parochialism."[5]

For anyone who wishes to reject Pinker's characterization, the awkward fact is that some opponents of Darwinism in the humanities have exemplified just such a position. Thirty years ago, the author and literary critic David Holbrook concluded a study of Darwinist theory in the humanities by stating that "there are words I want to use which science threatens to deny me: I want to speak of 'higher things,' a 'gradient' in nature, order, harmony, direction, primary consciousness, intelligence, striving, ingenuity, achievement and aims."[6] This desire does little to address the challenge of the evolutionary paradigm, and only fuels the suspicion of authors like Slingerland and Pinker that the humanities are unable to meet the challenge they have set. Moreover, the objection that proponents of neo-Darwinism are blind to the ideological underpinnings of scientific research, and thus of their own position, is unlikely

to gain purchase, for it depends on a constructionist epistemology that they explicitly dismiss as the "standard social science model."

Even though it undoubtedly *is* the case that Pinker, Slingerland, Wilson, and others adhere to a problematic and un-self-critical ideology of science and knowledge, simply pointing this out will achieve nothing, because they have already discounted the grounds on which one might make such an observation. Critics of neo-Darwinism must therefore take its arguments seriously, must consider whether they are tenable on their own terms, and, crucially, must examine whether they live up to their claim of rendering "humanistic" inquiry redundant. It is that kind of analysis that I have endeavored to provide here, by identifying the internal flaws in the logic of the neo-Darwinian position. Specifically, I have sought to demonstrate that evolutionary aesthetics relies on a self-contradictory view of aesthetic experience, positing a putative ancestral Pleistocene environment as the ground zero of human nature, as if all human history in the intervening 2.5 million years were a superficial cultural overlay, and as if evolution had then suddenly come to a halt. The neo-Darwinists view art and the capacity for aesthetic response as an evolved adapted behavior, but they operate with an attenuated idea of evolutionary theory focused on natural selection, ignoring the implications of Darwin's discussion of sexual selection.

Even if the idea of art as adaptation is accepted, Dawkins's argument about temporal lag raises the possibility that the aesthetic impulse is the expression of an adaptation that may have its origins in an entirely different (nonaesthetic) phenotype. This in turn raises questions as to what kinds of speculation are warranted about art's supposedly adaptive origins, even within the terms of evolutionary theory. Entirely opposed adaptational functions can be argued for with equal force, since there is no evidence to support any of them, and it is difficult to adjudicate what might even *count* as evidence. Furthermore, as Darwin and numerous others since have observed, many aesthetic behaviors, from birdsong to human art making, develop their own momentum and evolve out of pure pleasure in the activity itself, regardless of its putative adaptive origins. This argument has been advanced not only by opponents of the evolutionary model but also by evolutionary theorists who have sought to uncouple the evolutionary process from crude Darwinian accounts. For systems biologists and theorists such as Luhmann, this alternative can be found in the autopoietic operations of the art system. Alternatively, Michael Tomasello highlights the "ratcheting" effect whereby cultural learning and transmission enable the achievement of cognitive capacities and skills that bear no relation to putative adaptational pressures that may have once existed.

The adaptationist principle central to Darwinian accounts of art does not explain, either, why an image—a landscape painting, for example—that depicts an environment once conducive to survival should become the object of *aesthetic* pleasure. Even if the origin of aesthetic behavior *can* be traced back to sexual impulses and the drive to sexual selection—the much-cited instance of the bowerbird suggests such a relationship—this is still a long way from positing an identity of the two. Evolutionary aesthetics omits entirely from view the normative dimension of aesthetic judgment; as Anthony O'Hear has stated, "There would just be no sense in arguing that the peahen who failed to respond to luxuriant tails was making a *mistake* in judgment, as opposed to lacking a particular behavioral response."[7] It is in this difference that the crucial distinction between the aesthetic domain and evolutionarily programmed responses to certain phenotypic expressions can be located. This is not, of course, to deny that the one may find its origins in the other, but advocates of evolutionary aesthetics leave the argument at just the point where detailed analysis of the relation between the two is required. Even if the origins of art lie in the biological evolution of one or more capacities, the reason *why* art emerged out of these capacities, as well as *how* and *when* it did so, and why it was ascribed certain powers and took on normative status, are contingent, historical facts, not biological ones, and this is the point at which biological and evolutionary explanations must give way to others.[8]

The most persistent weakness of the theories examined in this book lies ultimately in their explanatory limitations. These limitations are several, but the first relates to the use of "distal explanations," in other words, the identification of ultimate causes and origins. Both evolutionary aesthetics and neuroaesthetics focus on identifying originary causes, in terms of either the origins and evolved functions of art or the neural processes underlying aesthetic behaviors. Thus Steven Pinker, for example, argues that it is not enough to explain that people eat sweets because they give pleasure. Rather, they eat them because primates evolved in "ecosystems in fruit-rich plants," and because sugar provides energy and thus enables reproduction.[9] In other words, people eat sweets because they have evolved to *want* to eat sweets. The fatuousness of this argument is clear if one traces the logic a bit further: people eat sweets in order to reproduce. This explains nothing; not only is the logic circular, but the same could be said of *any* chemical process that supports human biology, such as breathing or drinking water.

It is often remarked that evolutionary accounts are reductive, in that they always seek to explain cultural practices in terms of the same basic biological functions. Yet in many respects they are not reductive enough, if one

understands the term *reductive* as involving the replacement of one set of terms with another. Because they do not offer explanations that displace existing analytical frameworks, they simply create an *additional* descriptive layer. This is apparent in the arguments about the adaptive function of art, or about the neurological processes that both enable but are also triggered by certain formal visual features in works of art. It is apparent, too, in the argument about the cognitive evolutionary advances—the development of the so-called creative mind—that preceded art making or that enabled figurative representation. One can accept such propositions while still recognizing that they do not provide enough evidence to replace the humanities "paradigm" in the way that Slingerland, Onians, Wilson, and others claim they do. The identification of neural circuits and evolutionary origins does little more than describe the material substrate of art and aesthetic experience.[10] This is a problem, too, in the work of Luhmann, in which familiar sociohistorical phenomena are framed by a theory of systems evolution that offers abstract and general correspondences but nothing that might take the place of existing discourses. As Daniel Feige has remarked flippantly, the idea that the love of art is rooted in the desire for a suitable mate would, even if true, "be as relevant for a theory of art as the thesis that all artistic sculptures were made of atoms."[11] Under the atavistic approach of evolutionary theories of art, our response to all artworks or literary texts (and the process that led to their creation in the first place) turns out to be explicable in terms of the stock of inherited evolved cognitive dispositions that is the same everywhere. This conclusion reduces the particular to nothing more than an undifferentiated cipher of the general.

This is not the first time such a criticism has been voiced; in the late 1960s, there were similar concerns over Talcott Parsons's attempt to integrate sociology and the theory of evolution.[12] Indeed, Luhmann, for whom evolution is central to sociological theory, recognized the limitations of such abstract generalizations, admitting that "no theory ever touches on the concrete. That is neither its significance nor its aim." He then attempted to ward off his critics by asserting that "it would therefore be misplaced to discuss the relation of history to whatever theory . . . on the basis that its value should be located in its ability to achieve the concrete."[13] This offers an important qualification in the use of "theory," and, given the abstract and generalizing tendencies of Luhmann's own work, it is entirely explicable. But rather than decisively addressing a common criticism, it actually raises a *further* question about the significance and aim of "theory" in general, and of evolutionary theory in particular, when it comes to analysis of art and culture. As with Miller and others, Luhmann's work offers a "redescription" of concrete artistic practices, but this

does not lead to a rethinking of their significance, or indeed of their place within the accepted landscape of knowledge. Luhmann does at least acknowledge that evolutionary theory cannot take the place of concrete historical (and art-historical) analysis. This caution is absent in the work of many others who see evolutionary theory—in the guise of cognitive criticism, evolutionary psychology, or the phylogenetic study of lines of descent—as a source of new and important insights into art. But this remains to be demonstrated rather than merely asserted, and if they are to live up to their claims, the exponents of evolutionary theory need to develop much more sophisticated and finely calibrated conceptual tools.

Some scholars have embraced the new Darwinism as the path to a new paradigm of world art studies, for it is held to form the basis of a global framework in which meaningful cross-cultural comparisons can be made, and shared values and practices identified. Described in this way, as a project of achieving human solidarity, this seems like an appealing enterprise. Yet in many cases, its proponents have tried to disregard cultural difference, often with a shrill neoconservative hostility to difference. There is no small irony in this, given that a central aim of evolutionary theory in the first place was to explain why there is so much biological diversity. The question of diversity in evolutionary theory also pertains to questions of method and epistemology and highlights the inner contradictions of neo-Darwinian approaches to the humanities—particularly in relation to the plurality of cognitive interests and forms of knowledge, although many of the evolutionary theorists discussed in this book seem unaware of this fact. Dennett himself admits that "scientific" thought (however "science" is defined) is a product of human evolution. In other words, it is, in evolutionary terms, an adaptationally advantageous development. Yet, given that a central aim of evolutionary theory is the explanation (and indeed the celebration) of the diversity of life, this must also mean that scientific thought of the kind fetishized by Dennett, Slingerland, Dawkins, and others is itself only one of many possible evolved cognitive adaptations. In that case, however, other modes of cognition, such as poetic thought, or the hermeneutic preoccupations of the humanities, would logically also have to be seen as adaptations to particular environments and contexts, for numerous evolutionary theorists have argued that poetry and art have adaptive functions. To continue the biological and evolutionary analogy, it could be argued that within the ecology of human cognition there are various "niches" occupied by different kinds of thought. Even on its own terms, the "scientific" approach of evolutionary theory should be seen as merely an evolved adaptation for specific circumstances and interests, and not as a master discourse

that is better adapted than the putative North Koreans of the humanities, to use Slingerland's simile.

Evolutionary epistemology must therefore engage in some self-examination, a familiar epistemic issue but one in which exponents of bioaesthetics, neuroarthistory, and evolutionary aesthetics have shown little interest. Not content to dispute the insights of the humanities—with which they seldom engage, in any case—they also, in the name of consilience, question the legitimacy or the right of others to have cognitive interests different from their own. This is the point where debate turns into something else—intellectual oppression, as Habermas reminds us in his discussion of positivism. In *Knowledge and Human Interests*, Habermas critiques the positivistic reduction of knowledge to method; those who commit this error lose sight of the purpose and nature of epistemological inquiry. Thus, "by making a dogma of the sciences' belief in themselves, positivism assumes the prohibitive function of protecting scientific inquiry from epistemological inquiry, from self-reflection." Positivism, Habermas adds, "stands and falls with the principle of scientism, that is, that the meaning of knowledge is defined by what the sciences do and can thus be adequately explained through the methodological analysis of scientific procedures."[14]

These words were, of course, uttered in an entirely different context, namely, the dispute over positivism between German social theorists in the 1960s.[15] Yet Habermas's observations are pertinent here, for they identify problems that are equally characteristic of neo-Darwinian theories of art and aesthetics, with their unexamined notions of scientific knowledge and unexamined belief in scientific method. It may be asked, then, what neo-Darwinian theory has to offer the study of culture in general and art in particular. Once again, Habermas puts the question aptly: "How can the meaning of an individuated life-structure be grasped and represented in inevitably general categories?"[16] How can knowledge of the general and universal laws of the biological sciences inform our engagement with the images and artifacts that spur our interest in art? As we have seen, this is a recurring and unresolved issue in the various models this book has examined. Indeed, these models are unable to provide an adequate answer to this question, and their advocates seem unaware of its relevance, apparently content with abstract generalities about what they perceive to be the human condition.

Some of the weaknesses in the evolutionary approach become clear in the disputes between its different exponents. This study has repeatedly made the point that neo-Darwinian art and aesthetic theory does not in fact *have* a theory of art or aesthetic experience. Art is treated as visual stimulus or data, and

no distinction is made between aesthetic response and programmed behavior, or between the beautiful and the merely agreeable, to use the Kantian terms. No grounds are provided for how the viewer may make qualitative judgments between works of art, a problem that has become a subject of debate even within the community of Darwinian theorists. On the one hand, Steven Pinker has willingly embraced the logical consequences of the Darwinian method, namely, that it involves cultural "slumming," i.e., a refusal to use qualitative distinctions, and the position that no practice or artifact is more deserving of attention than any other.[17] This conclusion makes some evolutionary cultural theorists uncomfortable; Joseph Carroll, for one, has accused Pinker of aesthetic insensitivity.[18] Yet Pinker is being logically rigorous in a way that Carroll and others are not. For he is right to claim that evolutionary theory offers no way to measure or evaluate aesthetic choice; the preference for Vermeer, Ad Reinhardt, Constable, or Greek phalanxes is arbitrary, and the grounds for such preferences are never analyzed.[19]

There is something superficially appealing about Pinker's greater candor, especially when it comes to the question of the canon and its contestations, for his position is to argue that the canon has no relevance. A properly "scientific" study of art and culture would do away with judgments based on aesthetic preference. But closer inspection uncovers the flaws in this position. Not only does the evolutionary perspective fail to cast a welcome critical eye on existing unexamined aesthetic hierarchies; it offers no grounds for object choice of *any* kind. Yet even the most ardent critics of the canon draw aesthetic distinctions and select works (of art, literature, music) for critical attention on the basis of value judgments, albeit judgments that contest prevalent norms. And they consider the category of art meaningful, even if it is defined sociopolitically rather than aesthetically. For Pinker et al., and by extension for evolutionary theory, the category of art has no functional role, much as they write as if it did.

That object choice is so underdetermined helps to explain why sophisticated art, literary, and cultural critics can be drawn into making often grotesquely simplistic and laughable assertions, and it relates to the well-known phenomenon of confirmation bias. Confirmation bias, defined as "the tendency to search for, interpret, favor, and recall information in a way that confirms one's beliefs or hypotheses, while giving disproportionately less consideration to alternative possibilities," is a recurrent feature of the evolutionary approach.[20] Exponents select examples to illustrate theoretical arguments, and because there is no mechanism for assessing their validity, their pertinence cannot be contested. It is this basic structural flaw in the evolutionary theory

of culture that underlies, perhaps, the hugely misplaced confidence of its exponents in the correctness of their position. They harbor no self-doubt because there is nothing that could challenge their views. At the same time, however, critics need to exercise no small degree of humility, for the problem is no less prevalent in the humanities. When an art historian approvingly cites Gayatri Spivak's assertion that "it is the questions that we ask that produce the field of inquiry and not some body of materials which determines what questions need to be posed to it," a similar terrain is being traversed.[21] This sentiment, which has been cited approvingly on numerous occasions, exemplifies what David Bordwell calls "top-down inquiry." Bordwell, whose primary interest is films, refers to the theoretically driven interpretation of cultural texts, the "application" of a particular theory, and he points to numerous problems with this approach to scholarship. Not only do few theoretical methods articulate what it means to "apply" them, but there are also questions about the procedures for justifying claims advanced in such work. "A lone case cannot establish a theory," Bordwell asserts. "When theory projects downward to the datum, the latter becomes an illustrative example. The result may have rhetorical force, as vivid examples often do, but because of the under-determination of theories by data, a single instance is not particularly strong evidence." The function of theory-driven interpretations is not to subject their theoretical tenets (and their implications) to critical scrutiny but rather to confirm themselves; conversely, Bordwell notes, "no published interpretation has ever *disproven* the candidate theory."[22]

Bordwell's comments are a critical response to a specific issue—the dominance of psychoanalytical film theory in the mid-1990s—and they are linked to Bordwell's program of cognitive film criticism. Made some twenty years ago, they might seem of little relevance to the present discussion. Yet Bordwell might easily have been talking about much contemporary art criticism, or about Darwinian aesthetics and evolutionary art history, which likewise seek confirming examples rather than images and objects that might "test" or challenge theoretical and methodological assumptions. It might be objected that I am relying on a reductive and overly empiricist notion of inquiry, one based on the testing of hypotheses, and that this approach is particularly problematic when applied to the humanities. But the humanities, including art criticism and art history, have their own protocols of argumentation, their own canonical rules regarding logical inference and evidence. When these rules are ignored, or absent, dogma tends insidiously to displace reasoning and empirical evidence, as in the case of the evolutionary theorizing that is the subject of this book.

It would be reasonable to conclude, given the polemical tone adopted in this book, that I see neo-Darwinian approaches as having little value. Certainly, they prompt grave concern, and this study has tried to articulate what is most worrisome about the haste to proclaim the new "consilience." Yet it is important to maintain a constructive attitude, for there might still be important gains in engaging with the new Darwinism. To explore them, it is worth revisiting the past. As early as the 1890s, Alois Riegl and others recognized that the theory of evolution may be significant for the understanding of art-historical time. In place of the tendency, inherited from Hegel, to conceptualize the history of art in terms of periods and monolithic political and geographical spaces, Riegl famously drew on the model of incremental change in *Problems of Style* to map out the transhistorical and spatial evolution of the acanthus motif. The lessons of this exercise went beyond the mere registration of a line of formal succession and led to wider speculation about the nature of cultural diffusion and cross-cultural borrowing. The significance of Riegl's analysis was not that it cast light on an apparently esoteric and marginal topic but that it served as the basis for much larger claims about the relation of classical Greek art to the art of the late Roman Empire and the Islamic world. Despite the massive political disruptions that had taken place between the fifth century B.C.E. and the eighth century C.E., *Problems of Style* suggested that at a certain level there were remarkable patterns of continuity. Riegl can consequently be regarded as the ancestor of subsequent studies, including, more recently, those of Tehrani, Collard, and Shennan, that returned once more to the analysis of artistic and cultural genealogies. Riegl's aim was to point out that artistic forms that seemed strikingly dissimilar might nevertheless be genetically related if they could be traced over time.

Riegl's approach was copied by his student Max Dvořák, yet in time Dvořák came to espouse a view that emphasized the discontinuities and ruptures in the history of art, as well as the correspondences that could reemerge after centuries of interruption. Among art historians, the latter position has since gained critical dominance, but the Darwinian approach has not so much been thoroughly interrogated and found wanting as simply discarded in favor of a position that appeals to those committed to notions of epochal cultural and political renewal. This is evident in the readiness of art historians to engage in Kuhnian talk of paradigm shifts, to consider ruptures in Foucauldian epistemic régimes, or to recognize the revolutionary succession of Bourdieuian fields. Thus, when Hans Belting published *The End of the History of Art?* in 1983, a first superficial reaction was to view it as a parallel to the theoretical work on postmodernity being published at the same time.[23] But Belting was actually

more concerned with the impact of modernism on the tradition of historiography since Vasari, and with the fact that it was no longer possible to produce a linear narrative of art history. The advent of modernism marked such a break, he argued, that it was impossible to write a single history of art. This trope, emphasizing historical caesuras over continuity, has gained ascendancy. An interesting barometer of the resulting intellectual climate can be found in the changing interpretations of Aby Warburg. When Ernst Gombrich wrote about Warburg in the 1960s and 1970s, he saw him unambiguously as the exponent of an evolutionary art history, and this was also evident, Gombrich argued, in the extensive reference Warburg made to Darwin. The prevailing interpretation now, however, has been shaped by Georges Didi-Huberman, who has cast Warburg as the historian of the Renaissance and classical tradition, as the theorist of "impure" time, of historical and spatial discontinuity.[24]

This idea of an "anachronic Renaissance," as Alexander Nagel and Christopher Wood have recently put it, offers important new ways of thinking about the shape of historical time, and it has certain clear advantages over the linear model of art history that, as Belting noted, had become untenable. But it is also a political choice that legitimizes a specific rhetoric, and as such it exemplifies the top-down approach to inquiry that Bordwell describes. It is therefore open to the same dangers of confirmation bias that are so apparent in the examples of evolutionary art theory examined in this book. It is ironic, therefore, that in its most sophisticated form, the evolutionary paradigm also suggests ways in which high-level claims about patterns of historical continuity and discontinuity can be subjected to empirical scrutiny. Significant differences can result from small-scale incremental shifts and changes over time. The studies by Tehrani and Collard raise the possibility of multiple patterns of continuity and discontinuity, suggesting the resilience of traditional structures of cultural transmission even when those structures are faced with external political upheaval. Of course, such studies are vulnerable to the charge of arbitrariness; the choice of Turkestan carpet motifs is arbitrary, as was, ultimately, Riegl's decision to write a history of the acanthus motif. Yet such decisions nevertheless permit unexpected findings to emerge. Indeed, the weakness of such analyses lies not in their results as much as in the claims made on their behalf. The use of rigorously applied quantitative data and methods does not in itself make them more "scientific" (whatever that might mean) or rigorous, since they still rely on parameters not given within the method itself. Likewise, the results of such studies are a means to an end, and only begin to take on significance when placed in a broader context that includes other quantitative, as well as qualitative, data.

There is, of course, an implicit epistemology here that needs to be spelled out. It is taken as a given that most art historians are committed to some form of constructivism, whether consciously or not. The world—including art—does not consist of ready-made objects waiting to be discovered or described, particularly since art historians work with complex sociocultural abstractions such as "representation," "Renaissance," "modernism," "avant-garde," "patronage," and so forth. At the same time, however, such constructions and their use in construing the world is not a matter of arbitrary fiat, as some extreme versions of antirealism might suggest. As the philosopher Michael Dummett has argued, "Although we no longer accept correspondence theory, we remain realists *au fond*," for we implicitly assume that "for any statement there must be something in virtue of which either it or its negation is true." Further, to use Dummett's formulation, "Our investigations bring into existence what was not there before, but what they bring into existence is not of our own making."[25] In other words, statements about art and other cultural practices rub up against the world and cannot be willfully imposed on it, and this is the case even if one is, like Dummett, an antirealist.

It is the points at which their objects yield to or resist our readings of them that form the crux of inquiry, whether in the humanities or in the sciences. Critical engagement with evolutionary aesthetics and art history brings into relief these broader issues about the procedures and protocols of argumentation, evidence, and proof in the humanities. We may justifiably dismiss the exaggerated claims made on behalf of neo-Darwinian art and cultural theory; its allegedly scientific character falls far short of delivering what the advocates of consilience believe. Nevertheless, critical reflection reveals that the grounds on which art historians and theorists make their assertions are often equally vulnerable to criticism, and for not entirely dissimilar reasons. Despite such reservations, it may be that the evolutionary models examined here, for all their flaws, can suggest ways in which working assumptions and values in art history can be interrogated and subjected to empirical examination, using methods from outside the normal framework of the discipline. This is not to mouth another well-meaning platitude about the desirability of dialogue between the humanities and the sciences, but instead to acknowledge that some of the questions that evolutionary art theory asks, and their implications, have still to be worked through.

NOTES

PREFACE AND ACKNOWLEDGMENTS

1. See Oppenheimer, *Origins of the British*.
2. See Diamond, *Guns, Germs, and Steel* and *Collapse*.

INTRODUCTION

1. Charles Percy Snow, "The Two Cultures and the Scientific Revolution," *Encounter*, June 1959, 17–24, and July 1959, 22–27. Republished in Snow, *Two Cultures*, quotation on 19.
2. Ortolano, *Two Cultures Controversy*, 28–65.
3. See Jardine, "Snow's Two Cultures Revisited."
4. Weber, "Objectivity in Social Science," 72.
5. Wilhelm Windelband, *Geschichte und Naturwissenschaft* (Strassburg: Heitz, 1894), 12, 13.
6. Weber, "Objectivity in Social Science," 90.
7. See Wilhelm Dilthey, "Ideen über eine beschreibende und zergliedernde Psychologie" (1894), in Dilthey, *Die Geistige Welt: Einleitung in die Philosophie des Lebens* (Göttingen: Vandenhoeck & Ruprecht, 1990), 139–240.
8. Hempel, "Theoretician's Dilemma," 37.
9. Hempel, "Function of General Laws in History," 39.
10. Baxandall, *Patterns of Intention*, 13.
11. Wilson, *Consilience*, 9.
12. Ibid., 49.
13. Boyer, "From Studious Irrelevancy to Consilient Knowledge," 113.
14. See, for example, Boyer, *Naturalness of Religious Ideas*.
15. See Slingerland, "Mind-Body Dualism."
16. Ibid., 85.
17. See Dawkins, *Selfish Gene* and *Extended Phenotype*.
18. For an outline of technical art history, see Hermens, "Technical Art History."
19. See, for example, Fleck, *Kunstsystem im 21. Jahrhundert*.
20. Eitelberger, "Ansprache zur Eröffnung," 355.
21. See Thausing, "Status of the History of Art" (originally published as "Die Stellung der Kunstgeschichte als Wissenschaft" in 1873).
22. On the origins of art history and the notion of "Wissenschaft" in Germany and Austria, see Prange, *Geburt der Kunstgeschichte*.
23. Riegl, *Spätrömische Kunstindustrie*; Wölfflin, *Principles of Art History*.
24. See Warburg, *Renewal of Pagan Antiquity*.
25. See Semper, *Style in the Technical and Tectonic Arts*; Balfour, *Evolution of Decorative Art*; Riegl, *Problems of Style*; and Haddon, *Evolution in Art*.

26. See Hirn, *Origins of Art*; Worringer, *Abstraction and Empathy* (originally published as *Abstraktion und Einfühlung: Ein Beitrag zur Stilpsychologie* in 1908); and Gombrich, *Art and Illusion* and *Sense of Order*.

27. Panofsky, "History of Art."

28. Edgar Wind, *Experiment and Metaphysics*, trans. Cyril Edwards (Oxford: Legenda, 2001).

29. Trevor-Roper, *World Through Blunted Sight*.

30. Pliny the Elder, "The History of Painting," in *Natural History*, 324.

31. *World Art Studies*, a notable anthology of writings edited by Kitty Zijlmans and Wilfried van Damme, exemplifies this trend.

32. Laudan, *Beyond Positivism and Relativism*.

33. There are echoes here of the philosophical distinction between context of discovery and context of justification, first advanced by Hans Reichenbach and elaborated on by numerous thinkers since. See Reichenbach, "On Probability and Induction," 36–37.

34. As Elkins notes, "a concept like objectivity cannot be 'found in' or 'applied to' the text in the linear fashion that a philosophic account might propose. Indeed, it is difficult to be sure exactly what it means to 'find' the concept of 'objectivity' 'in' such a text at all." James Elkins, *Our Beautiful, Dry, and Distant Texts: Art History as Writing* (London: Routledge, 2000), 22.

35. See, for example, Appleton, *Experience of Landscape*; Hildebrand, *Origins of Architectural Pleasure*; and Dutton, *Art Instinct*.

36. Warburg, *Renewal of Pagan Antiquity*; Semon, *Mneme*.

37. See Runciman, *Treatise of Social Theory*.

38. John Maynard Smith, "Optimisation Theory in Evolution," *Annual Review of Ecology and Systematics* 9 (1978): 38.

39. See, for instance, Halsall, *Systems of Art*.

40. See, for instance, Onians, *Neuroarthistory*; Zeki, *Inner Vision*; Mallgrave, *Architect's Brain* and *Architecture and Embodiment*; Skov et al., *Neuroaesthetics*; and Starr, *Feeling Beauty*.

41. For the most extended such critique, see Tallis, *Aping Mankind*.

42. Faye, *After Postmodernism*, 38.

43. Luhmann, *Observations on Modernity*.

44. Gregory Bateson, "Form, Substance, and Difference," in Bateson, *Steps to an Ecology of Mind*, 460.

CHAPTER 1

1. See Wypijewski, *Painting by Numbers*.

2. The results of the poll can be found at http://awp.diaart.org/km/ (accessed 25 November 2014).

3. Arthur Danto, "Modalities of History," in Danto, *After the End of Art*, 193–220.

4. Dutton, *Art Instinct*, 18.

5. See, for example, Orians and Heerwagen, "Evolved Responses to Landscapes," 555–58.

6. Hildebrand, *Origins of Architectural Pleasure*, 26.

7. Charles Darwin, "Natural Selection," in Darwin, *On the Origin of Species*, 130–72.

8. Spencer, *Principles of Biology*, 1:444. Darwin later adopted the term in the fifth edition of *On the Origin of Species* (1869).

9. Darwin, *On the Origin of Species*, 137.

10. Darwin, *Descent of Man*, 684.

11. This idea was reiterated by Jared Diamond in "How Africa Became Black: The History of Africa," in Diamond, *Guns, Germs, and Steel*, 376–401.

12. See, for example, Blackwell, *Sexes Throughout Nature*; and Gamble, *Evolution of Woman*.

13. Grosz, *Becoming Undone*.

14. Charles Darwin, "Secondary Sexual Characters of Mammals," and

"Secondary Sexual Characters of Man," in Darwin, *Descent of Man*, 588–619 and 621–74, respectively.

15. Welsch, "Animal Aesthetics."

16. Darwin, *Descent of Man*, 115.

17. See, for example, Menninghaus, *Wozu Kunst*, 76–81.

18. Clive Catchpole and Peter Slater, *Bird Song: Biological Themes and Variations*, 2nd ed. (Cambridge: Cambridge University Press, 2008), 171–202.

19. Darwin, *Descent of Man*, 115–16.

20. O'Hear, *Beyond Evolution*, 182.

21. In the second edition of the essay, published in 1891, Spencer added a coda that took violent exception to Darwin's idea of the role of birdsong in sexual selection. See "The Origin and Function of Music," in Spencer, *Essays*, 2:400–451.

22. Although primarily concerned with the physiology of taste, pleasure, and pain, Allen made repeated reference to the evolutionary work of Herbert Spencer, speculating on the origins of beauty in the drive for sexual selection (see, for example, *Physiological Aesthetics*, 242). Allen also cited Spencer's essay "Personal Beauty," in Spencer's *Essays*, 2:387–99.

23. Sully, "Animal Music." See also Clark, "Animal Music: Its Nature and Origin."

24. On this topic, see Didi-Huberman, "Surviving Image"; Gombrich, "Aby Warburg, His Aims and Methods"; and Gombrich, "Aby Warburg und der Evolutionismus."

25. Tylor, *Primitive Culture*.

26. Wilson, *Sociobiology*, 289.

27. Wilson was the object of a fierce critique in Sahlins, *Use and Abuse of Biology*. For a brief overview of the debates over sociobiology, see Rose, "Colonising the Social Sciences?"

28. See Barkow, Cosmides, and Tooby, *Adapted Mind*.

29. For an overview, see Robert J. Richards, *Darwin and the Emergence of Evolutionary Theories of Mind and Behavior* (Chicago: University of Chicago Press, 1987).

30. For a succinct statement of this position, see Pinker, *How the Mind Works*.

31. Fodor, *Modularity of Mind*, 120.

32. See Pinker, *Language Instinct*.

33. Mithen, *Prehistory of the Mind*. See, too, Mithen, "A Creative Explosion? Theory of Mind, Language, and the Disembodied Mind of the Upper Palaeolithic," in Mithen, *Creativity in Human Evolution*, 122–40.

34. See, for example, Merlin Donald, *Origins of the Modern Mind: Three Stages in the Evolution of Culture and Cognition* (Cambridge, Mass.: Harvard University Press, 1991); see, too, Merlin Donald, "Art and Cognitive Evolution," in *The Artful Mind: Cognitive Science and the Riddle of Human Creativity*, ed. Mark Turner (Oxford: Oxford University Press, 2006), 3–20; and Nancy Easterlin, "The Functions of Literature and the Evolution of Extended Mind," *New Literary History* 44, no. 4 (2013): 661–82.

35. Joseph Carroll, Jonathan Gottschall, John Johnson, and Daniel Kruger, "Paleolithic Politics in British Novels of the Longer Nineteenth Century," in Boyd, Carroll, and Gottschall, *Evolution, Literature, and Film*, 490–506.

36. Examples of such evolutionary accounts include Symons, *Evolution of Human Sexuality*; Buss, *Evolution of Desire*; and Daly and Wilson, *Truth About Cinderella*.

37. Dutton, *Art Instinct*, 141–43.

38. Miller, *Mating Mind*, 281.

39. Power, "Beauty Magic," 158.

40. Kohn and Mithen, "Handaxes," 521.

41. Pagel, *Wired for Culture*, 133.

42. See, for example, Heinrich, "Biological Roots of Aesthetics."

43. Mithen, *Singing Neanderthals*, 152.

44. Dissanayake, "Arts After Darwin," 249.

45. See Dissanayake, *Homo Aestheticus*.

46. See Lisa Zunshine, "Introduction: What Is Cognitive Cultural Studies?," in Zunshine, *Introduction to Cognitive Cultural Studies*, 1–33. See also Zunshine, *Why We Read Fiction*.

47. See, for example, Spolsky and Richardson, *Work of Fiction*; Carroll, *Reading Human Nature*; Easterlin, *Biocultural Approach to Literary Theory*; and Collins, *Paleopoetics*.

48. "Human beings feed on pictures, metabolize them—turn them into nourishment—because we need the knowledge they provide." Ellen Spolsky, "Introduction: Iconotropism, or Turning Toward Pictures," in *Iconotropism: Turning Toward Pictures*, ed. Ellen Spolsky (Lewisburg: Bucknell University Press, 2004), 16.

49. Spolsky, "Brain Modularity and Creativity," 85.

50. Turner, "Ecopoetics of Beauty and Meaning," 119–20.

51. See John Baines, "On the Status and Purpose of Ancient Egyptian Art," in Baines, *Visual and Written Culture*, 298–337; and Cahill, *Painter's Practice*.

52. See Grosz, *Becoming Undone* and *Chaos, Territory, Art*; Menninghaus, *Wozu Kunst* and *Versprechen der Schönheit*; and Roughgarden, *Evolution's Rainbow*.

53. Darwin, *Descent of Man*, 246.

54. Grosz, *Becoming Undone*, 132.

55. Nietzsche's attitude toward Darwin remains a topic of debate, in that while he was critical of the idea of progress implicit in certain varieties of evolutionary thought, he was highly sympathetic to the Darwinian notion of animal origins. See, for example, Richardson, *Nietzsche's New Darwinism*; and Johnson, *Nietzsche's Anti-Darwinism*.

56. Darwin, *Descent of Man*, 246. Darwin goes on to add, "A more just comparison would be between the taste for the beautiful in animals and that in the lowest savages, who deck themselves with any brilliant, glittering or curious object."

57. On this issue, see Snaevarr, "Talk to the Animals." On the distinction between the beautiful and the agreeable, see Kant, *Critique of the Power of Judgment*, 91.

58. Davies, *Artful Species*, 12–15.

59. Dissanayake, "Arts After Darwin," 254.

60. Davies, "Ellen Dissanayake's Evolutionary Aesthetic," 299. As Richard Woodfield has also stated, "A prime difference between animals and humans is the latter's ability to reflect on their behaviour. . . . A theory of art that is adequate to the world's greatest achievement must incorporate, in some way or other, a theory of reflection." Woodfield, review of *Art and Intimacy*, 345.

61. Dawkins, *Extended Phenotype*, 35–38 (quotations on 38).

62. Alcock, *Triumph of Sociobiology*, 138. See, too, Dutton, *Art Instinct*, 141–44.

63. Hersey, *Evolution of Allure*, xiv–xv.

64. Alcock (*Triumph of Sociobiology*, 142) acknowledges that in some cultures— he cites the Yomybato of Peru—obesity seems to be an ideal of feminine beauty. Yet he tries to accommodate this by stating that it must relate to the fact that in the ancestral Yomybato environment, food must have been so scarce that obesity was desirable for other reasons. Acknowledging that this is an untested hypothesis (one might add that it is untestable), he still treats the Yomybato as the exception that proves the rule, rather than considering that the argument marshaled here could apply to *any* culture (i.e., that there is no universal set of biologically rooted constants that shape aesthetic preferences, but that such preferences are always related to the specific circumstances of each society).

65. Lewontin, "Sociobiology as an Adaptationist Programme," 11.

66. Gould and Lewontin, "Spandrels of San Marco." As a subsequent observer

has commented, "Just-so stories lack the support of evidence and the careful weighing of evidence that are crucial to historical narratives. They result from the wanton extrapolation of crude adaptation models and perhaps the fabrication of 'facts' to substantiate their claims." Sunny Auyang, *Foundations of Complex Systems Theories* (Cambridge: Cambridge University Press, 1998), 333.

67. Kramnick, "Literary Studies and Science," 446. The argument refers to Carroll, *Literary Darwinism*; Vermeule, *Why Do We Care*; and Boyd, *On the Origin of Stories*.

68. Brandon, *Adaptation and Environment*, 159–61.

69. Boyd, "Art and Evolution," 434.

70. Dan Sperber makes a similar point: "Most cultural institutions do not affect the chances of survival [of] the groups involved to an extent that would explain their persistence." Sperber, *Explaining Culture*, 48.

71. In *Wozu Kunst* (196–200), Menninghaus notes the adaptive function of play in the animal world; it is a way of practicing hunting skills or of honing various social skills within the group. Aesthetic play thus has its roots in adaptive behavior. This is not a decisive argument, however. For even if the *roots* of play can be traced to adaptive "proto-play," this says nothing about the role of aesthetic play *now* in uncoupling artistic practices from the evolutionary pressures that might have first favored their emergence. Moreover, it might simply underline the *difference* between animal "proto-play" and human play.

72. Laland and O'Brien, "Niche Construction Theory and Archaeology."

73. Odling-Smee, "Niche Construction, Evolution, and Culture."

74. The key works here are Cavalli-Sforza and Feldman, *Cultural Transmission and Evolution*; and Lumsden and Wilson, *Genes, Mind, and Culture*. Kevin Laland and Gillian Brown

provide an outline of the debate in *Sense and Nonsense*.

75. See Tomasello, *Cultural Origins of Human Cognition*.

76. Summers, *Real Spaces*, 19, 36.

77. Ibid., 435.

78. Ibid., 86–98.

79. Tomasello, *Cultural Origins of Human Cognition*, 86.

80. Summers, *Real Spaces*, 89.

81. See Erwin Panofsky, *Perspective as Symbolic Form* (1927), trans. Christopher S. Wood (New York: Zone Books, 1997).

82. See Lachterman, *Ethics of Geometry*.

83. Kemp, *Science of Art*.

84. See, for example, the writings of Indian art historians such as Rajendralal Mitra, *The Antiquities of Orissa* (Calcutta: Wyman, 1875); and Shyama Charan Srimani, *Suksha Shilper Utpatti o Arya Jatir Shilpa Chaturi* [The Fine Arts of India, with a Short Sketch of the Origins of Art] (Calcutta: Roy Press, 1874). Ananda Coomaraswamy provided a powerful denunciation of British imperialism in *Medieval Sinhalese Art* (Broad Campden: Essex House Press, 1908).

85. Firth, "Art and Anthropology," 24. Joanna Overing puts forward a similar view in Morphy et al., "Aesthetics Is a Cross-Cultural Category."

86. See, for example, Richard L. Anderson, *Calliope's Sisters: A Comparative Study of Philosophies of Art* (New York: Pearson, 1989).

87. See, for example, Thompson, "Yoruba Artistic Criticism"; Fernandez, "Principles of Opposition and Vitality"; and Susan Vogel, *Baulé: African Art, Western Eyes* (New Haven: Yale University Pres, 1997). On Yoruba art, see, too, the more recent study by Rowland Abiodun, *Yoruba Art and Language*.

88. Davidson, "Very Idea of a Conceptual Scheme," 198.

89. Lewis-Williams, *Mind in the Cave*, 41.

90. Onians, "World Art: Ways Forward," 132–33.

91. Paul Wood, "Moving the Goalposts: Modernism and 'World Art History,'" *Third Text* 25, no. 5 (2011): 505.

92. See, for example, Hulks, "World Art Studies."

93. See Wallerstein, *Modern World System.*

94. See, for example, Jaffer and Jackson, *Encounters*; Belting, *Florence and Baghdad*; and Belting and Buddensieg, *Global Contemporary.*

95. Davies, *Artful Species*, 122.

96. Carroll, "Theory, Anti-Theory," 147.

97. Turner, "Ecopoetics of Beauty and Meaning," 119–20.

98. Morin, "How Portraits Turned Their Eyes."

CHAPTER 2

1. Fergusson, *True Principles of Beauty in Art*, 164.

2. Greenough, *Form and Function*, 122.

3. See Steadman, *Evolution of Designs.*

4. Eugène-Emmanuel Viollet-le-Duc, "Style," in Viollet-le-Duc, *Dictionnaire raisonné*, 8:499. All translations are my own unless otherwise indicated.

5. Viollet-le-Duc, *Lectures on Architecture*, 1:426.

6. Gottfried Semper, "Über Baustile," in Semper, *Kleine Schriften*, 401.

7. Semper, *Style in the Technical and Tectonic Arts*, 103.

8. Pitt Rivers, "On the Evolution of Culture."

9. Evans, "Coinage of the Ancient Britons."

10. On the subject of evolution in Victorian design theory, see Steadman, *Evolution of Designs.*

11. John Addington Symonds, "A Democratic Art," in Symonds, *Essays, Speculative and Suggestive*, 37. I am grateful to John Holmes for alerting me to the work of Symonds.

12. For a helpful contemporary overview of this phenomenon, see Heuser, "Darwinistisches über Kunst und Technik." Heuser points to Darwinian motifs in a range of authors, including Wilhelm Lübke, Herman Grimm, and Adolf Göller. As Heuser concludes, after Darwin, "humanity learnt to think more modestly about the earth, for it was relegated to the status of an insignificant planet, and to think modestly about itself, too, for it belongs in body and soul to the rest of the animal world. The artist also learns modesty, for our works develop slowly like an echo of nature" (27). See, too, Heuser, "Werden von Stylformen."

13. Dvořák, "Rätsel der Kunst der Brüder van Eyck," 166–67.

14. Allen, *Evolution in Italian Art*, 366.

15. See the essays in Dvořák, *History of Art.*

16. Scott, *Architecture of Humanism*, 176, 183.

17. Focillon, *Life of Forms in Art*, 47.

18. Pinder, *Problem der Generation.*

19. Focillon, *Moyen Âge*, 11. More recent attempts to explore the possibilities of the stratigraphic metaphor include Bork, "Pros and Cons of Stratigraphic Models"; and Landa, *Thousand Years of Nonlinear History.*

20. Fingesten, "Theory of Evolution," 304.

21. On Kubler, see Wolf, "Shape of Time."

22. Kubler, *Shape of Time*, 37.

23. Gombrich, *Art and Illusion*, 247.

24. The key work for Gombrich was Popper's *Logic of Scientific Discovery.* See, too, Popper, "Truth, Rationality, and the Growth of Scientific Knowledge" (1960), in *Conjectures and Refutations*, 291–340.

25. Gombrich, *Sense of Order*, 191.

26. Steadman, *Evolution of Designs*, 99–118.

27. Springer, "Nachleben der Antike im Mittelalter."

28. Richard Semon's key work was *Die Mneme als erhaltendes Prinzip im Wechsel des organischen Geschehens* (Leipzig: Engelmann, 1904), translated into English in 1921 as *The Mneme.*

There has been a revival of critical interest in Semon's work recently. See, for example, Schacter, *Stranger Behind the Engram* and *Forgotten Ideas*.

29. For a more detailed articulation of this problem, see Rampley, "Iconology of the Interval."

30. On the cult of icons in Byzantium, for example, see Belting, *Likeness and Presence*.

31. See Steadman, *Evolution of Designs*, 107–8.

32. Sahlins, *Culture and Practical Reason*, 55.

33. Sahlins, *Use and Abuse of Biology*, 64, 65–66.

34. Dawkins, *Selfish Gene*, 92.

35. Dawkins, *Extended Phenotype*, 109.

36. Ibid.

37. The online *Journal of Memetics* was published between 1997 and 2005. It is available online at http://cfpm.org/jom -emit/ (accessed 20 January 2014).

38. See, for example, Dennett, "Memes and the Exploitation of Imagination"; Dennett, *Darwin's Dangerous Idea*; Distin, *Selfish Meme*; and Steven, *Memetics of Music*. On the popular publications, see, for example, Brodie, *Virus of the Mind*; and Blackmore, *Meme Machine*.

39. Laland and Odling-Smee, "Evolution of the Meme." Laland provides a more measured account in Laland and Brown, *Sense and Nonsense*, 197–240.

40. On Semon and Richard Dawkins, see Flannery, "Eyes at the Back of Your Head."

41. See, for example, Midgley, *Solitary Self*.

42. Susan Blackmore, "The Meme's Eye View," in Aunger, *Darwinizing Culture*, 29.

43. See Michael Tomasello, "Biological and Cultural Inheritance," in Tomasello, *Cultural Origins of Human Cognition*, 13–56.

44. Dan Sperber, "An Objection to the Memetic Approach to Culture," in Aunger, *Darwinizing Culture*, 171.

45. Kant, *Critique of the Power of Judgment*, 188.

46. Sigrid Weigel has also made this criticism in "Evolution of Culture."

47. Fracchia and Lewontin, "Price of Metaphor," 21. For all his adherence to Darwin, Aby Warburg recognized this, stressing that the art-historical tradition is anything but a merely passive reproduction of inherited images and practices. As Gombrich notes, for Warburg, "the borrowings of Renaissance artists from classical sculpture . . . occurred whenever a painter felt in need of a particularly expressive image of movement or gesture." Gombrich, *Art and Illusion*, 20.

48. Maurice Bloch makes this point in "Well-Disposed Social Anthropologist's Problems."

49. Runciman, *Theory of Cultural and Social Selection*, 53.

50. Fracchia and Lewontin, "Price of Metaphor," 14.

51. Flinn, "Culture and the Evolution," 32–33.

52. See Cavalli-Sforza and Feldman, *Cultural Transmission and Evolution*; and Boyd and Richerson, *Culture and the Evolutionary Process*.

53. See, for example, Boyd and Richerson, *Origin and Evolution of Cultures*; Richerson and Boyd, *Not by Genes Alone*; Mesoudi, *Cultural Evolution*; and Richerson and Christiansen, *Cultural Evolution*.

54. Mesoudi, *Cultural Evolution*, 46.

55. Boyd and Richerson, *Culture and the Evolutionary Process*, 81.

56. Mesoudi provides an overview in *Cultural Evolution*, 58–83.

57. Boyd and Richerson, *Origin and Evolution of Cultures*, 287–309.

58. Robert Boyd and Peter Richerson, with Monique Borgerhoff Mulder and William H. Durham, "Are Cultural Phylogenies Possible?," in Boyd and Richerson, *Origin and Evolution of Cultures*, 310.

59. Shennan, *Genes, Memes, and Human History*, 36. Shennan cites Avital and Jablonka, *Animal Traditions*.

60. Shennan, *Genes, Memes, and Human History*, 45.

61. R. Lee Lyman and Michael J. O'Brien, "Measuring and Explaining Change in Artifact Variation with Clade-Diversity Diagrams," *Journal of Anthropological Archaeology* 19 (2000): 39–74; O'Brien and Lyman, *Style, Function, Transmission*.

62. Tehrani and Collard, "Investigating Cultural Evolution"; Tehrani and Collard, "Weaving in Iranian Tribal Populations"; and Jordan and Shennan, "Cultural Transmission, Language, and Basketry."

63. See Kroeber and Kluckhohn, *Culture*.

64. Gould, *Bully for Brontosaurus*, 65.

65. Deleuze and Guattari, *Thousand Plateaus*, 10.

66. See Darwin's *On the Various Contrivances*.

67. On the question of biological convergence and horizontal transfer, see Laland and Brown, *Sense and Nonsense*, 161–64.

68. Collard, Shennan, and Tehrani, "Branching, Blending," 170.

69. Tehrani and Collard provide a more detailed outline of the method in "Investigating Cultural Evolution," 447–50.

70. Ibid., 449.

71. Collard, Shennan, and Tehrani, "Branching, Blending," 177.

72. See Collard and Shennan, "Ethnogenesis Versus Phylogenesis"; Shennan and Collard, "Investigating Processes of Cultural Evolution."

73. See Tehrani, Collard, and Shennan, "Co-Phylogeny of Populations and Cultures."

74. Ibid., 3872.

75. See Spooner, "Weavers and Dealers."

76. See, for example, Yates, *Valois Tapestries*; Delmarcel, *Flemish Tapestry Weavers*.

77. Mesoudi, Whiten, and Laland, "Unified Science of Cultural Evolution," 329.

78. See, for example, Slingerland, *What Science Offers the Humanities*.

79. Ibid., 345.

80. Émile Mâle, *The Gothic Image: Religious Art of France of the Thirteenth Century* (1899), trans. Dora Nussey (London: Collins, 1961).

81. Moretti, *Atlas of the European Novel*; and Moretti, "Graphs, Maps, Trees," parts 1 and 2.

82. Moretti, "Abstract Models for Literary History 3," 62.

83. Moretti, "World Systems Analysis," 220–21.

84. See Moretti, "Slaughterhouse of Literature."

85. See Prendergast, "Evolution and Literary Theory."

86. Bloch, "Philosophical View of the Detective Novel," 36–37.

87. Runciman, *Treatise of Social Theory*. Michael Rustin offers a critical analysis of Runciman's work in "New Social Evolutionalism?"

88. Runciman, *Treatise of Social Theory*, 2:38.

89. Runciman, *Theory of Cultural and Social Selection*, 46, 80.

90. This subject is also examined in Fracchia and Lewontin, "Price of Metaphor."

91. Koselleck, *Futures Past*, 99.

92. See Johann Joachim Winckelmann, *History of the Art of Antiquity*, trans. Harry Francis Mallgrave (Los Angeles: Getty Research Institute, 2006).

93. Koselleck, *Futures Past*, 103.

94. Ibid., 110.

95. Didi-Huberman, "Artistic Survival," 276.

CHAPTER 3

1. This approach is exemplified by Onians, *Neuroarthistory*. See, too, Skov et al.,

Neuroaesthetics; and Shimamura and Palmer, *Aesthetic Science*.

2. See Edelman, *Bright Air, Brilliant Fire*; and Gerald Edelman, *Consciousness: How Matter Becomes Imagination* (Harmondsworth: Penguin Books, 2001).

3. Ellen Spolsky, "Making 'Quite Anew': Brain Modularity and Creativity," in Zunshine, *Introduction to Cognitive Cultural Studies*, 86.

4. See the surveys in Chatterjee, "Neuroaesthetics"; and Jacobsen, "Beauty and the Brain." See, too, Jacobsen et al., "Brain Correlates of Aesthetic Judgment"; Frixione, "Art, the Brain, and Family Resemblances."

5. For the exhibition catalogue, see Cook, *Ice Age Art*.

6. Cumming, "Ice Age Art."

7. On the history of the reception of prehistoric art, see Paul Bahn, "The 'Discovery' of Prehistoric Art," in Bahn, *Cambridge History of Prehistoric Art*, 1–29; Günter Berghaus, "The Discovery and Study of Prehistoric Art," in Berghaus, *New Perspectives on Prehistoric Art*, 1–10; and Andrew Lawson, "Enlightenment and Discovery: The Birth of the Palaeolithic Period and the Discovery of the First Decorated Objects," in Lawson, *Painted Caves*, 15–48.

8. Bradley, *Image and Audience*, 5.

9. Schiller, *Lectures on the Aesthetic Education*, 191, 193.

10. Semper, *Über die formelle Gesetzmässigkeit*.

11. Piette, *Art pendant l'âge du Renne*. On the l'art pour l'art thesis, see Dijkstra, *Animal Substitute*, 227–40. The idea was later resurrected by Georges Bataille in *Lascaux*.

12. Reinach, "Art et la magie"; Breuil, *Four Hundred Centuries of Cave Art*. Breuil's ideas underpinned the work of English-language authors such as Thomas Powell and Nancy Sandars. See Powell, *Prehistoric Art*; Sandars, *Prehistoric Art in Europe*.

13. See, for example, Tylor, *Primitive Culture*; and Frazer, *Golden Bough*.

14. See Leroi-Gourhan, *Préhistoire de l'art occidental*.

15. See, for example, Lewis-Williams, *Rock Art of Southern Africa*; Lewis-Williams and Dowson, *Images of Power*.

16. Earlier versions of this thesis include Lewis-Williams and Dowson, "Signs of All Times"; Clottes and Lewis-Williams, *Shamans of Prehistory*.

17. Lewis-Williams, *Mind in the Cave*, 194.

18. See Palacio-Pérez, "Origins of the Concept of 'Palaeolithic Art.'"

19. Lewis-Williams, "Harnessing the Brain," 324.

20. See Hermann von Helmholtz, "Die entoptischen Erscheinungen," in Helmholtz, *Handbuch der Physiologischen Optik*, 184–201.

21. See Pfeiffer, *Creative Explosion*.

22. Lewis-Williams, *Mind in the Cave*, 188. The passage is a quotation from Edelman, *Bright Air, Brilliant Fire*.

23. See, for example, Barbara Olins Alpert, *The Creative Ice Age Brain: Cave Art in the Light of Neuroscience* (New York: Foundation 20 21, 2009).

24. See, for example, Finlayson, *Neanderthals and Modern Humans*; Mellars, *Neanderthal Legacy*.

25. Mithen, *Singing Neanderthals*, 232–33.

26. See Mithen, *Singing Neanderthals* and *Prehistory of the Mind*.

27. A key figure in this field is Nicholas Humphrey; see his *Consciousness Regained*.

28. "In the Neanderthal mind social intelligence was isolated from that concerning tool-making and interaction with the natural mind. . . . Neanderthals had no conscious awareness of the cognitive processes they used in the domains of technical and natural history intelligence." Mithen, *Prehistory of the Mind*, 166.

29. Dan Sperber, "Metarepresentations in an Evolutionary Perspective," in Sperber, *Metarepresentations*, 117–37.

30. See Winkelman, "Shamanism and Cognitive Evolution."

31. Fodor, *Mind Doesn't Work That Way*, 77.

32. Leda Cosmides and John Tooby, "Cognitive Adaptations for Social Exchange," in Barkow, Cosmides, and Tooby, *Adapted Mind*, 163–228.

33. "Even if early man had modules for 'natural intelligence' and 'technical intelligence,' he couldn't have become modern man just by adding what he knew about fires to what he knew about cows. The trick is in thinking out what happens when you put the two together; you get steak au poivre by integrating knowledge bases, not by merely summing them." Fodor, "Review of Steven Mithen's *The Prehistory of the Mind*," in Fodor, *In Critical Condition*, 159.

34. The meaning of a wink is famously discussed by Gilbert Ryle in "The Thinking of Thoughts: What Is 'Le Penseur' Doing?," in Ryle, *Collected Papers*, 2:480–96.

35. Layton, "Shamanism, Totemism, and Rock Art," 179.

36. See, for example, Anne Solomon's articles "The Myth of Ritual Origins?" and "Ethnography and Method."

37. On the wider topic of the appropriation of shamanism, see Francort and Hamayon, *Concept of Shamanism*.

38. See Hamayon, "Idée de 'contacte directe avec les esprits.'"

39. "Today few, if any neuropsychologists would consider phenomena produced within the eyeball to have any significant relevance to typical visual hallucinations. . . . The human visual system simply does not 'build' from those kind of 'bricks' and it seems a priori unlikely that any 'hallucinations' of that particular sort . . . would be meticulously recalled and recreated in a nonintoxicated state." Bahn, *Prehistoric Rock Art*, 70–71.

40. See Watson, "Oodles of Doodles?"

41. See Watson's essays "Rock Art and the Neurovisual Bases" and "Body and the Brain."

42. Cook, *Ice Age Art*, 42, 30, 17.

43. Hegel, *Aesthetics: Lectures on Fine Art*, 1:335.

44. A much-commented-on analysis by Alexander Marshack has attempted to discern the complex semiotic function of incisions on bones and other artifacts. See Marshack, "Upper Paleolithic Symbol Systems." See, too, Marshack's earlier extended study, *Roots of Civilization*.

45. See, for example, Leroi-Gourhan, *Préhistoire de l'art occidental*.

46. See Bednarik's essays "Pleistocene Palaeoart of Africa" and "Art Origins."

47. Gallese et al., "Action Recognition in the Premotor Cortex."

48. Freedberg and Gallese, "Motion, Emotion, and Empathy," 198.

49. Gallese and Freedberg, "Mirror and Canonical Neurons," 411.

50. Sbriscia-Foretti et al., "ERP Modulation During Observation," 2, 8.

51. See Aby Warburg, "Sandro Botticelli's *Birth of Venus* and *Spring*: An Examination of Concepts of Antiquity in the Italian Early Renaissance," in Warburg, *Renewal of Pagan Antiquity*, 89–156; Wölfflin, "Prolegomena to a Psychology of Architecture."

52. Gallese and Wojciehowski, "Mirror Neuron Mechanism," 3.

53. Wölfflin, *Renaissance and Baroque*, 77.

54. Gosetti-Ferencei, "Mimetic Dimension."

55. Cronan, *Against Affective Formalism*, 56–64.

56. Julia Kristeva, "Giotto's Joy," in Kristeva, *Desire in Language*, 210–36.

57. Bois et al., *Art Since 1900*, 101.

58. Deleuze, *Francis Bacon*, 35, 34.

59. Rancière, "Is There a Deleuzian Aesthetics," 13.

60. Mallgrave, *Architect's Brain*, 137–38.

61. Ibid., 146. Mallgrave refers to Semir Zeki's book *Inner Vision*.

62. Mallgrave, *Architect's Brain*, 146, 149.

63. Arnheim, *Dynamics of Architectural Form*, 258.

64. Whitney Davis, "Neurovisuality," *Nonsite.org*, no. 2 (12 June 2011), http://nonsite.org/issues/issue-2/neurovisuality (accessed 4 June 2015).

65. John Onians, "Greek Temple and Greek Brain," in Onians, *Art, Culture, and Nature*, 457, 459.

66. Ibid., 523, 522.

67. Onians, *Neuroarthistory*, 178–88. Onians cites two works by Baxandall that he deems to be engaged in a similar project to his own: *Shadows and Enlightenment* and "Fixation and Distraction."

68. See Baxandall, *Painting and Experience*.

69. Onians, *Neuroarthistory*, 93.

70. Jennifer Ashton makes a similar point in "Two Problems with a Neuroaesthetic Theory."

71. An important first step was made by Jean-Pierre Changeux in "Art and Neuroscience." This essay seeks to link the neurologically conditioned predispositions activated by art to the inheritance of cultural memes. Other prominent examples include Shimamura and Palmer, *Aesthetic Science*; Martindale, Locher, and Petrov, *Evolutionary and Neurocognitive Approaches*; Chatterjee, *Aesthetic Brain*; Skov et al., *Neuroaesthetics*; Starr, *Feeling Beauty*; Finger et al., *Fine Arts, Neurology, and Neuroscience*; and Zaidel, *Neuropsychology of Art*.

72. Ramachandran first provided an exposition of these "laws" in Ramachandran and Hirstein, "Science of Art." He then popularized the idea in the 2003 Reith lectures on BBC Radio 4. See Ramachandran, "The Artful Brain," in his *Emerging Mind*, 46–69. The text of the lecture is available online at http://www.bbc.co.uk/radio4/reith2003/lecture3.shtml (accessed 1 May 2015).

73. Ramachandran and Hirstein, "Science of Art," 17, 24.

74. Zeki, *Inner Vision*, 1.

75. Ibid., 12, 10.

76. Ibid., 25–26.

77. Ibid., 29.

78. See Kahnweiler, *Rise of Cubism*.

79. Zeki, *Inner Vision*, 52, citing John Golding, *Cubism: A History and Analysis* (London: Faber and Faber, 1959).

80. See, for example, Malevich, *Non-Objective World*; Mondrian, *New Art, the New Life*.

81. Zeki, *Inner Vision*, 124–25.

82. Ibid., 167.

83. See, for example, Lorne Campbell, "Poses," in Campbell, *Renaissance Portraits*, 69–108; Jodi Cranston, "Dialogue with the Beholder," in Cranston, *Poetics of Portraiture*, 15–61.

84. Zeki, *Inner Vision*, 172.

85. Leder and Belke, "Art and Cognition," 157.

86. Martin Skov, "Neuroaesthetic Problems: A Framework for Neuroaesthetic Research," in Skov et al., *Neuroaesthetics*, 16.

87. Hyman, "Art and Neuroscience," 250.

88. Stafford has made this argument in other books, including *Good Looking* and *Visual Analogy*.

89. Stafford, *Echo Objects*, 36.

90. Tallis, *Aping Mankind*, 138. See also 85–94.

91. See, for example, Searle, *Intentionality*.

92. See Libet's articles "Unconscious Cerebral Initiative" and "Consciousness, Free Action, and the Brain."

93. Tallis, *Aping Mankind*, 247–50. See also Tallis, *Knowing Animal*, 36ff.

94. See, for example, Shimamura, *Experiencing Art*.

95. Paolo Legrenzi and Carlo Umiltà make a similar criticism in *Neuromania*.

96. Davis notes, "In seeing man-made artifacts, we do not only recognize the objects *simpliciter* . . . we also tend to apprehend their configurative, stylistic, representational and cultural aspects." Davis, *General Theory of Visual Culture*, 36. Davis borrowed this idea from Wollheim, *Painting as an Art*.

97. Ashton, "Two Problems with a Neuroaesthetic Theory."

CHAPTER 4

1. Maturana and Varela, *Autopoiesis and Cognition*, 9.

2. See Mesarović, *Systems Theory and Biology*; Bertalanffy, *General Systems Theory*.

3. Bertalanffy, *General Systems Theory*, 121.

4. See, for example, Maly, *Systems Biology*; Capra and Luisi, *Systems View of Life*.

5. Bertalanffy, *General Systems Theory*, 209, 131.

6. Maturana and Varela, *Autopoiesis and Cognition*, 105.

7. Maturana and Varela, *Tree of Knowledge*, 114, 117.

8. Maturana and Varela, *Autopoiesis and Cognition*, 119.

9. See, for example, Mingers, *Self-Producing Systems*.

10. See Riedl, *Ordnungen des Lebendigen* and *Riedls Kulturgeschichte der Evolutionstheorie*; Wuketits, *Grundriss der Evolutionstheorie* and *Evolutionary Epistemology*.

11. Wuketits, *Grundriss der Evolutionstheorie*, 136–37.

12. Wuketits, *Evolutionary Epistemology*, 94–95.

13. Bertalanffy, *General Systems Theory*, 232. It is notable, too, that some of Bertalanffy's earliest publications were on art-historical topics. See his review of *Das Ornamentwerk*, by Theodor Bossert, and his review of *Die Krisis der Geisteswissenschaften*, by Josef Strzygowski.

14. The major essays are published in Bateson, *Steps to an Ecology of Mind*.

15. As Bateson notes, "if we desire to understand the mental aspect of any biological event, we must take into account the system—that is, the network of closed circuits, within which that biological event is determined." Ibid., 317.

16. Bateson, "Style, Grace, and Information in Primitive Art," ibid., 145.

17. Bateson, "The Role of Somatic Change in Evolution," ibid., 350.

18. Noel G. Charlton provides an analysis of Bateson's work in *Understanding Gregory Bateson*.

19. See Parsons, *Structure of Social Action*.

20. The major text in this regard is Luhmann, *Art as a Social System*, but Luhmann also wrote numerous shorter essays, published in Luhmann, *Schriften zu Kunst und Literatur*.

21. Habermas and Luhmann, *Theorie der Gesellschaft oder Sozialtechnologie*; Habermas, "Excursus on Niklas Luhmann's Appropriation of the Philosophy of the Subject Through Systems Theory," in Habermas, *Philosophical Discourse of Modernity*, 368–85; Habermas, "The Development of Systems Theory," in Habermas, *Theory of Communicative Action*, 235–82. See, too, the extensive engagement with Luhmann's account of evolution in Habermas, "Zum Thema." This is a response to Luhmann's essay "Evolution und Geschichte," in the same issue of the journal.

22. See, for example, Wiener, *Human Use of Human Beings*.

23. See Jack Burnham, "Systems Esthetics," in Burnham, *Great Western Salt Works*, 15–25; and Burnham, "Real Time Systems," ibid., 27–38. Burnham's account is outlined in Halsall, *Systems of Art*, 99–126.

24. Burnham, "Aesthetics of Intelligent Systems," 103. For a critical discussion of Burnham, see Skrebowski, "All Systems Go."

25. In addition to *Art as Social System*, see Luhmann, *Risk: A Sociological Theory*; *Love as Passion*; *Reality of the Mass Media*; *Law as a Social System*; and *Systems Theory of Religion*.

26. Luhmann, *Art as a Social System*, 213.

27. Luhmann, *Theory of Society*, 21.

28. Luhmann, *Art as a Social System*, 49.

29. Luhmann, *Social Systems*, 49.

30. Ibid., 265.

31. Luhmann, *Art as a Social System*, 13.

32. Luhmann, *Theories of Distinction*, 169.

33. Luhmann, *Social Systems*, 150.

34. Luhmann, "Deconstruction as Second-Order Observing," *New Literary History* 24, no. 4 (1993): 763–82; Andrew Koch, "Niklas Luhmann, Jacques Derrida, and the Politics of Epistemological Closure," in Koch, *Poststructuralism and the Politics of Method* (Lanham, Md.: Lexington Books, 2007), 43–62.

35. See the extended discussion in Luhmann, *Social Systems*, 59–102 (quotations on 60, 61).

36. Luhmann, *Art as a Social System*, 126, 62.

37. Ibid., 213, 216.

38. See Luhmann, "Evolution und Geschichte."

39. Luhmann, *Theory of Society*, 343.

40. Luhmann, "Evolution und Geschichte," 288, 286.

41. Ibid., 236.

42. Luhmann, *Art as a Social System*, 218.

43. Luhmann, *Theory of Society*, 268, 269.

44. As Luhmann states in *Social Systems* (349–50), "The primary question then becomes: With which semantics does the system determine the distinction between system and environment, and how does this semantics affect the processes of information processing and what necessities of adaptation appear in consequence against the backdrop of the system?"

45. Luhmann, *Art as a Social System*, 235.

46. Luhmann, *Theory of Society*, 57.

47. See in particular the chapters "Evolution," in *Theory of Society*, 251–358, and "Evolution," in *Art as a Social System*, 211–43.

48. Luhmann, *Art as a Social System*, 138.

49. Ibid., 139, 141, 23, 25.

50. Ibid., 50.

51. See Luhmann, "Weltkunst," 7.

52. Luhmann, "Redescription of 'Romantic Art,'" 514.

53. Luhmann, *Art as a Social System*, 287.

54. Luhmann, "Weltkunst," 14.

55. Luhmann, *Theory of Society*, 210.

56. Luhmann, *Art as a Social System*, 142.

57. Ibid., 309. As David Roberts has noted, the functional role of art lies in its "capacity to symbolize the conditions and consequences of functional differentiation on the level of society." Roberts, "Paradox Preserved," 65.

58. Luhmann, *Art as a Social System*, 90.

59. Luhmann, "Weltkunst," 9.

60. Luhmann, *Art as a Social System*, 227, 154, 237.

61. See, for example, Martin Warnke, *The Court Artist: On the Ancestry of the Modern Artist* (Cambridge: Cambridge University Press, 1993).

62. Luhmann, *Art as a Social System*, 157.

63. See Francis Hutcheson, *An Inquiry Concerning Beauty, Order, Harmony, Design* (1725) (The Hague: Martinus Nijhoff, 1973); and Anthony Ashley Cooper, Earl of Shaftesbury, *Characteristics of Men, Manners, Opinions, Times* (1711), ed. Lawrence E. Klein (Cambridge: Cambridge University Press, 2000).

64. See Eldredge and Gould, "Punctuated Equilibria."

65. See, for example, Foucault, *Order of Things*; Bourdieu, *Rules of Art*.

66. See Kuhn, *Structure of Scientific Revolutions*.

67. Luhmann, *Art as a Social System*, 235.

68. Mingers, "Can Social Systems Be Autopoietic?," 290.

69. Systems theory gained a particular hold in literary theory and criticism in the 1990s in Germany. See, for example, Schmidt, *Selbstorganisation des Sozialsystems*; Werber, *Literatur als System*; Plumpe, *Epochen moderner Literatur*; and Schmidt, *Histories and Discourses*.

70. Wyss, *Vom Bild zum Kunstsystem*, 125.

71. In particular, Belting's *Likeness and Presence*.

72. See Zijlmans, "Kunstgeschichte als Systemtheorie," in *Gesichtspunkte: Kunstgeschichte Heute*, ed. Marlite Halbertsma and Kitty Zijlmans (Berlin: Reimer, 1993), 251–78; and Zijlmans, "Kunstgeschichte der modernen Kunst."

73. See Luhmann, "Self-Organization: Coding and Programming," in *Art as a Social System*, 185–210.

74. Zijlmans, "Kunstgeschichte der modernen Kunst," 67–68.

75. Krieger, "Kunst als Kommunikation," 68.

76. See, in particular, Clement Greenberg, "Towards a Newer Laocoon" (1940), in *Art in Theory 1900–2000*, ed. Charles Harrison and Paul Wood (Oxford: Blackwell, 1993), 562–68.

77. Krieger, "Kunst als Kommunikation," 69.

78. Ibid., 67.

79. "The postmodern human is an orphaned subject of reflection, which, deprived of self-possession, desperately tries to go behind itself and, ultimately, to present itself performatively." Krieger, *Kommunikationssystem Kunst*, 151.

80. Halsall, *Systems of Art*, 67–98.

81. See Danto, "Artworld."

82. Arthur Danto, "Approaching the End of Art," in Danto, *State of the Art*, 202–20.

83. Halsall, *Systems of Art*, 128.

84. Sabine Kampmann, *Künstler sein: Systemtheoretische Beobachtungen von Autorschaft* (Munich: Wilhelm Fink, 2006).

85. Habermas, "Der systemtheoretische Begriff der Ideologie und Systemtheorie als neue Form der Ideologie," in Habermas and Luhmann, *Theorie der Gesellschaft*, 267.

86. Habermas, *Philosophical Discourse of Modernity*, 378.

87. Ibid., 380.

88. See, for example, Leydesdorff, "Luhmann, Habermas, and the Theory."

89. See Holub, "Luhmann's Progeny."

90. As Jameson notes, "Luhmann's concept can deal adequately neither with its antagonistic contradiction—the possibility of some system radically different from capitalist modernity—nor with its non-antagonistic contradiction—the coming into existence of a stage of capitalism that is no longer 'modern' in the traditional ways." Jameson, *Singular Modernity*, 94.

91. Luhmann, "Redescription of 'Romantic Art.'"

92. Habermas, *Philosophical Discourse of Modernity*, 384.

93. The discussion here builds on the argument in my article "Social Theory and the Autonomy of Art: The Case of Niklas Luhmann," in *Aesthetic and Artistic Autonomy*, ed. Owen Hulatt (New York: Continuum, 2013), 217–40.

94. On the revisiting of Duchamp, see Buskirk and Nixon, *Duchamp Effect*.

95. See Andrea Fraser, "From the Critique of Institutions to an Institution of Critique," in Welchman, *Institutional Critique and After*, 123–36.

96. Luhmann, *Art as a Social System*, 163, 164.

97. Bauman, "On Art, Death, and Postmodernity," 21.

98. Lash and Urry, *Economies of Signs and Space*, 2–3.

99. Bateson, *Steps to an Ecology of Mind*, 459.

CONCLUSION

1. Dennett, *Darwin's Dangerous Idea*, 63.

2. Ibid., 467–80.

3. "Showing that a particular type of human behaviour is ubiquitous in widely separated human cultures goes no way at all towards showing that there is a genetic predisposition for that particular behaviour. So far as I know, in every culture known to anthropologists the hunters throw their spears pointy-end-first, but this obviously doesn't establish that there is a pointy-end-first gene." Ibid., 486.

4. Slingerland, *What Science Offers the Humanities*, 300.

5. Pinker, "Toward a Consilient Study of Literature," 163.

6. Holbrook, *Evolution and the Humanities*, 205.

7. O'Hear, *Beyond Evolution*, 185.

8. See Faye, *After Postmodernism*, 42.

9. Pinker, "Toward a Consilient Study of Literature," 170.

10. See O'Hear, *Beyond Evolution*, 189.

11. Feige, "Kunst als Produkt," 29.

12. As John Peel argues, evolutionary theory "is profoundly anti-historical, for it aims to show us universal mechanisms of change, rather than the individual historical configurations out of which change comes about. Changes are called forth by an ill-defined environment rather than produced by men's evaluations and purposes in an environment." Peel, "Spencer and the Neo-Evolutionists," 183–84.

13. Luhmann, "Evolution und Geschichte," 284.

14. Habermas, *Knowledge and Human Interests*, 67.

15. The key texts are published in Adorno et al., *Positivist Dispute in German Sociology*.

16. Habermas, *Knowledge and Human Interests*, 160.

17. See Pinker, "Toward a Consilient Study of Literature."

18. See Carroll, "Pinker's Cheesecake for the Mind."

19. Jon Adams makes a similar point in relation to Carroll's interest in Jane Austen. See Adams, "Value Judgments and Functional Roles."

20. Scott Plous, *The Psychology of Judgment and Decision Making* (New York: McGraw-Hill, 1993), 233.

21. Gayatri Chakravorty Spivak, comment in a Harvard lecture, quoted in Solum, *Women, Patronage, and Salvation*, 9.

22. Bordwell, "Contemporary Film Theory," 19, 26.

23. Belting's *End of the History of Art* was first published as *Das End der Kunstgeschichte* in 1983.

24. See Didi-Huberman, *Image survivante*.

25. Dummett, *Truth and Other Enigmas*, 14, 18.

SELECTED BIBLIOGRAPHY

Abiodun, Rowland. *Yoruba Art and Language: Seeking the African in African Art*. Cambridge: Cambridge University Press, 2014.

Adams, Jon. "Value Judgments and Functional Roles: Carroll's Quarrel with Pinker." In *The Evolution of Literature: Legacies of Darwin in European Cultures*, edited by Nicholas Saul and Simon J. James, 155–70. Leiden: Brill, 2011.

Adorno, Theodor, Hans Albert, Ralf Dahrendorf, Jürgen Habermas, Harald Pilot, and Karl Popper. *The Positivist Dispute in German Sociology*. Translated by Glyn Adey and David Frisby. London: Heinemann, 1976.

Alcock, John. *The Triumph of Sociobiology*. Oxford: Oxford University Press, 2001.

Allen, Grant. *Evolution in Italian Art*. London: Grant Richards, 1908.

———. *Physiological Aesthetics*. New York: Appleton, 1877.

Ansell-Pearson, Keith. *Germinal Life: The Difference and Repetition of Deleuze*. London: Routledge, 1999.

Appleton, Jay. *The Experience of Landscape*. Chichester: Wiley, 1996.

Arnheim, Rudolf. *The Dynamics of Architectural Form*. Berkeley: University of California Press, 1975.

Ashton, Jennifer. "Two Problems with a Neuroaesthetic Theory of Interpretation." *NonSite.org*, no. 2 (12 June 2011). Accessed 29 May 2015. http://nonsite.org/category/issues /issue-2.

Attenborough, David. *The Tribal Eye*. Seven-part BBC documentary, written and presented by David Attenborough, first broadcast 27 May 1975.

Aunger, Robert, ed. *Darwinizing Culture: The Status of Memetics as a Science*. Oxford: Oxford University Press, 2000.

Avital, Eytan, and Eva Jablonka. *Animal Traditions: Behavioural Inheritance in Evolution*. Cambridge: Cambridge University Press, 2000.

Bahn, Paul. *The Cambridge History of Prehistoric Art*. Cambridge: Cambridge University Press, 1998.

———. *Prehistoric Rock Art: Polemics and Progress*. Cambridge: Cambridge University Press, 2010.

Baines, John. *Visual and Written Culture in Ancient Egypt*. Oxford: Oxford University Press, 2007.

Bakhtin, Mikhail, and Pavel Medvedev. *The Formal Method in Literary Scholarship*. Baltimore: Johns Hopkins University Press, 1978.

Balfour, Henry. *The Evolution of Decorative Art: An Essay upon Its Origin and Development as Illustrated by the Art of Modern Races of Mankind*. London: Rivington, Percival, 1893.

Barkow, Jerome H., Leda Cosmides, and John Tooby, eds. *The Adapted Mind: Evolutionary Psychology and the Generation of Culture*. New York: Oxford University Press, 1992.

Bataille, Georges. *Lascaux, or The Birth of Art*. Milan: Skira, 1955.

Bateson, Gregory. *Steps to an Ecology of Mind: Collected Essays in Anthropology*. Chicago: University of Chicago Press, 2000.

Bauman, Zygmunt. "On Art, Death, and Postmodernity and What They Do to Each Other." In *Fresh Cream: Contemporary Art in Culture*, edited by Iwona Blazwick, 20–23. London: Phaidon Press, 2000.

Baxandall, Michael. "Fixation and Distraction: The Nail in Braque's *Violin and Pitcher* (1910)." In *Sight and Insight: Essays on Art and Culture in Honour of E. H. Gombrich at Eighty-Five*, edited by John Onians, 399–415. London: Phaidon Press, 1994.

———. *Painting and Experience in Fifteenth-Century Italy*. Oxford: Clarendon Press, 1972.

———. *Patterns of Intention: On the Historical Explanation of Pictures*. New Haven: Yale University Press, 1985.

———. *Shadows and Enlightenment*. New Haven: Yale University Press, 1995.

Bednarik, Robert G. "Art Origins." *Anthropos* 89 (1994): 169–80.

———. "Pleistocene Palaeoart of Africa." *Arts* 2 (2013): 6–34.

Belting, Hans. *An Anthropology of Images: Picture, Medium, Body*. Translated by Thomas Dunlap. Princeton: Princeton University Press, 2014.

———. *The End of the History of Art?* Translated by Christopher Wood. Chicago: University of Chicago Press, 1987.

———. *Florence and Baghdad: Renaissance Art and Arab Science*. Translated by Deborah Lucas Schneider. Cambridge, Mass.: Harvard University Press, 2011.

———. *Likeness and Presence: A History of the Image Before the Era of Art*. Translated by Edmund Jephcott. Chicago: University of Chicago Press, 1993.

Belting, Hans, and Andrea Buddensieg, eds. *The Global Contemporary and the Rise of New Art Worlds*. Cambridge, Mass.: MIT Press, 2013.

Berghaus, Günter, ed. *New Perspectives on Prehistoric Art*. Westport, Conn.: Greenwood, 2004.

Bertalanffy, Ludwig von. *General Systems Theory: Foundations, Development, Applications*. New York: George Braziller, 1968.

———. Review of *Das Ornamentwerk*, by Helmut Theodor Bossert. *Zeitschrift für Ästhetik und allgemeine Kunstwissenschaft* 22 (1928): 505–6.

———. Review of *Die Krisis der Geisteswissenschaften*, by Josef Strzygowski. *Zeitschrift für Ästhetik und allgemeine Kunstwissenschaft* 22 (1928): 213–20.

Blackmore, Susan J. *The Meme Machine*. Oxford: Oxford University Press, 1999.

Blackwell, Antoinette. *The Sexes Throughout Nature*. New York: G. P. Putnam's Sons, 1875.

Bloch, Ernst. "A Philosophical View of the Detective Novel." Translated by Roswitha Mueller and Stephen Thamann. *Discourse* 2 (1980): 32–52.

Bloch, Maurice. "A Well-Disposed Social Anthropologist's Problems with Memes." In *Darwinizing Culture: The Status of Memetics as a Science*, edited by Robert Aunger, 189–203. Oxford: Oxford University Press, 2000.

Blocker, H. Gene. "Non-Western Aesthetics as a Colonial Invention." *Journal of Aesthetic Education* 35, no. 4 (2001): 3–13.

Bois, Yve-Alain, Benjamin Buchloh, Hal Foster, and Rosalind Krauss. *Art Since*

1900: Modernism, Antimodernism, Postmodernism. London: Thames and Hudson, 2004.

Bordwell, David. "Contemporary Film Theory and the Vicissitudes of Grand Theory." In *Post-Theory: Reconstructing Film Studies*, edited by David Bordwell and Noel Carroll, 3–36. Madison: University of Wisconsin Press, 1996.

Bork, Robert. "Pros and Cons of Stratigraphic Models in Art History." *Res* 40 (2001): 177–87.

Bourdieu, Pierre. *The Rules of Art: Genesis and Structure of the Literary Field*. Translated by Susan Emanuel. Stanford: Stanford University Press, 1995.

Boyd, Brian. "Art and Evolution: The Avant-Garde as Test Case; Spiegelmann in *The Narrative Corpse*." In *Evolution, Literature, and Film: A Reader*, edited by Brian Boyd, Joseph Carroll, and Jonathan Gottschall, 433–56. New York: Columbia University Press, 2010.

———. *On the Origin of Stories: Evolution, Cognition, and Fiction*. Cambridge, Mass.: Harvard University Press, 2010.

Boyd, Brian, Joseph Carroll, and Jonathan Gottschall, eds. *Evolution, Literature, and Film: A Reader*. New York: Columbia University Press, 2010.

Boyd, Robert, and Peter Richerson. *Culture and the Evolutionary Process*. Chicago: University of Chicago Press, 1985.

———. *The Origin and Evolution of Cultures*. New York: Oxford University Press, 2005.

Boyer, Pascal. "From Studious Irrelevancy to Consilient Knowledge: Modes of Scholarship and Cultural Anthropology." In *Creating Consilience: Integrating the Sciences and the Humanities*, edited by Edward Slingerland and Mark Collard, 113–28. Oxford: Oxford University Press, 2012.

———. *The Naturalness of Religious Ideas: A Cognitive Theory of Religion*. Berkeley: University of California Press, 1994.

Bradley, Richard. *Image and Audience: Rethinking Prehistoric Art*. Oxford: Oxford University Press, 2009.

Brandon, Robert. *Adaptation and Environment*. Princeton: Princeton University Press, 1990.

Breuil, L'Abbé. *Four Hundred Centuries of Cave Art*. Translated by Mary Boyle. Montignac: Centre d'Etudes et de Documentation Préhistoriques, 1952.

Brodie, Richard. *Virus of the Mind: The Revolutionary New Science of the Meme and How It Can Help You*. London: Hay House, 2009.

Brubaker, Leslie. *Inventing Byzantine Iconoclasm*. Bristol: Bristol Classical Press, 2012.

Bryson, Norman. *Vision and Painting: The Logic of the Gaze*. London: Macmillan, 1981.

Burke, Peter. *The Italian Renaissance: Culture and Society*. Cambridge: Polity Press, 1987.

Burnham, Jack. "The Aesthetics of Intelligent Systems." In *The Future of Art*, edited by Edward Fry, 95–122. New York: Viking Press, 1970.

———. *Great Western Salt Works: Essays on the Meaning of Postformalist Art*. New York: George Braziller, 1973.

———. *Software: Information Technology, Its New Meaning for Art*. New York: Jewish Museum, 1970.

Buskirk, Martha, and Mignon Nixon, eds. *The Duchamp Effect*. Cambridge, Mass.: MIT Press, 1996.

Buss, David. *The Evolution of Desire: Strategies of Human Mating*. New York: Basic Books, 1994.

Cahill, James. *The Painter's Practice: How Artists Lived and Worked in Traditional China*. New York: Columbia University Press, 1995.

Campbell, Lorne. *Renaissance Portraits: European Portrait Painting in the Fourteenth, Fifteenth, and Sixteenth*

Centuries. New Haven: Yale University Press, 1990.

Capra, Fritjof, and Pier Luigi Luisi. *The Systems View of Life: A Unifying Vision*. Cambridge: Cambridge University Press, 2014.

Carrier, David. *A World Art History and Its Objects*. University Park: Pennsylvania State University Press, 2008.

Carroll, Joseph. *Literary Darwinism: Evolution, Human Nature, and Literature*. New York: Routledge, 2003.

———. *Reading Human Nature: Literary Darwinism in Theory and Practice*. Albany: SUNY Press, 2011.

———. "Steven Pinker's Cheesecake for the Mind." *Philosophy and Literature* 22 (1998): 478–85.

———. "Theory, Anti-Theory, and Empirical Criticism." In *Biopoetics: Evolutionary Explorations in the Arts*, edited by Brett Cooke and Frederick Turner, 139–54. St. Paul: Paragon House, 1999.

Cartailhac, Émile. "La grotte d'Altamira, Espagne: Mea culpa d'un sceptique." *L'anthropologie* 13 (1902): 348–54.

Cavalli-Sforza, Luigi Luca, and Marcus Feldman. *Cultural Transmission and Evolution: A Quantitative Approach*. Princeton: Princeton University Press, 1981.

Chakrabarty, Dipesh. *Provincializing Europe: Postcolonial Thought and Historical Difference*. Princeton: Princeton University Press, 2000.

Changeux, Jean-Pierre. "Art and Neuroscience." *Leonardo* 27, no. 3 (1994): 189–201.

Charlton, Noel G. *Understanding Gregory Bateson: Mind, Beauty, and the Sacred*. Albany: SUNY Press, 2008.

Chatterjee, Anjal. *The Aesthetic Brain: How We Evolved to Desire Beauty and Enjoy Art*. New York: Oxford University Press, 2013.

———. "Neuroaesthetics: A Coming of Age Story." *Journal of Cognitive Neuroscience* 23, no. 1 (2010): 53–62.

Clark, Xenos. "Animal Music: Its Nature and Origin." *American Naturalist* 13, no. 4 (1879): 209–23.

Clottes, Jean, and David Lewis-Williams. *The Shamans of Prehistory*. New York: Abrams, 1998.

Collard, Mark, and Stephen J. Shennan. "Ethnogenesis Versus Phylogenesis in Prehistoric Culture Change: A Case Study Using European Neolithic Pottery and Biological Phylogenetic Techniques." In *Archaeogenetics: DNA and the Population Prehistory of Europe*, edited by Colin Renfrew and Katie Boyle, 89–97. Cambridge: McDonald Institute for Archaeological Research, 2000.

Collard, Mark, Stephen J. Shennan, and Jamshid Tehrani. "Branching, Blending, and the Evolution of Cultural Similarities and Differences Among Human Populations." *Evolution and Human Behaviour* 27 (2006): 169–84.

Collins, Christopher. *Paleopoetics: The Evolution of the Preliterate Imagination*. New York: Columbia University Press, 2013.

Cook, Jill. *Ice Age Art: Arrival of the Modern Mind*. London: British Museum, 2013. Exhibition catalogue.

Coombes, Annie. *Reinventing Africa: Museums, Material Culture, and Popular Imagination in Late Victorian and Edwardian England*. New Haven: Yale University Press, 1997.

Courajod, Louis. *Louis Courajod: Leçons professées à l'École du Louvre (1887–1896)*. Edited by Henry André and Michel André. 3 vols. Paris: Alphonse Picard et Fils, 1899–1903.

Cranston, Jodi. *The Poetics of Portraiture in the Italian Renaissance*. Cambridge: Cambridge University Press, 2000.

Crary, Jonathan. *Techniques of the Observer: On Vision and Modernity in the*

Nineteenth Century. Cambridge, Mass.: MIT Press, 1992.

Cronan, Todd. *Against Affective Formalism: Matisse, Bergson, Modernism*. Minneapolis: University of Minnesota Press, 2013.

Crowther, Paul. *Art and Embodiment: From Aesthetics to Self-Consciousness*. Oxford: Clarendon Press, 1993.

———. "More Than Ornament: The Significance of Riegl." *Art History* 17, no. 3 (1994): 482–93.

Cumming, Laura. "Ice Age Art: Arrival of the Modern Mind—Review." *Guardian Online*, 9 February 2013. Accessed 10 June 2016. https://www.theguardian.com/artanddesign/2013/feb/10/ice-age-art-british-museum-review.

Daly, Martin, and Margo Wilson. *The Truth About Cinderella: A Darwinian View of Parental Love*. London: Weidenfeld and Nicolson, 1998.

Damme, Wilfried van, and Kitty Zijlmans. "Art History in a Global Frame: World Art Studies." In *Art History and Visual Studies in Europe: Transnational Discourses and National Frameworks*, edited by Matthew Rampley, Thierry Lenain, Hubert Locher, Andrea Pinotti, Charlotte Schoell-Glass, and Kitty Zijlmans, 231–46. Leiden: Brill, 2012.

Danto, Arthur. *After the End of Art: Contemporary Art and the Pale of History*. Princeton: Princeton University Press, 1998.

———. "The Artworld." *Journal of Philosophy* 61 (1964): 571–84.

———. *The State of the Art*. New York: Simon and Schuster, 1987.

Darwin, Charles. *The Descent of Man, and Selection in Relation to Sex*. 2nd ed., 1879. Harmondsworth: Penguin, 2004.

———. *The Expression of Emotions in Animals and Man*. London: John Murray, 1872.

———. *On the Origin of Species*. 1859. Harmondsworth: Penguin, 1982.

———. *On the Various Contrivances by Which British and Foreign Orchids Are Fertilised by Insects and the Good Effects of Intercrossing*. London: John Murray, 1862.

———. *The Voyage of the Beagle: Charles Darwin's Journal of Researches*. 1839. Harmondsworth: Penguin, 1989.

Davidson, Donald. "On the Very Idea of a Conceptual Scheme." In Davidson, *Inquiries into Truth and Interpretation*, 183–98. Oxford: Blackwell, 1984.

Davies, Stephen. *The Artful Species: Aesthetics, Art, and Evolution*. Oxford: Oxford University Press, 2012.

———. "Ellen Dissanayake's Evolutionary Aesthetic." *Evolutionary Biology* 20 (2005): 291–304.

Davis, Whitney. *A General Theory of Visual Culture*. Princeton: Princeton University Press, 2011.

Dawkins, Richard. *The Extended Phenotype: The Long Reach of the Gene*. Oxford: Oxford University Press, 1982.

———. *The Selfish Gene*. 2nd ed. Oxford: Oxford University Press, 1989.

Deleuze, Gilles. *Francis Bacon: The Logic of Sensation*. Translated by Daniel W. Smith. London: Continuum, 2003.

Deleuze, Gilles, and Félix Guattari. *A Thousand Plateaus: Capitalism and Schizophrenia*. Translated by Brian Massumi. London: Athlone Press, 1988.

Delmarcel, Guy, ed. *Flemish Tapestry Weavers Abroad: Emigration and the Founding of Manufactories in Europe*. Louvain: Louvain University Press, 2002.

Dennett, Daniel. *Darwin's Dangerous Idea: Evolution and the Meanings of Life*. Harmondsworth: Penguin, 1995.

———. "Memes and the Exploitation of Imagination." *Journal of Aesthetics and Art Criticism* 48, no. 2 (1990): 127–35.

Diamond, Jared. *Collapse: How Societies Choose to Fail or Survive.* Harmondsworth: Penguin, 2011.

———. *Guns, Germs, and Steel: The Fates of Human Societies.* New York: W. W. Norton, 1997.

———. *The Rise and Fall of the Third Chimpanzee: How Our Animal Heritage Affects the Way We Live.* London: Vintage Books, 1992.

Didi-Huberman, Georges. "Artistic Survival: Panofsky vs. Warburg and the Exorcism of Impure Time." *Common Knowledge* 9, no. 2 (2003): 273–85.

———. *L'image survivante: Histoire de l'art et temps des fantômes selon Aby Warburg.* Paris: Éditions de Minuit, 2002.

———. "The Surviving Image: Aby Warburg and Tylorian Anthropology." *Oxford Art Journal* 25, no. 1 (2002): 61–69.

Dijkstra, Marjolein Efting. *The Animal Substitute: An Ethnological Perspective on the Origin of Image-Making and Art.* Delft: Eburon, 2010.

Dissanayake, Ellen. *Art and Intimacy: How the Arts Began.* Seattle: University of Washington Press, 2000.

———. "The Arts After Darwin. Does Art Have an Origin and Adaptive Function?" In *World Art Studies: Exploring Concepts and Approaches,* edited by Kitty Zijlmans and Wilfried van Damme, 241–63. Amsterdam: Valiz, 2008.

———. *Homo Aestheticus: Where Art Comes from and Why.* New York: Free Press, 1992.

Distin, Kate. *The Selfish Meme: A Critical Reassessment.* Cambridge: Cambridge University Press, 2005.

Dummett, Michael. *Truth and Other Enigmas.* Cambridge, Mass.: Harvard University Press, 1978.

Dutton, Denis. *The Art Instinct: Beauty, Pleasure, and Human Evolution.* Oxford: Oxford University Press, 2009.

Dvořák, Max. *The History of Art as the History of Ideas.* Translated by John Hardy. London: Routledge and Kegan Paul, 1984.

———. "Das Rätsel der Kunst der Brüder Van Eyck." *Jahrbuch der Kunsthistorischen Sammlungen des Allerhöchsten Kaiserhauses* 24 (1904): 161–317.

Easterlin, Nancy. *A Biocultural Approach to Literary Theory and Interpretation.* Baltimore: Johns Hopkins University Press, 2012.

Edelman, Gerald. *Bright Air, Brilliant Fire: On the Matter of the Mind.* Harmondsworth: Allen Lane, 1992.

Eitelberger, Rudolf. "Ansprache zur Eröffnung des ersten Kunstwissenschaftlichen Kongresses." 1873. In *Kunsttheorie und Kunstgeschichte des 19. Jahrhunderts in Deutschland,* vol. 1, edited by Werner Busch and Wolfgang Beyrodt, 351–55. Stuttgart: Reclam, 1982.

Eldredge, Niles, and Stephen Jay Gould. "Punctuated Equilibria: An Alternative to Phyletic Gradualism." In *Models in Paleobiology,* edited by Thomas J. M. Schopf, 82–115. New York: Doubleday, 1972.

Elkins, James, ed. *Is Art History Global?* London: Routledge, 2007.

———. Review of *Real Spaces,* by David Summers. *Art Bulletin* 86 (2004): 373–80.

———. *Stories of Art.* New York: Routledge, 2002.

Evans, John. "On the Coinage of the Ancient Britons and Natural Selection." *Proceedings of the Royal Society* 7 (1875): 476–87.

Faye, Jan. *After Postmodernism: A Naturalistic Reconstruction of the Humanities.* London: Palgrave, 2011.

Feige, Daniel. "Kunst als Produkt der natürlichen Evolution?" *Zeitschrift für Ästhetik und allgemeine Kunstwissenschaft* 53 (2008): 21–38.

Fergusson, James. *An Historical Inquiry into the True Principles of Beauty in Art More Especially with Reference to Architecture.* London: Longman, Brown, Green and Longmans, 1849.

Fernandez, James. "Principles of Opposition and Vitality in Fang Aesthetics." *Journal of Aesthetics and Art Criticism* 25, no. 1 (1966): 53–64.

Finger, Stanley, Dahlia W. Zaidel, François Boller, and Julien Bogousslavsky, eds. *The Fine Arts, Neurology, and Neuroscience: New Discoveries and Changing Landscapes.* Oxford: Elsevier, 2013.

Fingesten, Peter. "The Theory of Evolution in the History of Art." *College Art Journal* 13, no. 4 (1954): 302–10.

Finlayson, Clive. *Neanderthals and Modern Humans: An Ecological and Evolutionary Perspective.* Cambridge: Cambridge University Press, 2004.

Firth, Raymond. "Art and Anthropology." In *Anthropology, Art, and Aesthetics*, edited by Jeremy Coote and Anthony Shelton, 15–39. Oxford: Oxford University Press, 1992.

Flannery, Tim. "Eyes at the Back of Your Head—How Richard Semon's Mnemes Gave Way to Richard Dawkins's Memes." *Times Literary Supplement*, 19 October 2001, 10–11.

Fleck, Robert. *Das Kunstsystem im 21. Jahrhundert: Museen, Künstler, Sammler, Galerien.* Vienna: Passagen Verlag, 2015.

Flinn, Mark V. "Culture and the Evolution of Social Learning." *Evolution and Human Behaviour* 18, no. 1 (1997): 23–67.

Focillon, Henri. *The Life of Forms in Art.* 1934. Translated by C. Hogan and G. Kubler. New York: Zone Books, 1989.

———. *Moyen Âge: Survivances et reveils; Études d'art et d'histoire.* New York: Bretano's, 1943.

Fodor, Jerry. *In Critical Condition: Polemical Essays on Cognitive Science and the Philosophy of Mind.* Cambridge, Mass.: MIT Press, 2000.

———. *The Mind Doesn't Work That Way: The Scope and Limits of Computational Psychology.* Cambridge, Mass.: MIT Press, 2001.

———. *The Modularity of Mind.* Cambridge, Mass.: MIT Press, 1983.

Foucault, Michel. *The Order of Things: An Archaeology of the Human Sciences.* London: Tavistock, 1986.

Fracchia, Joseph, and Richard C. Lewontin. "The Price of Metaphor." *History and Theory* 44 (2005): 14–29.

Francort, Henri, and Robert Hamayon, eds. *The Concept of Shamanism: Uses and Abuses.* Budapest: Akadémia Kiadó, 2002.

Frank, Mitchell B., and Daniel Adler, eds. *German Art History and Scientific Thought.* Farnham: Ashgate, 2012.

Frazer, James. *The Golden Bough: A Study in Magic and Religion.* 3rd ed. 12 vols. London: Macmillan, 1911–15.

Freedberg, David. *The Power of Images: Studies in the History and Theory of Response.* Chicago: University of Chicago Press, 1989.

Freedberg, David, and Vittorio Gallese. "Motion, Emotion, and Empathy in Esthetic Experience." *Trends in Cognitive Sciences* 11, no. 5 (2007): 197–203.

Frixione, Marcello. "Art, the Brain, and Family Resemblances: Some Considerations on Neuroaesthetics." *Philosophical Psychology* 24, no. 5 (2011): 699–715.

Gallese, Vittorio, Luciano Fadiga, Leonardo Fogassi, and Giacomo Rizzolatti. "Action Recognition in the Premotor Cortex." *Brain* 119 (1996): 593–609.

Gallese, Vittorio, and David Freedberg. "Mirror and Canonical Neurons Are Crucial Elements in Esthetic Response." *Trends in Cognitive Sciences* 11, no. 10 (2007): 411.

Gallese, Vittorio, and Hannah Chapelle Wojciehowski. "The Mirror Neuron

Mechanism and Literary Studies:
An Interview with Vittorio Gallese."
California Italian Studies 2, no. 1
(2010). Accessed 20 March 2016.
https://escholarship.org/uc/ismrg
_cisj.

Gamble, Eliza. *The Evolution of Woman:
An Inquiry into the Dogma of Her
Inferiority to Man.* New York: G. P.
Putnam's Sons, 1894.

Gombrich, E. H. *Aby Warburg: An
Intellectual Biography.* Oxford:
Phaidon Press, 1970.

———. "Aby Warburg, His Aims and
Methods: An Anniversary Lecture."
*Journal of the Warburg and Courtauld
Institutes* 62 (1999): 268–82.

———. "Aby Warburg und der
Evolutionismus des 19. Jahrhunderts."
In *Aby M. Warburg: Ekstatische
Nymphe und Trauernder Flussgott;
Porträt eines Gelehrten*, edited by
Robert Gallitz and Brita Reimers,
52–73. Hamburg: Dölling und Gallitz,
1995.

———. *Art and Illusion: A Study in the
Psychology of Pictorial Representation.*
Oxford: Phaidon Press, 1960.

———. "Research in the Humanities: Ideals
and Idols." In Gombrich, *Ideals and
Idols: Essays on Values in History and
in Art*, 112–22. Oxford: Phaidon Press,
1979.

———. *The Sense of Order: A Study in the
Psychology of Decorative Art.* London:
Phaidon Press, 1979.

———. *The Story of Art.* London: Phaidon
Press, 1950.

Gosetti-Ferencei, Jennifer. "The Mimetic
Dimension: Literature Between
Neuroscience and Phenomenology."
British Journal of Aesthetics 54, no. 4
(2014): 425–48.

Gould, Stephen Jay. *Bully for Brontosaurus.*
New York: W. W. Norton, 1991.

Gould, Stephen Jay, and Richard C.
Lewontin. "The Spandrels of San
Marco and the Panglossian Paradigm:
A Critique of the Adaptationist

Programme." *Proceedings of the
Royal Society of London* B 205 (1979):
581–98.

Gray, Russell D., Simon Greenhill, and
Quentin Atkinson. "Phylogenetic
Models of Language Change."
In *Cultural Evolution: Society,
Technology, Language, and Religion*,
edited by Peter J. Richerson and
Morten Christiansen, 285–302.
Cambridge, Mass.: MIT Press, 2013.

Greenough, Horatio. *Form and Function:
Remarks on Art, Design, and
Architecture.* 1852. Edited by Harold
Small. Berkeley: University of
California Press, 1947.

Grosz, Elizabeth. *Becoming Undone:
Darwinian Reflections on Life and Art.*
Durham: Duke University Press, 2011.

———. *Chaos, Territory, Art: Deleuze and
the Framing of the Earth.* New York:
Columbia University Press, 2008.

Habermas, Jürgen. *Knowledge and Human
Interests.* Translated by Jeremy J.
Shapiro. 2nd ed. Cambridge: Polity
Press, 1987.

———. *The Philosophical Discourse of
Modernity.* Translated by Thomas
McCarthy. Cambridge: Polity Press,
1987.

———. *The Theory of Communicative Action.*
Translated by Thomas McCarthy.
New York: Beacon Books, 1987.

———. "Zum Thema: Geschichte und
Evolution." *Geschichte und
Gesellschaft* 2, no. 3 (1976): 310–57.

Habermas, Jürgen, and Niklas Luhmann.
*Theorie der Gesellschaft oder
Sozialtechnologie—Was leistet die
Systemforschung?* Frankfurt am Main:
Suhrkamp, 1971.

Haddon, Alfred. *Evolution in Art as
Illustrated by the Life-Histories of
Designs.* London: Walter Scott, 1895.

Halsall, Francis. *Systems of Art: Art, History,
and Systems Theory.* New York: Peter
Lang, 2008.

Hamayon, Robert. "L'idée de 'contacte di-
recte avec les esprits' et ses contraintes

d'après l'exemple des sociétés sibéri-ennes." *Afrique et histoire* 6 (2006): 15–39.

Hegel, Georg Wilhelm Friedrich. *Aesthetics: Lectures on Fine Art.* Translated by T. M. Knox. 2 vols. Oxford: Clarendon Press, 1975.

Heinrich, Bernd. "The Biological Roots of Aesthetics and Art." *Evolutionary Psychology* 11, no. 3 (2013): 743–61.

Helmholtz, Hermann von. *Handbuch der Physiologischen Optik.* Leipzig: Voss, 1867.

Hempel, Carl. "The Function of General Laws in History." *Journal of Philosophy* 39, no. 2 (1942): 35–48.

———. "The Theoretician's Dilemma." *Minnesota Studies in the Philosophy of Science* 2 (1958): 37–98.

Hermens, Erma. "Technical Art History: The Synergy of Art, Conservation, and Science." In *Art History and Visual Studies in Europe: Transnational Discourses and National Frameworks*, edited by Matthew Rampley, Thierry Lenain, Hubert Locher, Andrea Pinotti, Charlotte Schoell-Glass, and Kitty Zijlmans, 151–66. Leiden: Brill, 2012.

Hersey, George L. *The Evolution of Allure: Sexual Selection from the Medici Venus to the Incredible Hulk.* Cambridge, Mass.: MIT Press, 1996.

Heuser, Georg. "Darwinistisches über Kunst und Technik." *Allgemeine Bauzeitung* 55 (1890): 17–19, 25–27.

———. "Das Werden von Stylformen: Fortsetzung Darwinistischer Studien." *Allgemeine Bauzeitung* 59 (1894): 53–54, 63–69.

Heyes, Cecilia, and Bennett G. Garef, eds. *Social Learning in Animals: The Roots of Culture.* London: Academic Press, 1996.

Hildebrand, Grant. *The Origins of Architectural Pleasure.* Berkeley: University of California Press, 1999.

Hirn, Yrjö. *The Origins of Art: A Psychological and Sociological Inquiry.* New York: Macmillan, 1900.

Holbrook, David. *Evolution and the Humanities.* Aldershot: Gower, 1987.

Holub, Robert. "Luhmann's Progeny: Systems Theory and Literary Studies in the Post-Wall Era." *New German Critique* 61 (1994): 143–59.

Hulks, David. "World Art Studies: A Radical Proposition?" *World Art* 3, no. 2 (2013): 189–200.

Humphrey, Nicholas. *Consciousness Regained: Chapters in the Development of Mind.* Oxford: Oxford University Press, 1984.

Hyman, John. "Art and Neuroscience." In *Beyond Mimesis and Convention: Representation in Art and Science*, edited by Roman Frigg and Matthew Hunter, 245–61. Dordrecht: Springer, 2010.

Irwin, Darren E. "Culture in Songbirds and Its Contribution to the Evolution of New Species." In *Creating Consilience: Integrating the Sciences and the Humanities*, edited by Edward Slingerland and Mark Collard, 163–78. Oxford: Oxford University Press, 2012.

Iversen, Margaret. *Alois Riegl: Art History and Theory.* Cambridge, Mass.: MIT Press, 1993.

Jacobsen, Thomas. "Beauty and the Brain: Culture, History, and Individual Differences in Aesthetic Appreciation." *Journal of Anatomy* 216 (2010): 184–91.

Jacobsen, Thomas, Ricarda I. Schubotz, Lea Höfel, and D. Yves von Cramon. "Brain Correlates of Aesthetic Judgment of Beauty." *NeuroImage* 29 (2006): 276–85.

Jaffer, Amin, and Anna Jackson, eds. *Encounters: The Meeting of Asia and Europe.* London: V&A, 2004.

Jameson, Fredric. *A Singular Modernity: Essay on the Ontology of the Present.* London: Verso, 2002.

Jardine, Lisa. "C. P. Snow's Two Cultures Revisited." *Christ's College Magazine* 235 (2010): 49–57.

Johnson, Dirk R. *Nietzsche's Anti-Darwinism.* Cambridge: Cambridge University Press, 2010.

Jordan, Peter, and Stephen Shennan. "Cultural Transmission, Language, and Basketry Traditions Amongst the California Indians." *Journal of Anthropological Archaeology* 22 (2003): 42–74.

Kahnweiler, Daniel-Henry. *The Rise of Cubism.* Translated by Henry Aronson. New York: Wittenborn, Schultz, 1949.

Kant, Immanuel. *Critique of the Power of Judgment.* Translated by Paul Guyer and Eric Matthews. Cambridge: Cambridge University Press, 2000.

Kemp, Martin. *The Science of Art: Optical Themes in Western Art from Brunelleschi to Seurat.* New Haven: Yale University Press, 1992.

Kohn, Marek, and Steven Mithen. "Handaxes: Products of Sexual Selection?" *Antiquity* 73 (1999): 518–26.

Koselleck, Reinhart. *Futures Past: On the Semantics of Historical Time.* Translated by Keith Tribe. Cambridge, Mass.: MIT Press, 1985.

Kramnick, Jonathan. "Literary Studies and Science: A Reply to My Critics." *Critical Inquiry* 38, no. 2 (2012): 431–60.

Krieger, David J. *Kommunikationssystem Kunst.* Vienna: Passagen Verlag, 1997.

———. "Kunst als Kommunikation: Systemtheoretische Beobachtungen." In *Was konstruiert Kunst?*, edited by Stefan Weber, 47–82. Vienna: Passagen Verlag, 1997.

Kristeva, Julia. *Desire in Language.* Translated by Léon Roudiez. New York: Columbia University Press, 1982.

Kroeber, Alfred, and Clyde Kluckhohn. *Culture: A Critical Review of Concepts and Definitions.* Cambridge, Mass.: Peabody Museum of American Archaeology and Ethnology, 1952.

Kubler, George. *The Shape of Time: Remarks on the History of Things.* New Haven: Yale University Press, 1962.

Kuhn, Thomas. *The Structure of Scientific Revolutions.* Chicago: University of Chicago Press, 1962.

Lachterman, David. *The Ethics of Geometry: Genealogy of Modernity.* London: Routledge, 1989.

Laland, Kevin, and Gillian Brown. *Sense and Nonsense.* Oxford: Oxford University Press, 2002.

Laland, Kevin, and Bennett G. Galef, eds. *The Question of Animal Culture.* Cambridge, Mass.: Harvard University Press, 2009.

Laland, Kevin, and Michael J. O'Brien. "Niche Construction Theory and Archaeology." *Journal of Archaeological Method and Theory* 17, no. 4 (2010): 323–55.

Laland, Kevin, and John Odling-Smee. "The Evolution of the Meme." In *Darwinizing Culture: The Status of Memetics as a Science*, edited by Robert Aunger, 121–42. Oxford: Oxford University Press, 2000.

Landa, Manuel de. *A Thousand Years of Nonlinear History.* Cambridge, Mass.: MIT Press, 2000.

Lash, Scott, and John Urry. *Economies of Signs and Space.* London: Sage, 1994.

Laudan, Larry. *Beyond Positivism and Relativism: Theory, Method, and Evidence.* Boulder: Westview Press, 1996.

Lawson, Andrew. *Painted Caves: Palaeolithic Rock Art in Western Europe.* Oxford: Oxford University Press, 2012.

Layton, Robert. "Shamanism, Totemism, and Rock Art: *Les Chamanes de la Préhistoire* in the Context of Rock Art Research." *Cambridge Archaeological Journal* 10, no. 1 (2000): 169–86.

Leder, Helmut, and Benno Belke. "Art and Cognition: Cognitive Processes in

Art Appreciation." In *Evolutionary and Neurocognitive Approaches to Aesthetics, Creativity, and the Arts*, edited by Colin Martindale, Paul Locher, and Vladimir M. Petrov, 149–63. Amityville, N.Y.: Baywood, 2007.

Legrenzi, Paolo, and Carlo Umiltà. *Neuromania*. Translated by Frances Anderson. Oxford: Oxford University Press, 2011.

Leroi-Gourhan, André. "Interprétation esthétique et religieuse des figures et symboles dans la préhistoire." *Archives de sciences sociales des religions* 42 (1976): 5–15.

———. *Préhistoire de l'art occidental*. Paris: Mazenod, 1965.

Lewis-Williams, David. "Harnessing the Brain: Vision and Shamanism in Upper Paleolithic Western Europe." In *Beyond Art: Pleistocene Image and Symbol*, edited by Margaret Conkey, Olga Soffer, Deborah Stratmann, and Nina G. Jablonski, 321–42. San Francisco: California Academy of Sciences, 1997.

———. *The Mind in the Cave: Consciousness and the Origins of Art*. London: Thames and Hudson, 2002.

———. *The Rock Art of Southern Africa*. Cambridge: Cambridge University Press, 1983.

Lewis-Williams, David, and Thomas Dowson. *Images of Power: Understanding Bushman Rock Art*. Cape Town: Southern Book Publishing, 1990.

———. "The Signs of All Times: Entoptic Phenomena in Upper Palaeolithic Art." *Current Anthropology* 29, no. 2 (1988): 201–17.

Lewontin, Richard C. "Sociobiology as an Adaptationist Programme." *Behavioural Science* 24 (1979): 5–14.

Leydesdorff, Loet. "Luhmann, Habermas, and the Theory of Communication." *Systems Research and Behavioral Science* 17, no. 3 (2000): 273–88.

Libet, Benjamin. "Consciousness, Free Action, and the Brain." *Journal of Consciousness Studies* 8 (2001): 59–65.

———. "Unconscious Cerebral Initiative and the Role of Conscious Will in Voluntary Action." *Behavioural and Brain Sciences* 8 (1985): 529–66.

Luhmann, Niklas. *Art as a Social System*. Translated by Eva Knodt. Stanford: Stanford University Press, 2000.

———. "Evolution und Geschichte." *Geschichte und Gesellschaft* 2, no. 3 (1976): 284–309.

———. *Law as a Social System*. Translated by Klaus Ziegert. Oxford: Oxford University Press, 2008.

———. *Love as Passion: The Codification of Intimacy*. Translated by Jeremy Gaines and Doris Jones. Stanford: Stanford University Press, 1999.

———. *Observations on Modernity*. Translated by William Whobrey. Stanford: Stanford University Press, 1998.

———. *The Reality of the Mass Media*. Translated by Kathleen Cross. Cambridge: Polity Press, 2000.

———. *Risk: A Sociological Theory*. Translated by Rhodes Barrett. Berlin: Walter de Gruyter, 1993.

———. *Schriften zu Kunst und Literatur*. Frankfurt am Main: Suhrkamp, 2008.

———. *Social Systems*. Translated by Eva Knodt. Stanford: Stanford University Press, 1996.

———. *A Systems Theory of Religion*. Translated by David Brenner and Adrian Hermann. Stanford: Stanford University Press, 2013.

———. *Theories of Distinction: Redescribing the Descriptions of Modernity*. Translated by Joseph O'Neill, Elliott Schreiber, Kerstin Behnke, and William Whobrey. Stanford: Stanford University Press, 2002.

———. *Theory of Society*. Translated by Rhodes Barrett. Stanford: Stanford University Press, 2012.

———. "Towards a Redescription of 'Romantic Art.'" *Modern Language Notes* 111, no. 3 (1996): 506–22.

———. "Weltkunst." In *Unbeobachtbare Welt: Über Kunst und Literatur*, edited by Niklas Luhmann, Frederick D. Bunsen, and Dirk Baecker, 7–45. Bielefeld: Haux, 1990.

Lumsden, Charles J., and Edward O. Wilson. *Genes, Mind, and Culture: The Coevolutionary Process*. Cambridge, Mass.: Harvard University Press, 1981.

Lyam, R. Lee, and Michael J. O'Brien. "Measuring and Explaining Change in Artifact Variation with Clade-Diversity Diagrams." *Journal of Anthropological Archaeology* 19 (2000): 39–74.

Malevich, Kazimir. *The Non-Objective World: The Manifesto of Suprematism*. Translated by Howard Dearstyne. New York: Dover, 2003.

Mallgrave, Harry Francis. *The Architect's Brain: Neuroscience, Creativity, and Architecture*. Chichester: John Wiley, 2010.

———. *Architecture and Embodiment: The Implications of the New Sciences and Humanities for Design*. London: Routledge, 2013.

Maly, Ivan V., ed. *Systems Biology*. New York: Humana Press, 2009.

Marshack, Alexander. *The Roots of Civilization: The Cognitive Beginnings of Man's First Art, Symbol, and Notation*. New York: McGraw-Hill, 1972.

———. "Upper Paleolithic Symbol Systems of the Russian Plain: Cognitive and Comparative Analysis." *Current Anthropology* 20, no. 2 (1979): 271–311.

Martindale, Colin, Paul Locher, and Vladimir M. Petrov, eds. *Evolutionary and Neurocognitive Approaches to Aesthetics, Creativity, and the Arts*. Amityville, N.Y.: Baywood, 2007.

Maturana, Humberto, and Francesco Varela. *Autopoiesis and Cognition: The Realization of the Living*. Boston: D. Reidel, 1980.

———. *The Tree of Knowledge: The Biological Roots of Human Understanding*. Boston: Shambhala, 1987.

Mellars, Paul. *The Neanderthal Legacy: An Archaeological Perspective of Western Europe*. Princeton: Princeton University Press, 1996.

Menninghaus, Winfried. *Das Versprechen der Schönheit*. Frankfurt am Main: Suhrkamp, 2003.

———. *Wozu Kunst? Ästhetik nach Darwin*. Frankfurt am Main: Suhrkamp, 2011.

Mesarović, Mihajlo D. *Systems Theory and Biology*. Berlin: Springer, 1968.

Mesoudi, Alex. *Cultural Evolution: How Darwinian Theory Can Explain Human Culture and Synthesize the Social Sciences*. Chicago: University of Chicago Press, 2011.

Mesoudi, Alex, Andrew Whiten, and Kevin Laland. "Toward a Unified Science of Cultural Evolution." *Behavioral and Brain Sciences* 29 (2006): 329–83.

Midgley, Mary. *The Solitary Self: Darwin and the Selfish Gene*. London: Acumen, 2010.

Miller, Geoffrey. *The Mating Mind: How Sexual Choice Shaped the Evolution of Human Nature*. London: Vintage Books, 2001.

Mingers, John. "Can Social Systems Be Autopoietic? Assessing Luhmann's Social Theory." *Sociological Review* 50, no. 2 (2002): 278–99.

———. *Self-Producing Systems: Implications and Applications of Autopoiesis*. New York: Plenum Press, 1995.

Mithen, Steven, ed. *Creativity in Human Evolution and Prehistory*. London: Routledge, 1998.

———. *The Prehistory of the Mind: A Search for the Origins of Art, Religion, and Science*. London: Thames and Hudson, 1996.

———. *The Singing Neanderthals*. London: Weidenfeld and Nicolson, 2005.

Mondrian, Piet. *The New Art, the New Life: The Collected Writings of Piet Mondrian*. Edited and translated by Harry S. Holtzmann and Martin S. James. New York: Da Capo Press, 1993.

Moretti, Franco. "Abstract Models for Literary History 3." *New Left Review* 28 (July–August 2004): 43–63.

———. *Atlas of the European Novel: 1800–1900*. London: Verso, 1999.

———. "Graphs, Maps, Trees: Abstract Models for Literary History—1." *New Left Review* 24 (November–December 2003): 67–93.

———. "Graphs, Maps, Trees: Abstract Models for Literary History—2." *New Left Review* 26 (March–April 2004): 79–103.

———. "The Slaughterhouse of Literature." *Modern Language Quarterly* 61, no. 1 (2000): 207–27.

———. "World Systems Analysis, Evolutionary Theory, *Weltliteratur*." *Review: A Journal of the Fernand Braudel Center* 28, no. 3 (2005): 217–28.

Morin, Olivier. "How Portraits Turned Their Eyes upon Us: Visual Preferences and Demographic Change in Cultural Evolution." *Evolution and Human Behaviour* 34 (2013): 222–29.

Morphy, Howard, Joanna Overing, Jeremy Coote, and Peter Gow. "Aesthetics Is a Cross-Cultural Category." In *Key Debates in Anthropology*, edited by Tim Ingold, 260–65. London: Routledge, 1996.

Nagel, Alexander, and Christopher S. Wood. *Anachronic Renaissance*. New York: Zone Books, 2010.

O'Brien, Michael J., and R. Lee Lyman. *Style, Function, Transmission: Evolutionary Archaeological Perspectives*. Salt Lake City: University of Utah Press, 2003.

Odling-Smee, John. "Niche Construction, Evolution, and Culture." In *Companion Encyclopedia of Anthropology: Humanity, Culture, and Social Life*, edited by Tim Ingold, 162–96. London: Routledge, 1994.

O'Hear, Anthony. *Beyond Evolution: Human Nature and the Limits of Evolutionary Explanation*. Oxford: Oxford University Press, 1997.

Onians, John. *Art, Culture, and Nature: From Art History to World Art Studies*. London: Pindar Press, 2006.

———. *Atlas of World Art*. New York: Oxford University Press, 2004.

———, ed. *Compression vs. Expression: Containing and Explaining the World's Art*. New Haven: Yale University Press, 2006.

———. *Neuroarthistory: From Aristotle and Pliny to Baxandall and Zeki*. New Haven: Yale University Press, 2008.

———. "World Art History and the Need for a New Natural History of Art." *Art Bulletin* 78, no. 2 (1996): 206–9.

———. "World Art: Ways Forward, and a Way to Escape the 'Autonomy of Culture' Delusion." *World Art* 1, no. 1 (2011): 125–34.

Orians, Gordon H., and Judith H. Heerwagen. "Evolved Responses to Landscapes." In *The Adapted Mind: Evolutionary Psychology and the Generation of Culture*, edited by Jerome H. Barkow, Leda Cosmides, and John Tooby, 555–80. New York: Oxford University Press, 1992.

Ortolano, Guy. *The Two Cultures Controversy: Science, Literature, and Cultural Politics in Postwar Britain*. New York: Cambridge University Press, 2009.

Pagel, Mark. *Wired for Culture: The Natural History of Human Cooperation*. Harmondsworth: Penguin, 2012.

Palacio-Pérez, Eduardo. "The Origins of the Concept of 'Palaeolithic Art': Theoretical Roots of an Idea." *Journal of Archaeological Method and Theory* 20, no. 4 (2013): 682–714.

Panofsky, Erwin. "The History of Art as a Humanistic Discipline." 1940. In Panofsky, *Meaning in the Visual Arts*,

1–25. Chicago: University of Chicago Press, 1983.

Parsons, Talcott. *The Structure of Social Action: A Study in Social Theory with Special Reference to a Group of Recent European Writers.* New York: Free Press, 1949.

Peel, J. D. Y. "Spencer and the Neo-Evolutionists." *Sociology* 3, no. 2 (1969): 173–91.

Pfeiffer, John E. *The Creative Explosion: An Inquiry into the Origins of Art and Religion.* Ithaca: Cornell University Press, 1982.

Pfisterer, Ulrich. "Origins and Principles of World Art History: 1900 (and 2000)." In *World Art Studies: Exploring Concepts and Approaches*, edited by Kitty Zijlmans and Wilfried van Damme, 69–89. Amsterdam: Valiz, 2008.

Piette, Edouard. *L'art pendant l'âge du Renne.* Paris: Masson, 1907.

Pinder, Wilhelm. *Problem der Generation in der Kunstgeschichte Europas.* Berlin: Frankfurter Verlags-Anstalt, 1926.

Pinker, Steven. *How the Mind Works.* Harmondsworth: Penguin, 1997.

———. *The Language Instinct.* New York: William Morrow, 1994.

———. "Toward a Consilient Study of Literature." *Philosophy and Literature* 31, no. 1 (2007): 162–78.

Pitt Rivers, Augustus. "On the Evolution of Culture." 1875. In *The Evolution of Culture and Other Essays*, edited by J. L. Myres, 20–44. Oxford: Clarendon Press, 1906.

Pliny the Elder. *Natural History.* Translated by John Healy. Harmondsworth: Penguin, 1991.

Plumpe, Gerhard. *Epochen moderner Literatur: Ein systemtheoretischer Entwurf.* Opladen: Westdeutscher Verlag, 1995.

Popper, Karl. *Conjectures and Refutations: The Growth of Scientific Knowledge.* London: Routledge, 2002.

———. *The Logic of Scientific Discovery.* 1934. London: Routledge, 2002.

Powell, Thomas. *Prehistoric Art.* London: Thames and Hudson, 1996.

Power, Camilla. "Beauty Magic: The Origins of Art." In *The Evolution of Culture*, edited by Robin Dunbar, Chris Knight, and Camilla Power, 91–112. Edinburgh: Edinburgh University Press, 1999.

Prange, Regine. *Die Geburt der Kunstgeschichte: Philosophische Ästhetik und empirische Wissenschaft.* Cologne: Deubner, 2004.

Prendergast, Christopher. "Evolution and Literary Theory." *New Left Review* 34 (July–August 2005): 40–62.

Ramachandran, Vilayanur. *The Emerging Mind: The BBC Reith Lectures 2003.* London: Profile Books, 2004.

Ramachandran, Vilayanur, and William Hirstein. "The Science of Art: A Neurological Theory of Aesthetic Experience." *Journal of Consciousness Studies* 6 (1999): 15–51.

Rampley, Matthew. "Iconology of the Interval: Aby Warburg's Legacy." *Word and Image* 17, no. 4 (2001): 303–24.

Rancière, Jacques. "Is There a Deleuzian Aesthetics?" Translated by Radmila Djordjevic. *Qui parle* 14, no. 2 (2004): 1–14.

Reichenbach, Hans. "On Probability and Induction." *Philosophy of Science* 5, no. 1 (1938): 21–45.

Reinach, Salomon. "L'art et la magie: A propos des peintures et des gravures de l'âge du Renne." *L'anthropologie* 14 (1903): 257–66.

Richardson, John. *Nietzsche's New Darwinism.* Oxford: Oxford University Press, 2004.

Richerson, Peter J., and Robert Boyd. *Not by Genes Alone: How Culture Transformed Human Evolution.* Chicago: University of Chicago Press, 2008.

Richerson, Peter J., and Morten Christiansen, eds. *Cultural Evolution: Society, Technology, Language, and Religion.* Cambridge, Mass.: MIT Press, 2013.

Riedl, Rupert. *Die Ordnungen des Lebendigen: Systembedingungen der Evolution.* Berlin: Parey, 1998.

———. *Riedls Kulturgeschichte der Evolutionstheorie.* Berlin: Springer, 2003.

Riegl, Alois. *The Group Portraiture of Holland.* 1905. Translated by Evelyn Kain and David Britt. Los Angeles: Getty Research Institute, 1999.

———. *Problems of Style: Foundations for a History of Ornament.* 1893. Edited by David Castriota. Translated by Evelyn Kain. Princeton: Princeton University Press, 1992.

———. *Spätrömische Kunstindustrie nach den Funden in Österreich-Ungarn im Zusammenhange mit der Gesamtentwicklung der bildenden Künste bei den Mittelmeervölkern.* Vienna: K. K. Hof- und Staatsdruckerei, 1901.

Roberts, David. "Paradox Preserved: From Ontology to Autology; Reflections on Niklas Luhmann's *The Art of Society.*" *Thesis Eleven* 51 (1997): 53–74.

Rose, Hilary. "Colonising the Social Sciences?" In *Alas, Poor Darwin: Arguments Against Evolutionary Psychology,* edited by Hilary Rose and Steven Rose, 106–28. London: Vintage Books, 2001.

Roughgarden, Joan. *Evolution's Rainbow: Diversity, Gender, and Sexuality in Nature and People.* Berkeley: University of California Press, 2003.

Runciman, W. G. *The Theory of Cultural and Social Selection.* Cambridge: Cambridge University Press, 2009.

———. *A Treatise of Social Theory.* 3 vols. Cambridge: Cambridge University Press, 1983–97.

Rustin, Michael. "A New Social Evolutionalism?" *New Left Review* 234 (March–April 1999): 106–26.

Ryle, Gilbert. *Collected Papers.* 2 vols. London: Hutchinson, 1971.

Sahlins, Marshall. *Culture and Practical Reason.* Chicago: University of Chicago Press, 1976.

———. *The Use and Abuse of Biology: An Anthropological Critique of Sociobiology.* Ann Arbor: University of Michigan Press, 1977.

Sandars, Nancy K. *Prehistoric Art in Europe.* Harmondsworth: Penguin, 1968.

Sbriscia-Foretti, Beatrice, Cristina Berchio, David Freedberg, Vittorio Gallese, and Maria Alessandra Umiltà. "ERP Modulation During Observation of Abstract Paintings by Franz Kline." *Plos One* 8, no. 10 (2013): 1–12.

Schacter, Daniel. *Forgotten Ideas, Neglected Pioneers: Richard Semon and the Story of Memory.* Hove: Psychology Press, 2001.

———. *Stranger Behind the Engram: Theories of Memory and the Psychology of Science.* Hillsdale, N.J.: Lawrence Erlbaum, 1982.

Schapiro, Meyer. "The Nature of Abstract Art." 1937. In Schapiro, *Modern Art: Nineteenth and Twentieth Centuries, Selected Papers,* 185–212. New York: George Braziller, 1978.

Schiller, Friedrich. *Lectures on the Aesthetic Education of Man.* Translated by Elizabeth Wilkinson and L. A. Willoughby. Oxford: Clarendon Press, 1967.

Schillinger, Joseph. *The Mathematical Basis of the Arts.* New York: Philosophical Library, 1948.

Schmidt, Siegfried J. *Histories and Discourses: Rewriting Constructivism.* Exeter: Imprint Academic, 2007.

———. *Die Selbstorganisation des Sozialsystems Literatur im 18. Jahrhundert.* Frankfurt am Main: Suhrkamp, 1989.

Scott, Geoffrey. *The Architecture of Humanism: A Study in the History of Taste.* Boston: Houghton Mifflin, 1914.

Searle, John R. *Intentionality: An Essay in the Philosophy of Mind*. Cambridge: Cambridge University Press, 1983.

Semon, Richard. *The Mneme*. 1904. Translated by Louis Simon. London: George Allen and Unwin, 1921.

Semper, Gottfried. *The Four Elements of Architecture and Other Writings*. Translated and edited by Harry Francis Mallgrave and Wolfgang Herrmann. Cambridge: Cambridge University Press, 1989.

———. *Kleine Schriften*. Edited by Manfred Semper and Hans Semper. Berlin: B. Speman, 1884.

———. *Style in the Technical and Tectonic Arts, or Practical Aesthetics*. Translated by Harry Francis Mallgrave and Michael Robinson. Los Angeles: Getty Research Institute, 2004.

———. *Über die formelle Gesetzmässigkeit des Schmuckes und dessen Bedeutung als Kunstsymbol*. 1856. Berlin: Alexander Verlag, 1987.

Shennan, Stephen. *Genes, Memes, and Human History: Darwinian Archaeology and Cultural Evolution*. London: Thames and Hudson, 2002.

Shennan, Stephen, and Mark Collard. "Investigating Processes of Cultural Evolution on the North Coast of New Guinea with Multivariate and Cladistic Analyses." In *The Evolution of Cultural Diversity: A Phylogenetic Approach*, edited by Ruth Mace, Clare J. Holden, and Stephen Shennan, 133–64. London: UCL Press, 2005.

Shimamura, Arthur. *Experiencing Art: In the Brain of the Beholder*. Oxford: Oxford University Press, 2013.

Shimamura, Arthur, and Stephen E. Palmer, eds. *Aesthetic Science: Connecting Minds, Brains, and Experience*. New York: Oxford University Press, 2013.

Skov, Martin, Oshin Vartanian, Colin Martindale, and Arnold Berleant, eds. *Neuroaesthetics*. Amityville, N.Y.: Baywood, 2009.

Skrebowski, Luke. "All Systems Go: Recovering Jack Burnham's 'Systems Aesthetics.'" *Tate Papers* 5 (2006). Accessed 1 April 2015. http://www.tate.org.uk/research/publications/tate-papers/05/all-systems-go-recovering-jack-burnhams-systems-aesthetics.

Slingerland, Edward. "Mind-Body Dualism and the Two Cultures." In *Creating Consilience: Integrating the Sciences and the Humanities*, edited by Edward Slingerland and Mark Collard, 74–87. Oxford: Oxford University Press, 2012.

———. *What Science Offers the Humanities: Integrating Body and Culture; Beyond Dualism*. Cambridge: Cambridge University Press, 2008.

Slingerland, Edward, and Mark Collard, eds. *Creating Consilience: Integrating the Sciences and the Humanities*. Oxford: Oxford University Press, 2012.

Snaevarr, Stefan. "Talk to the Animals: A Short Comment on Wolfgang Welsch's 'Animal Aesthetics.'" *Contemporary Aesthetics* 2 (2004). Accessed 13 January 2014. http://www.contempaesthetics.org/index.html.

Snow, C. P. *The Two Cultures*. Edited by Stefan Collini. Cambridge: Cambridge University Press, 1998.

Solomon, Anne. "Ethnography and Method in Southern African Rock-Art Research." In *The Archaeology of Rock Art*, edited by Christopher Chippindale and Paul Taçon, 268–84. Cambridge: Cambridge University Press, 1998.

———. "The Myth of Ritual Origins? Ethnography, Mythology, and Interpretation of San Rock Art." *South African Archaeological Bulletin* 52 (1997): 3–13.

Solum, Stefanie. *Women, Patronage, and Salvation in Renaissance Florence: Lucrezia Tornabuoni and the Chapel of the Medici Palace*. Farnham: Ashgate, 2015.

Spencer, Herbert. *Essays: Scientific, Political, and Speculative.* 3 vols. London: Williams and Norgate, 1891.

———. "The Origin and Function of Music." *Fraser's Magazine* 56 (1857): 396–408. Second edition reprinted in *Essays: Scientific, Political, and Speculative*, 2:400–451.

———. *Principles of Biology.* 2 vols. London: Williams and Norgate, 1864–67.

Sperber, Dan. *Explaining Culture: A Naturalistic Approach.* Oxford: Blackwell, 1996.

———. *Metarepresentations: A Multidisciplinary Perspective.* Oxford: Oxford University Press, 2000.

Spolsky, Ellen. "Brain Modularity and Creativity." In *Introduction to Cognitive Cultural Studies*, edited by Lisa Zunshine, 84–102. Baltimore: Johns Hopkins University Press, 2010.

Spolsky, Ellen, and Alan Richardson, eds. *The Work of Fiction: Cognition, Culture, and Complexity.* Farnham: Ashgate, 2004.

Spooner, Brian. "Weavers and Dealers: The Authenticity of an Oriental Carpet." In *The Social Life of Things: Commodities in Cultural Perspective*, edited by Arjun Appadurai, 195–235. Cambridge: Cambridge University Press, 1986.

Springer, Anton. "Das Nachleben der Antike im Mittelalter." 1862. In Springer, *Bilder aus der neueren Kunstgeschichte*, 1–40. Bonn: Adolph Marcus, 1886.

Stafford, Barbara Maria. *Echo Objects: The Cognitive Work of Images.* Chicago: University of Chicago Press, 2007.

———. *Good Looking: Essays on the Virtues of Images.* Cambridge, Mass.: MIT Press, 1996.

———. *Visual Analogy: Consciousness as the Art of Connecting.* Cambridge, Mass.: MIT Press, 1999.

Starr, G. Gabrielle. *Feeling Beauty: The Neuroscience of Aesthetic Experience.* Cambridge, Mass.: MIT Press, 2013.

Steadman, Philip. *The Evolution of Designs: Biological Analogy in Architecture and the Applied Arts.* Cambridge: Cambridge University Press, 1979.

Steven, Jan. *The Memetics of Music: A Neo-Darwinian View of Musical Structure and Culture.* Farnham: Ashgate, 2007.

Stoichita, Victor. *The Self-Aware Image: An Insight into Early Modern Metapainting.* Cambridge: Cambridge University Press, 1997.

Sully, James. "Animal Music." *Cornhill Magazine* 40 (1879): 605–21.

Summers, David. *Real Spaces: World Art History and the Rise of Western Modernism.* London: Phaidon Press, 2003.

Symonds, John Addington. *Essays, Speculative and Suggestive.* London: Chapman and Hall, 1893.

Symons, Donald. *The Evolution of Human Sexuality.* Oxford: Oxford University Press, 1979.

Taine, Hippolyte. *Philosophie de l'art: Leçons professées à l'Ecole des beaux-arts.* Paris: Germer Baillière, 1865.

Tallis, Raymond. *Aping Mankind: Neuromania, Darwinitis, and the Misrepresentation of Humanity.* London: Acumen, 2011.

———. *The Knowing Animal: A Philosophical Inquiry into Knowledge and Truth.* Edinburgh: Edinburgh University Press, 2005.

Tehrani, Jamshid, and Mark Collard. "Investigating Cultural Evolution Through Biological Phylogenetic Analyses of Turkmen Textiles." *Journal of Anthropological Archaeology* 21 (2002): 443–63.

———. "On the Relationship Between Interindividual Cultural Transmission and Population-Level Cultural Diversity: A Case Study of Weaving in Iranian Tribal Populations." *Evolution and Human Behaviour* 30 (2009): 286–300.

Tehrani, Jamshid, Mark Collard, and Stephen Shennan. "The Co-Phylogeny

of Populations and Cultures: Reconstructing the Evolution of Iranian Tribal Craft Traditions Using Trees and Jungles." *Philosophical Transactions of the Royal Society: Biological Sciences* 365 (2010): 3865–74.

Thausing, Moritz. "The Status of the History of Art as an Academic Discipline." 1873. Translated and edited by Karl Johns. *Journal of Art Historiography* 1 (2009). Accessed 30 September 2014. https://arthistoriography.files .wordpress.com/2011/02/media _139135_en.pdf.

Thompson, Robert Farris. "Yoruba Artistic Criticism." In *The Traditional Artist in African Societies*, edited by Warren d'Azevedo, 19–61. Bloomington: Indiana University Press, 1973.

Tomasello, Michael. *The Cultural Origins of Human Cognition.* Cambridge, Mass.: Harvard University Press, 2001.

Trevor-Roper, Patrick. *The World Through Blunted Sight: Inquiry into the Influence of Defective Vision on Art and Character.* London: Thames and Hudson, 1970.

Turner, Frederick. "An Ecopoetics of Beauty and Meaning." In *Biopoetics: Evolutionary Explorations in the Arts*, edited by Brett Cooke and Frederick Turner, 119–38. Lexington, Ky.: ICUS, 1999.

Tylor, Edward. *Primitive Culture: Researches into the Development of Mythology, Philosophy, Religion, Art, and Custom.* 2 vols. London: John Murray, 1871.

Ungar, Steven. "Phantom Lascaux: Origin of the Work of Art." *Yale French Studies* 78 (1990): 246–62.

Vermeule, Blakey. *Why Do We Care About Literary Characters?* Baltimore: Johns Hopkins University Press, 2010.

Viollet-le-Duc, Eugène-Emmanuel. *Dictionnaire raisonné de l'architecture française du XIème au XVIème siècle.* Vol. 8. Paris: Morel, 1875.

———. *Lectures on Architecture.* Translated by Benjamin Bucknall. 4 vols. Boston: James Osgood, 1877–81.

Vischer, Robert. "On the Optical Sense of Form: A Contribution to Aesthetics." In Vischer et al., *Empathy, Form, and Space*, 89–123.

Vischer, Robert, Conrad Fiedler, Heinrich Wölfflin, Adolf Goller, Adolf Hildebrand, and August Schmarsow. *Empathy, Form, and Space: Problems in German Aesthetics, 1873–1893.* Translated by Harry Francis Mallgrave and Eleftherios Ikonomou. Los Angeles: Getty Center for the History of Art and the Humanities, 1993.

Wallace, Alfred Russel. *Darwinism.* London: Macmillan, 1889.

Wallerstein, Immanuel. *The Modern World System.* 3 vols. New York: Academic Press, 1974.

Warburg, Aby. *The Renewal of Pagan Antiquity.* Translated by David Britt. Edited by Kurt Forster. Los Angeles: Getty Research Institute, 1999.

Watson, Ben. "The Body and the Brain: Neuroscience and the Representation of Anthropomorphs in Palaeoart." *Rock Art Research* 29, no. 1 (2012): 3–18.

———. "Oodles of Doodles? Doodling Behaviour and Its Implications for Understanding Palaeoarts." *Rock Art Research* 25, no. 1 (2008): 35–60.

———. "Rock Art and the Neurovisual Bases of Subjective Visual Phenomena." *Time and Mind: The Journal of Archaeology, Consciousness, and Culture* 5, no. 2 (2012): 211–16.

Weber, Max. "Objectivity in Social Science and Social Policy." 1904. In Weber, *The Methodology of the Social Sciences*, translated and edited by Edward A. Shils and Henry A. Finch, 50–112. New Brunswick: Transaction, 2011.

Weigel, Sigrid. "The Evolution of Culture or the Cultural History

of the Evolutionary Concept: Epistemological Problems at the Interface Between the Two Cultures." In *Darwin and Theories of Aesthetics and Cultural History*, edited by Barbara Larson and Sabine Flach, 83–108. Farnham: Ashgate, 2013.

Welchman, John C., ed. *Institutional Critique and After*. Zurich: Ringier, 2006.

Welsch, Wolfgang. "Animal Aesthetics." *Contemporary Aesthetics* 2 (2004). Accessed 13 January 2014. http://www.contempaesthetics.org/index.html.

Werber, Niels. *Literatur als System: Zur Ausdifferenzierung literarischer Kommunikation*. Opladen: Westdeutscher Verlag, 1992.

Wiener, Norbert. *The Human Use of Human Beings: Cybernetics and Society*. London: Eyre and Spottiswoode, 1954.

Wilson, Edward O. *Consilience: The Unity of Knowledge*. London: Abacus, 1999.

———. *Sociobiology: The New Synthesis*. Cambridge, Mass.: Harvard University Press, 1975.

Winkelman, Michael. "Shamanism and Cognitive Evolution." *Cambridge Archaeological Journal* 12, no. 1 (2002): 71–86.

Winthrop-Young, Geoffrey. "On a Species of Origin: Luhmann's Darwin." *Configurations* 11, no. 3 (2003): 305–49.

Wolf, Reva. "The Shape of Time: Of Stars and Rainbows." *Art Journal* 68, no. 4 (2009): 62–70.

Wölfflin, Heinrich. *Classic Art: An Introduction to the Italian Renaissance*. 1898. Translated by Peter Murray and Linda Murray. London: Phaidon Press, 1952.

———. *Principles of Art History: The Problem of the Development of Style in Later Art*. Translated by M. Hottinger. New York: Dover, 1953.

———. "Prolegomena to a Psychology of Architecture." In Vischer et al., *Empathy, Form, and Space*, 149–90.

———. *Renaissance and Baroque*. 1888. Translated by Kathryn Simon. London: Fontana, 1964.

Wollheim, Richard. *Painting as an Art*. London: Thames and Hudson, 1990.

Woodfield, Richard. Review of *Art and Intimacy*, by Ellen Dissanayake. *British Journal of Aesthetics* 41, no. 3 (2001): 343–45.

Worringer, Wilhelm. *Abstraction and Empathy*. 1908. Translated by Michael Bullock. New York: International University Press, 1953.

Wuketits, Franz. *Evolutionary Epistemology and Its Implications for Humankind*. New York: SUNY Press, 1990.

———. *Grundriss der Evolutionstheorie*. Darmstadt: Wissenschaftliche Buchgesellschaft, 1982.

Wypijewski, JoAnn, ed. *Painting by Numbers: Komar and Melamid's Scientific Guide to Art*. Berkeley: University of California Press, 1998.

Wyss, Beat. *Vom Bild zum Kunstsystem*. Cologne: DuMont, 2006.

Yates, Frances. *The Valois Tapestries*. 2nd ed. London: Routledge and Kegan Paul, 1975.

Zaidel, Dahlia. *Neuropsychology of Art: Neurological, Cognitive, and Evolutionary Perspectives*. London: Psychology Press, 2005.

Zeki, Semir. *Inner Vision: An Exploration of Art and the Brain*. Oxford: Oxford University Press, 1999.

Zelevansky, Lynn, ed. *Picasso and Braque: A Symposium*. New York: Museum of Modern Art, 1992.

Zijlmans, Kitty. "Kunstgeschichte der modernen Kunst: Periodisierung oder Codierung?" In *Kommunikation und Differenz: Systemtheoretische Ansätze in der Literatur- und Kunstwissenschaft*, edited by Henk de Berg and Matthias Prangel, 53–68. Opladen: Springer, 1993.

Zijlmans, Kitty, and Wilfried van Damme, eds. *World Art Studies: Exploring*

Concepts and Approaches.
Amsterdam: Valiz, 2008.
Zunshine, Lisa, ed. *Introduction to Cognitive Cultural Studies.* Baltimore: Johns Hopkins University Press, 2010.
———. *Why We Read Fiction: Theory of Mind and the Novel.* Columbus: Ohio State University Press, 2006.

INDEX

use of term, 39–40
Art and Illusion (Gombrich), 49
Art and Intimacy (Dissanayake), 27–28
"Art and Neuroscience" (Changeux), 153 n. 71
Art as a Social System (Luhmann), 111, 118, 130
art historians, viii, 3, 7, 10, 15, 22, 50, 61, 83, 87, 109, 114, 140, 142. *See also individual art historians*
art history, scientific status of, 7
art market, the, 129
art system, evolution of, 111, 115–130
Ashdown, Clifford, 67
Asher, Michael, 128
Ashton, Jennifer, 103
atavism, 7, 10, 17, 44, 51–52, 135
Athens, Parthenon, 45
Atlas of World Art (Onians), 41
atomism, 58, 66, 67–68
Attenborough, David, 39
Australia, 46
Austria, 22
autopoiesis, 107, 108, 114, 115, 124, 133
Auyang, Sunny, 146–47 n. 66
axes, 26, 46

Bacon, Francis, 87–88
Bahn, Paul, 152 n. 39
Balfour, Henry, 8, 46, 61
Barr, Alfred, 11
basketry, 61, 65
Bateson, Gregory, 15, 109, 130
Bauman, Zygmut, 129
Baxandall, Michael, 3, 41, 70, 91
BBC (British Broadcasting Corporation), 39
beauty
 sense of, 14, 15, 21, 25–26, 30–31
 views on, 17, 19, 21, 23, 27–28, 29, 30–31, 123
Belke, Benno, 97
Belting, Hans, 123, 140–41
Bemba peoples, Zambia, 26
Bernini, Gian Lorenzo, 85
Bertalanffy, Ludwig von, 107, 109, 110, 115
Bierstadt, Albert, 15, 16
bifurcation, 51, 62, 63
biological sciences, vii, viii, 4, 5, 6, 9, 55, 132, 137
biologists, 5, 48, 55, 59, 108, 131. *See also individual biologists*

biology, evolutionary, 5, 6, 56, 65
bipedalism, 27
birdsong, 21–22, 23, 27, 36
Blackmore, Susan, 56
Bleek, Wilhelm, 77
 blinding, 87, 89
Bloch, Ernst, 67, 67–68
body, the, 20, 26
 gesture, 7, 22, 83, 84, 87, 149 n. 47
 measuring, 25, 33–34
 mind and, 5–6, 74, 131
Bois, Yve-Alain, 87
Boltanski, Christian, 125
bonding, 27–28, 31
Boothby, Guy, 67
Bordwell, David, 139, 141
Bourdieu, Pierre, 121, 140
bowerbirds, 20, 26, 30, 31
Boyd, Brian, 30, 35
Boyd, Robert, 59–60, 60, 66
Boyer, Pascal, 5
brain, the
 brain science, 6, 78–79, 79
 brain-mind relationship, 74, 99
 in the cave, 74–78
 "Decade of the Brain", 73
 fMRI scans, 12–13, 74, 98, 99 100, 101
 modules, 24, 28, 74, 79–80
 in monkeys, 83, 86
 neurotransmitters, 29
 perception and, 74
 plasticity of, 74, 88, 90, 92
 pre-frontal cortex, 81
 visual cortex, 94, 96
 See also memes; neuroaesthetics; neuro-arthistory; neurology; neuroscience
Bramante, Donato, 48
Braque, Georges, 95
bridge building, 45
Britain
 British army, 69
 British society, 1
 Celtic British coinage, 46, 50, 56
 Celts in, vii
 Darwin's influence in, 7–8
British Museum, *Ice Age Art* exhibition, vii, 74–75, 81, 82
Bronze Age, 34
Brunelleschi, Filippo, 38, 48, 91, 118

The Expression of Emotions in Animals and Man, 7, 22

On the Origin of Species, 7, 18–19

Darwinism, 10–11, 14, 18–22, 30, 42, 106

social, 22, 49, 113

See also neo-Darwinism

Darwinism (Wallace), 30

Darwin's Dangerous Idea (Dennett), 131

Davidson, Donald, 40

Davies, Stephen, 31, 32, 41

Davis, Whitney, 89–90, 102

Dawkins, Richard, 6, 133, 136

theory of the meme, 11, 53–58

The Extended Phenotype, 23, 32–33, 54

The Selfish Gene, 11, 23, 54

Death of the Virgin (Caravaggio), 53

decoration, 8, 46, 49, 75, 118–19

deer, 19, 20

Deleuze, Gilles, 62, 87–88

Della Francesca, Piero, 3

Dennett, Daniel, 131, 136

Derain, André, 87

Derrida, Jacques, 42, 112

The Descent of Man (Darwin), 19–20

detective fiction, 11, 66–68

devotional statuettes, 34

Dialectic of Enlightenment (Adorno and Horkheimer), 126

Diamond, Jared, vii, 144 n. 11

Dickie, George, 124

Diderot, Denis, 4

Didi-Huberman, Georges, 71–72, 141

diffusion, cultural. *See* cultural diffusion

Dionysian legacy, 51, 52

Discus Thrower (Myron), 15

Dissanayake, Ellen, 8, 27–28, 31

distal explanations, 41, 43, 127, 134

DNA, 18

doppelgänger, the, 117

Doyle, Arthur Conan, 67

dualism, ix, 5–6, 43, 99, 131, 132

Duchamp, Marcel, 128

Dummett, Michael, 142

Dutton, Denis

on childbearing capacity, 25

evolutionary theory of art, 8–9, 17, 22–23, 25, 33, 91, 106

on literature, 35

on multiculturalism, 42

as a rationalist, 30

on universality, 29, 39

Dvořák, Max, 7, 47, 140

The Dynamics of Architectural Form (Arnheim), 89

dynamograms, 11, 51–52

Echo Objects (Stafford), 98–99

Edelman, Gerald, 74

education, in Britain, 1

Egypt, ancient, 29, 47, 81

Eitelberger, Rudolf, 7

El Greco, 47

Eldredge, Niles, 121

Elkins, James, 10

empathy theory, 83–86, 88

enabling conditions, 37, 38, 70, 118–19

The End of the History of Art? (Belting), 140–41

engrams, 51–52, 55

Enlightenment, the, 4, 29

entoptic phenomena, 78, 81

environmental issues, vii, 4, 23, 36, 90–92

Equivalent VIII (André), 27

essentialism, 27, 42, 94, 96, 101

ethnogenesis, 62

Europe

colonialism and, 39

Darwin's influence in, 7

European society and culture, 34, 71, 115

folk art in, 29

medieval, 119

prehistoric art in, 37–38, 46

privileging the art of, 39–41

world art and, 41

See also individual countries

Eva & Adele, 125

Evans, John, 46, 56

evolution

of art, 8–9, 10, 11, 12, 22–24, 25, 29, 111, 115–130

art history as, 7, 44–72

critical issues, 64–70

history of an idea, 45–50

memes and the reinvention of evolutionary theory, 53–58

patterns of evolution, 58–64

provisional observations, 51–53

See also cultural evolution

Kristeva, Julia, 87
Kroeber, Alfred, 61
Kubler, George, 11, 49
Kuhn, Thomas, 121–22, 140
Kunstgeographie, 90
Kunstwissenschaft (art history), 7
Kunstwollen (aesthetic volition), 47, 109

Lachmann, Karl, 59
Lady at the Virginals with a Gentleman (Vermeer), 94–95
Laland, Kevin, 55, 65, 101
landscape / landscape painting, 32, 98, 99
 history of, 10
 Hudson River school, 15, 16
 the ideal landscape, 16–17
 response to, 15, 17–18, 33, 134
language, 2, 27, 36–37, 46, 57, 63–64. *See also* linguistics
Lascaux caves, France, 37–38, 75, 76
Lash, Scott, 129–130
Late Roman Art Industry (Riegl), 109
Laudan, Larry, 9
Lectures on Fine Art (Hegel), 81
Leder, Helmut, 97
Leroi-Gourhan, André, 76
Les Demoiselles d'Avignon (Picasso), 95
Lewis-Williams, David, 40, 76–79, 80
Lewontin, Richard, 34
Libet, Benjamin, 101
Library of Congress, US, 73
line, the, Zeki on, 93, 96, 102
linguistics, vii, 45, 46, 59, 126. *See also* language
literature / literary studies, 11, 25, 28, 35, 42, 46–47, 66–68, 92, 116–18, 132, 135. *See also* poetics
Littérature (magazine), 128
Lloyd, Lucy, 77
London, National Gallery, 97
Luhmann, Niklas
 on the art market, 129
 on autopoiesis, 133
 on beauty, 123
 critiqued, 119–120, 126
 on historical analysis, 113–14
 on literature, 116, 117–18
 systems theory, 7, 11–12, 13–14, 110, 111–15, 115–122, 125, 127–28, 130, 135–36

Art as a Social System, 111, 118, 130
 Social Theory or Social Technology, 110
Lüpertz, Markus, 125
Lyman, R. Lee, 61

Mach, Ernst, 42
magic, 75–76, 78
maladaptations, 11, 18, 24, 27, 53, 68–69, 114
Mâle, Émile, 66
Malevich, Kazimir, 88, 96, 99, 102
Mallgrave, Francis, 88–89, 90, 92, 106
Man with a Violin (Picasso), 95
Manet, Édouard, 27, 53, 69–70
Marshack, Alexander, 152 n. 44
Marx, Karl, 42
Marxism, 71, 127
"masterpieces", 40, 57
materialism, 10, 30, 84, 99, 101
mathematical knowledge, 37, 38–39, 66
Matisse, Henri, 87, 89
Maturana, Humberto, 107, 108, 110
Maynard Smith, John, 11
means-end reasoning, 126
medieval art, 50–51
Mediterranean culture, 34
Melamid, Alexander, 16–17, 25, 33
memes, 11, 23, 53–59, 69
memory
 Semon on, 10, 55
 Warburg on, 22, 51–52, 55
Menninghaus, Winfried, 8–9, 30, 147 n. 71
Mesarović, Mihajlo, 107
Mesolithic era, 37–38
Mesoudi, Alex, 60, 65, 68, 101
metaphysics, 8, 11, 76
metarepresentations, 79
Michelangelo, 85
military dress and drill, 68–69
Miller, Geoffrey, 25–26, 30, 135
mimesis, 83–84, 85–86, 98
mind, the
 brain-mind relationship, 74, 99
 development of the modern, 82
 mind and body, 5–6, 74, 131
 theories of. *See* neuroscience
The Mind in the Cave (Lewis-Williams), 76
Mingers, John, 122
mirror neurons, 83–85, 98
Mithen, Steven, 8–9, 24, 26, 27, 75, 79

Spencer-Brown, George, 110
Sperber, Dan, 56–57, 79, 147 n. 70
Spivak, Gayatri Chakravorty, 139
Spolsky, Ellen, 28, 74
Springer, Anton, 50–51
Stafford, Barbara Maria, 98–99, 99
Stoichita, Victor, 118
The Story of Art (Gombrich), 49
structural coupling, 13, 115
style, 8, 47, 85, 123, 124, 140
Sudan, 26
Sully, James, 22
Summers, David, 37–38, 43
survival instinct, 17–18, 19–21, 22, 25–26,
 31–32, 34, 49, 71–72
Swiss army knife metaphor, 24
Switzerland, vii
symmetry, 25, 37–38
Symonds, John Addington, 46–47
systems theory, viii, 41, 106–30
 background, 6–7
 idea of a social system, 111–15
 modernity and the evolution of the art
 system, 115–130

Tallis, Raymond, 99–100, 101
Tasso, Torquato, 85
taste, 7, 16, 20, 25, 30, 30–31
technocratic liberalism, 1
Tehrani, Jamshid, 61, 62, 63–65, 66, 68, 71,
 140
textiles, 11, 61–65, 141
Thausing, Moriz, 7
Third of May 1808 (Goya), 53
Thucydides, 70
time
 deep, 44
 historical, 43, 44, 48, 113, 140, 141
 Koselleck on, 70
 Kubler on, 49
 time lag, 32, 61, 133
 time-keeping, 27
 timelessness, 64, 102
Tintoretto, 120–21
Titian, 69–70, 97
Tomasello, Michael, 36–37, 39, 43, 133
Tooby, John, 23, 80, 101
top-down approach, 139, 141
Torres Strait islanders, Australia, 46

Transfiguration (Raphael), 28
The Tree of Knowledge (Maturana and Vare-
 la), 108
The Tree of Life (Klimt), 10
Trevor-Roper, Patrick, 8
The Tribal Eye (BBC documentary), 39
Troy, 46
Turkmen textiles, 61, 62–63, 65, 141
Turner, Frederick, 29, 42
"The Two Cultures" (lecture), 1–2, 13
Tylor, Edward, 22
types
 development of, 47
 the "ideal type", 2
Tzara, Tristan, 128

Uecker, Günther, 98
underdetermination, 9, 35, 41
United States, indigenous Californians, 61, 65
universal laws of art, 81, 93
universality of art, 29, 39–42
upbringing, formative role of, 92–93
Urry, John, 129–130

value, 7, 15, 32, 42, 138
Varela, Francesco, 107, 108, 110
Vasari, Giorgio, 8, 140–41
Venice, 91
Venus of Urbino (Titian), 69–70
Venus of Willendorf, 37–38, 74
Vermeer, Johannes, 94–95, 101–2
Vermeule, Blakey, 35
Verstehen (understanding), 5
Victorian fiction, 25
Vienna, 7, 47
Viollet-le-Duc, Eugène-Emmanuel, 45
Vischer, Robert, 84
vision / the visual
 Baxandall on, 91
 blinding, 87, 89
 evolution of, 7
 Lewis-Williams on, 78
 semantics of, 89–90
 Trevor-Roper on, 8
 Zeki on, 94, 96, 104
 See also perception
Vlaminck, Maurice de, 87
Voltaire, 4

Wales, vii
Wallace, Alfred Russel, 20, 30
Wallerstein, Immanuel, 41
Warburg, Aby
 changing interpretations of, 141
 empathy theory, 84–85
 on fear, 51, 85
 on gesture, 7, 22, 149 n. 47
 mnemic recall and, 10–11
 Nachleben concept, 22, 71–72
 theory of cultural memory, 51–52, 55
Warhol, Andy, 124
Weaver, Warren, 112
weavers / weaving, 52, 61, 63–65, 112
Weber, Max, 2
Welsch, Wolfgang, 20–21
west Africa, 26
What Science Offers the Humanities (Slinger-
 land), 132
Whiten, Andrew, 65
Whitman, Walt, 46
Wickhoff, Franz, 7
Wiener, Norbert, 110
Wilson, Anne, 98
Wilson, Edward O., 4, 5, 23, 131–32, 135
Winckelmann, Johann Joachim, 8, 70
Wind, Edgar, 8
Windelband, Wilhelm, 2

winking, 80
Wittgenstein, Ludwig, 42
Wölfflin, Heinrich, 7, 8, 84, 85
Wollheim, Richard, 102
women
 female choice, 20, 30
 feminism, 30, 71, 127
 hip-to-waist ratio, 25, 33–34
 mother-child relationship, 27–28
 Paleolithic figurines of, 37–38
 puberty rites, 26
Wood, Christopher, 141
Wood, Paul, 40
Woodfield, Richard, 146 n. 60
world art, 9, 29, 37–38, 39–42, 43
World Art (journal), 40
Worringer, Wilhelm, 8
Wuketits, Franz, 108
Wundt, Wilhelm, 84
Wyss, Beat, 123, 125, 127

Yomybato peoples, Peru, 146 n. 64

Zambia, 26
Zeki, Semir, 88, 93, 94–97, 98, 99, 102–3, 104
Zijlmans, Kitty, 123–24
Zunshine, Lisa, 28